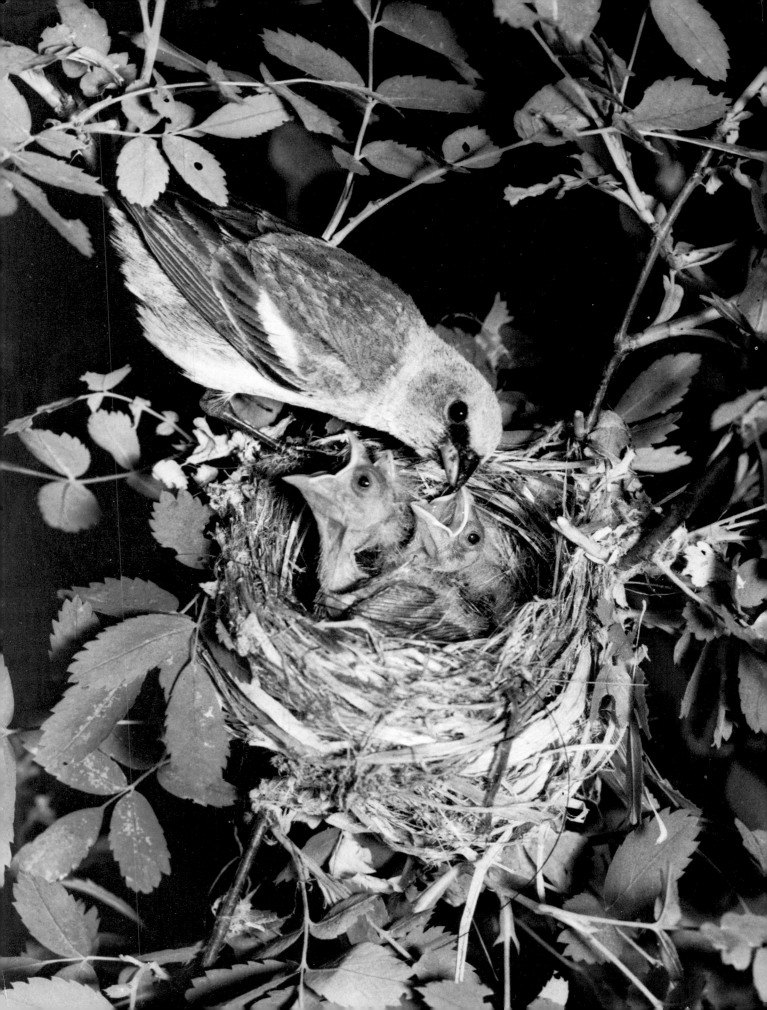

# Cruickshank's Photographs of Birds of America

177 PHOTOGRAPHS AND TEXT BY
## ALLAN D. CRUICKSHANK

WITH A PREFACE BY
HELEN G. CRUICKSHANK

*Dover Publications, Inc.,*
*New York*

[FRONTISPIECE]

## LAZULI BUNTINGS
*Passerina amoena*

The lazuli bunting is the abundant species of *Passerina* in our West. The male suggests a pale bluebird except for his wing bars, short conical bill, and small body. Most lazuli bunting nests I have found were in wild rose tangles, where the fragrant flowers made a delightful setting for the colorful bird.

Whenever I watch from my blind the nest activities of lazuli buntings, I envy Dr. Thomas Say, a member of the Yellowstone Expedition of 1819, who was the first scientist to observe this azure bird. He was standing among the strange red sandstone formations in Colorado's Garden of the Gods when he heard it singing—probably from the highest twig of a cliff rose—but he was too delighted to describe the perch of this newly discovered, beautiful bird. The day when a scientist is likely to discover a new species of bird is almost gone. When a rare discovery is made today it is usually a bird so like its companions that even trained eyes have overlooked it. To discover a new species as beautiful as a lazuli bunting must be more satisfying to an ornithologist than the discovery of a gold mine is to a prospector.

---

Published in Canada by General Publishing Company, Ltd., 30 Lesmill Road, Don Mills, Toronto, Ontario. Published in the United Kingdom by Constable and Company, Ltd., 10 Orange Street, London WC2H 7EG.

*Cruickshank's Photographs of Birds of America* is a new work, first published by Dover Publications, Inc., in 1977. Some of the photographs and captions, as well as the Introduction, first appeared in *Wings in the Wilderness*, published by Oxford University Press, New York, in 1947.

*International Standard Book Number: 0-486-23497-5*
*Library of Congress Catalog Card Number: 77-70078*

Manufactured in the United States of America
Dover Publications, Inc.
180 Varick Street
New York, N.Y. 10014

# Preface

*Cruickshank's Photographs of Birds of America* contains a total of 177 photographs; 76 of these photographs, 82 of the captions and the Introduction originally appeared in *Wings in the Wilderness*, published in 1947 by Oxford University Press.

The photographs were selected from the more than 40,000 negatives in the Cruickshank collection, which covers almost 550 species of North American birds. They were taken with either a Graflex or Speed Graphic 4 x 5 camera on panchromatic film; although he enjoyed color photography, Allan Cruickshank preferred the forthright clarity and elegance obtainable with black-and-white. The plates and captions are arranged in the sequence established by the American Orinithologists' Union; birds with the most primitive structure come first, followed by those that have evolved into more highly developed species. (The only departure from this order is the frontispiece, the lazuli bunting, which officially belongs after the cardinal on page 175.) All common and scientific names also correspond to the latest A.O.U. decisions.

Birds have very sharply defined habitat requirements. Therefore, in order to photograph a great many species it is necessary to visit widely separated places having many habitats. All the photographs in this collection, most of which were taken within the United States, show birds in their natural, undisturbed surroundings, where the subjects were free to come and go at will. Most often the photographer worked from a blind, where he remained hidden for many a long day. Sometimes he waited hip-deep in water, sometimes in the chill wind of mountain slopes, and very often in the hot, muggy bird colonies along our southern coast. The excitement of bird photography includes not only the subject, but the challenge of locating it and the always interesting habitat in which it lives.

Allan Cruickshank's love for birds as a child matured into dedicated activity, aimed at sharing their beauty and worth with others as well as communicating the urgent need to protect them and their environment. After graduating from the Heights of New York University in 1931, he worked as an instructor at the first of the National Audubon Society's adult summer conservation workshops in 1936. The next year he became a full-time member of the staff of the Society and remained so until his retirement in 1972. During that time he gave almost 6,000 lectures to a combined audience of nearly 3,000,000 people. The superb quality of his films and sense of humor, coupled with an important conservation message, certainly contributed in an important way to the present rise in concern for the human environment.

As a member of the editorial board of *American Birds* (formerly *Audubon Field Notes*) he edited the Christmas Bird Counts for 17 years. He also found time to write *Birds Around New York City*; *A Pocket Guide to Birds*; *Hunting with the Camera*; *Summer Birds of Lincoln County, Maine*; *Wings in the Wilderness*; and, with myself as coauthor, *1001 Questions Answered About Birds* (Dover reprint, 1976).

As a photographer he not only produced all the movies for his lectures but also used his still photographs for Audubon's educational programs and exhibits. He enjoyed the challenge of difficult photography and reveled in the rugged side of this activity. He was ruthless in discarding any photographs that did not meet his high standards of excellence. With his boundless energy and enthusiasm it is difficult to realize that his life could end in its 67th year.

Photographs from the Cruickshank collection have been used in most national magazines, in newspapers and encyclopedias, on billboards and calendars, in advertisements, and even in mathematics textbooks. Many an artist's drawings or paintings suggest that reference was made to a

Cruickshank photograph. But Allan Cruickshank always placed the welfare of birds above his burning desire to photograph them; if his activity was a threat to the bird or its nest he always surrendered his chance for a picture. It should be obvious from this collection that the birds were comfortable and able to carry on their normal activities in spite of the photographer busily capturing their images on film. The result is a timeless beauty of great integrity.

HELEN G. CRUICKSHANK

*Rockledge, Florida*
*10 December 1976*

*Allan D. Cruickshank photographing a raven's nest on a Maine seacoast cliff in the summer of 1947. (Photograph by Helen D. Cruickshank)*

# Introduction

Bird photography is a captivating hobby, an exciting sport, and inevitably adds a great deal to the full enjoyment of life. It is a year-round avocation with few limitations, for there are no closed seasons, no bag limits, no protected species. Furthermore, it not only affords pleasure and healthy recreation, but it provides an unusual opportunity to study intimately the life activities of our birds and to gain a more appreciative understanding of their requirements.

Just when my own interest in nature originated I cannot say. All I know is, that as far back as my memory allows me to probe I can recall the excitement that some mammal, bird, snake, turtle, frog, or butterfly brought to me. When and how my interest in photography began is more easily determined. When I was a freshman in high school, I completed a correspondence course in taxidermy and was intent on acquiring a collection of every species of bird in our vicinity. Soon my pursuits conflicted with those of the bird-watchers in the neighborhood, and complaints began to reach my parents. Although they had always encouraged me in my out-of-door interests, they had been constantly and unequivocally critical of my shooting. In order to dissuade me, they enlisted the cooperation of George T. Hastings, one of the biology teachers in Evander Childs High School. This kindly neighbor talked to me with great skill and understanding. He praised my knowledge of nature and invited me to go on field trips each weekend with his senior high school Audubon Club, even though I was not yet in the upper school. Under his leadership on these never-to-be-forgotten trips, my eagerness to know more about the avifauna became so intense that I passed every free minute in the field. I became more intimately acquainted with the fascinating habits of birds, I developed a strong distaste for any destruction of them.

My discovery of the second king rail's nest ever found in southeastern New York State filled me with such pride that I was determined to get a picture of the prize. After a few instructions from my father in the general mechanics of photography, I borrowed his camera. By a lucky sequence of events I managed to get not only a fairly good photograph of the nest and eggs, but quite a recognizable image of the king rail itself. This picture immediately became my most cherished possession and stimulated me to try for more. With the optimism of a high-school boy, I decided to try to get good pictures of a hundred different species of birds. When this figure was reached some years later I moved the goal to what then seemed an impossible total of two hundred different species. This mark has long been passed and now I am out to try for photographs of every one of the approximately seven hundred species that occur on our continent north of Mexico, even though I know that this ambition can never be completely realized.

Those who are easily discouraged or who are unwilling to plan meticulously for ever-varying situations should not attempt wildlife photography. There will be many failures, there will be many hardships. But for the individual who is patient, who is willing to accept plenty of disappointments, who is prepared to face difficulties, there is no sport more exciting, more instructive, more completely satisfying.

Since many readers may be quite unfamiliar with the methods used by bird photographers it is necessary to explain a few details. To get the best results, a sound knowledge of the habits of various birds is necessary: it is essential to know how a certain species generally behaves or how close an approach it will allow. As birds are generally shy and difficult to approach, most pictures must be taken from a natural or well-camouflaged blind, which conceals the photographer from the subject. These hideouts vary widely. I have hidden in rubbish piles, packing cases, fish shacks, canoes, boats, pup tents, corn shocks, holes in the sand, special portable artificial grass blinds, *ad infinitum*. The blind must be either some natural object with which the birds

are thoroughly familiar and which they do not fear, or a portable structure that is small and stable. Birds will accept almost any object so long as there is no flapping or shaking.

Some photographs can or must be obtained by stalking. This is even more exciting, and a thorough understanding of the camera is essential. Under these tense conditions with the necessity for split-second decisions, there is not time to deliberate over the correct exposure or the manner of focusing. Every move must be smooth and almost automatic and all attention must be centered on the birds, their actions, the best composition for capturing the feeling of the moment.

Any reliable make of camera may be used but naturally the most satisfactory are those with good sharp lenses, a wide variety of shutter speeds, and allowance for interchanging lenses, long bellows extension or equivalent compensation. It is important for the bird photographer to know his camera well and be thoroughly cognizant of its limitations.

The problem of selecting the photographs for this book, from the many thousands of good negatives, has been a difficult one. Some of them were selected because they are beautiful photographs, some because the bird represented has an interesting story connected with it, a few because the species is rare, and others merely because they recall some incident that is one of the bright spots in my memory. That I treasure these pictures is only natural. They are graphic records of exciting days passed in widely scattered corners of this continent. They are the results of a great deal of time and effort and represent experiences which have added richness and beauty to life.

I wish I were able to thank everyone who has aided me in making this volume possible. Although this is impractical I hope all of these friends realize my sincere appreciation. There are some, however, who unselfishly went far out of their way. I am indebted to the entire staff of the National Audubon Society, in particular to Mr. John H. Baker, who has made it possible for me to visit so many of the inspiring Audubon Sanctuaries. Mr. Richard H. Pough was most responsible for urging me to get this book together. Special thanks must be given to Mr. Carl W. Buchheister, with whom I have passed ten wonderful summers at the Audubon Nature Camp on the coast of Maine, and who has constantly encouraged and aided me in my photographic efforts. It is impossible to mention all those tireless and conscientious Audubon wardens who guided me through almost impenetrable wilderness country to spectacular colonies of birds. I must also express my gratitude to many members of our Federal Fish and Wildlife Service for their graciousness and their unfailing efforts to help me obtain many of my favorite shots; I am grateful to Mr. and Mrs. Edwin Way Teale for their kindly interest, encouragement and assistance. Above all I am indebted to my wife for being very patient with a husband who spends much more time wandering around the country than in his home. Even when able to accompany me on photographic trips she has frequently had to pass long hours alone while her fanatical husband explored the wilderness or crouched in a blind. Moreover, she kindly volunteered her services for the arduous tasks of deciphering my scrawl, typing the manuscript, and reading proof.

A. D. C.

*Rye, New York*
*20 January 1947*

# Alphabetical List of Birds

*The numbers refer to the pages on which the illustrations appear.*

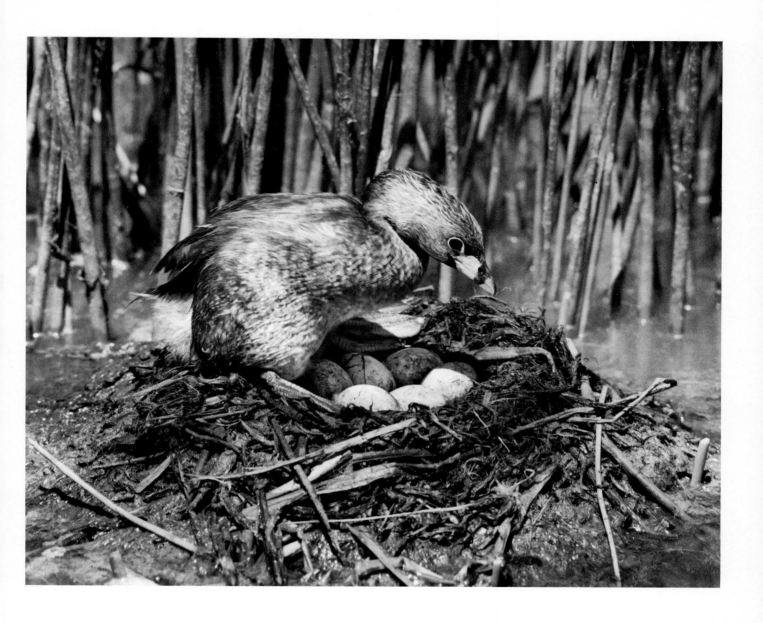

## PIED-BILLED GREBE
### Podilymbus podiceps

Often mistaken for a duck, the roundish, nine-inch pied-billed grebe can change its specific gravity at will. Strollers beside ponds often see one suddenly sink beneath the surface apparently never to rise again, and so the pied-billed grebe has been dubbed "hell diver." From time to time the black-and-white (pied) bill does emerge inconspicuously for a breath of air.

These are widespread birds, appearing in suitable habitats over much of North America. The nest usually floats but is anchored firmly to surrounding vegetation. When it leaves the nest, the grebe covers the eggs with some of the soft plant material of which the nest is made.

At one time the pied-billed grebe was threatened with extinction because there was such a demand for its feathers. They were formed into bands to decorate gowns and coats. The feathers are very soft, lustrous and extremely dense; in fact, a pied-billed grebe has more than twice as many feathers as an eagle.

1

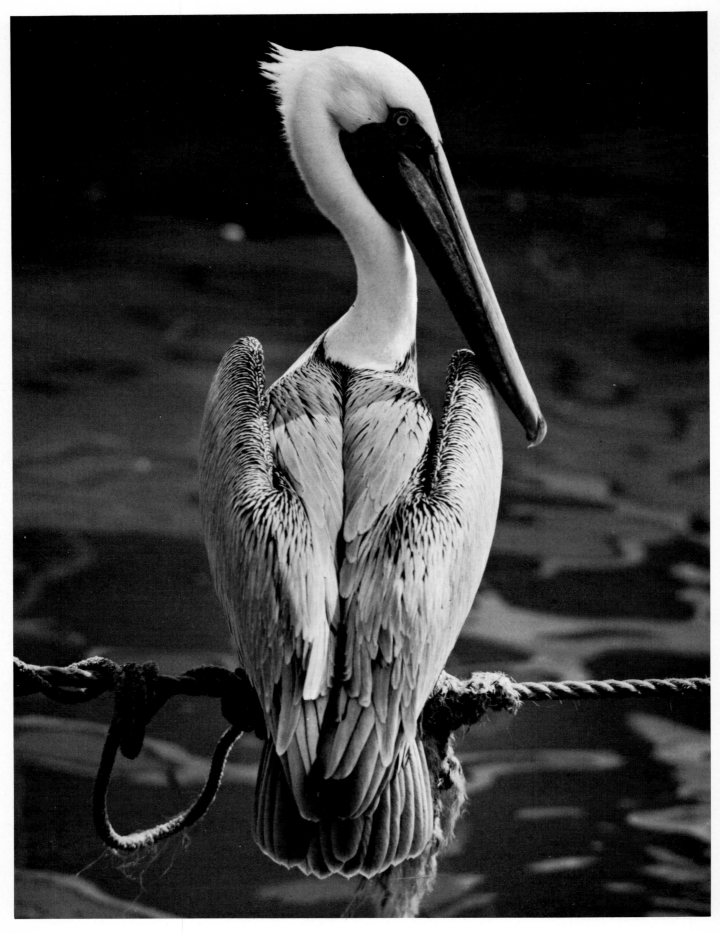

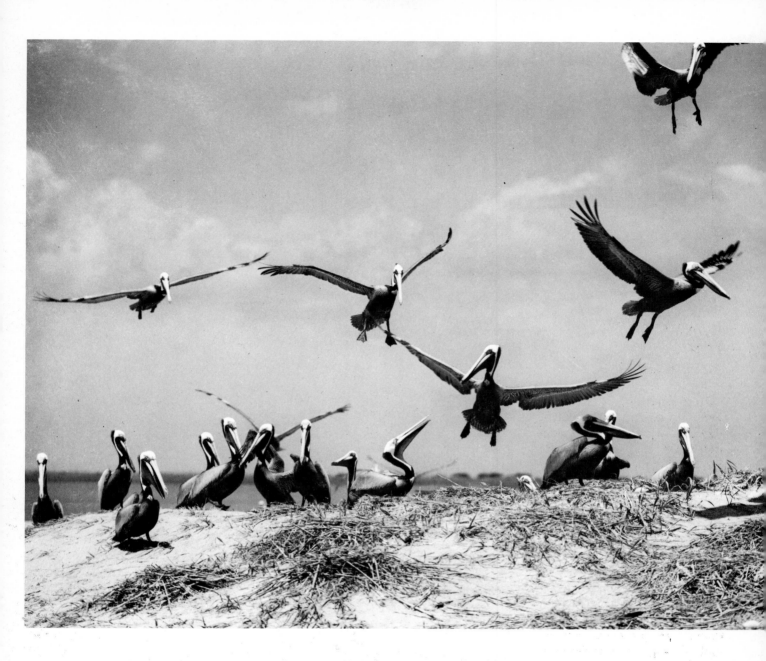

## BROWN PELICAN
*Pelecanus occidentalis*

Once this large droll-looking species was a familiar sight along the coast of the southern United States from South Carolina to Texas and the shores of southern California. In recent years its numbers have diminished seriously. It is the state bird of Louisiana and appeared on the first flag and seal of that state. Sadly, it no longer breeds in Louisiana, though recent attempts by scientists to reintroduce pelicans there from states where they still nest may be successful.

The brown pelican possesses the enormous membranous pouch for which all pelicans are famous. A set of muscles enables the bird to expand the sides of its lower mandible, quickly converting its pouch into a huge and effective dip-net for scooping up fish.

## BROWN PELICAN COLONY
*Pelecanus occidentalis*

The great majority of birds are strictly territorial during the breeding season. They assiduously chase all intruders of the same species off the area on which they plan to raise a family. Thus direct competition is partially eliminated and the family more assured of sufficient food. Birds such as pelicans, terns, herons and swallows, however, which feed over vast areas and are not dependent on their small nesting tracts for food, are seldom territorial. Instead they are gregarious, often nesting in extensive compact colonies.

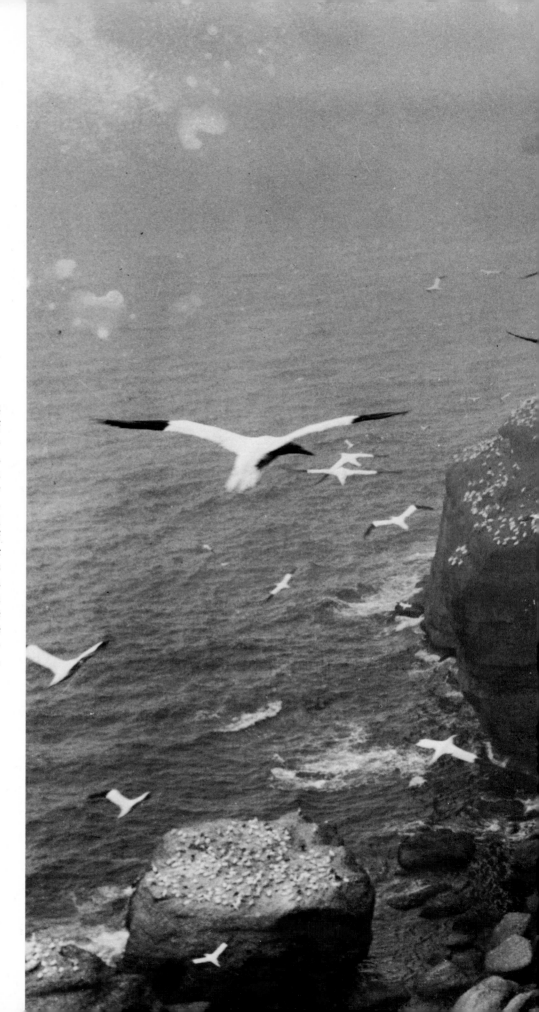

## GANNETS IN THE FOG
*Morus bassanus*

Off the eastern tip of the Gaspé Peninsula in Canada are some of the most spectacular ornithological sights in North America. Here during the breeding season I have seen more than twenty thousand pairs of gannets crowding every available ledge and crack until the entire side of the island looked as though it were covered with snow. This photograph was taken just as a great fog bank rolled in from the Gulf of St. Lawrence. The suspended vapor blanketed the island and prevented photography for three consecutive days.

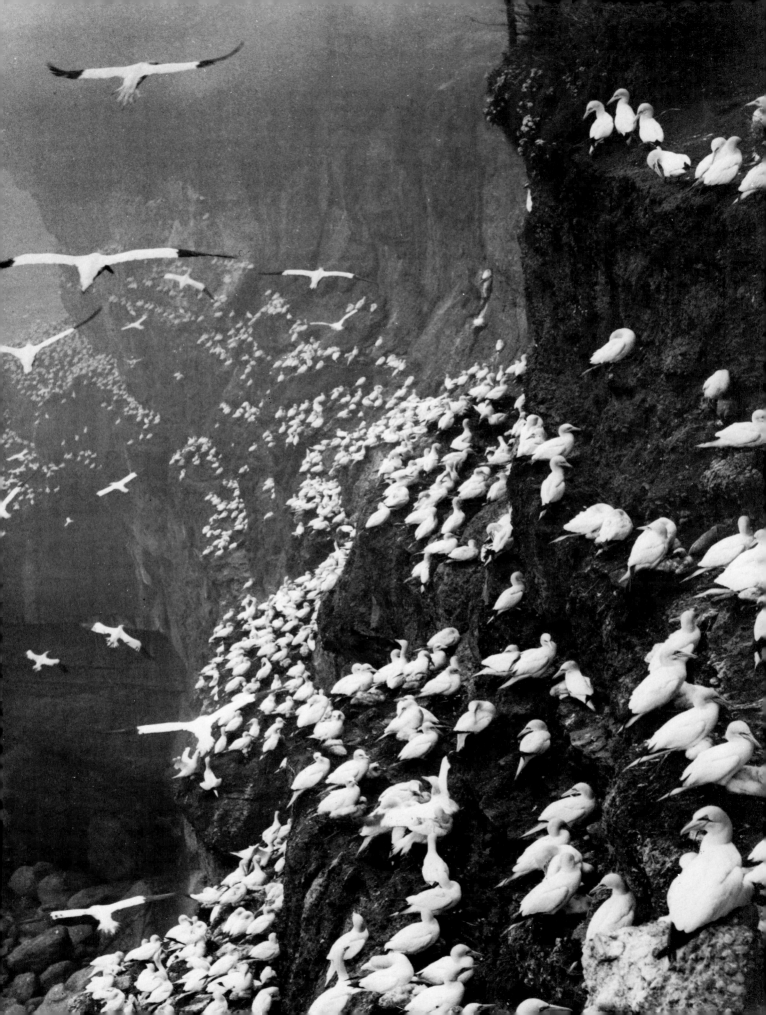

## GANNET THREE-POINT LANDING
*Morus bassanus*

Hiding in a crevice on the perpendicular face of Bonaventure Island off the Gaspé Peninsula in Canada, I adjusted my camera so that it pointed a few feet over an incubating gannet. After setting the speed for one thousandth of a second I waited for its mate to return to the nest. For three quarters of an hour I watched from my rocky retreat with alert expectancy. Finally the bird came, with such speed that it seemed certain to crash against the cliff. Just above the nest it put on the brakes and in that split second I obtained this picture. With tail spread and feet thrown forward, the great white bird is suspended in midair ready for the three-point landing.

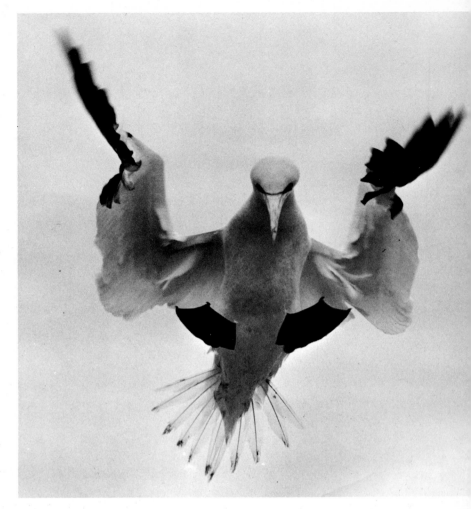

## DOUBLE-CRESTED CORMORANTS
*Phalacrocorax auritus*

Scientists, in classifying the avifauna of the world, place cormorants very low in the evolutionary scale. The birds look as though they were left over from some bygone age. When young, a cormorant breathes through its nostrils. Shortly a bone structure closes the nose and forces the bird to breathe through its mouth for the remainder of its life. In China, Japan, and India trained cormorants are commonly used for fishing. A collar placed around the bird's neck prevents it from swallowing fish. When the bird comes to the surface it is scooped up in a net and relieved of its catch.

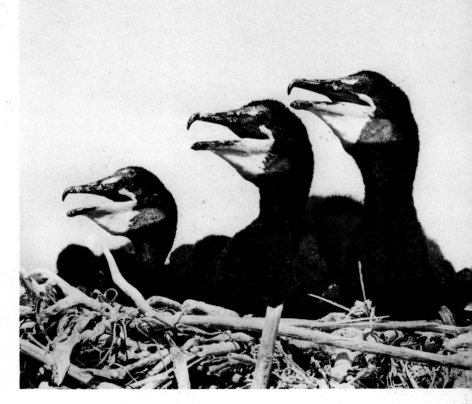

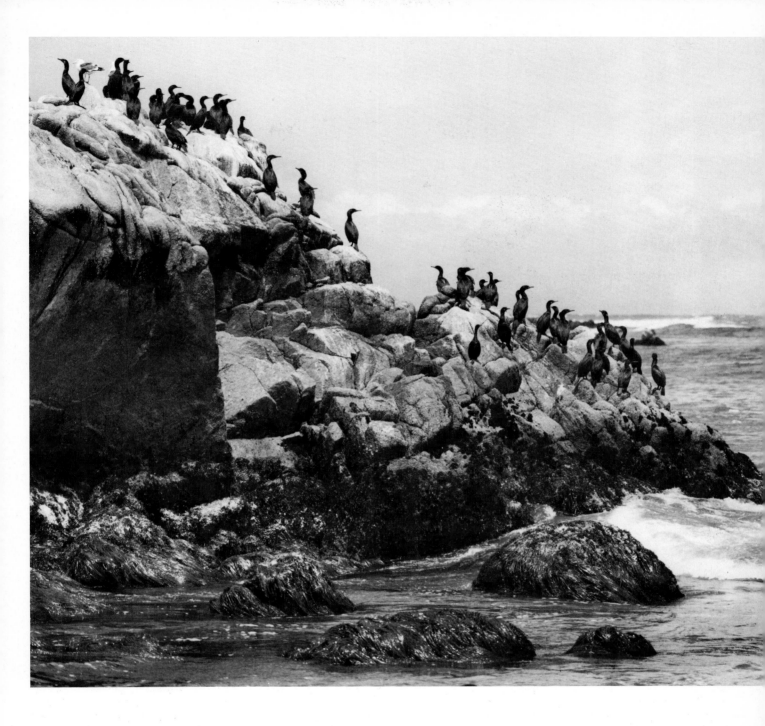

## BRANDT'S CORMORANTS
*Phalacrocorax penicillatus*

While double-crested cormorants not only nest on Atlantic oceanic islands but also on islands in lakes across the continent, Brandt's cormorants cling to the Pacific coast from Washington to Baja California, nesting on sheer cliffs above the surf or on inaccessible islands. They are remarkable divers and have been caught in fish traps set at a depth of 40 meters. Excrement from cormorant nesting colonies in the Northern Hemisphere is washed away by rain and fog; this is in contrast with coastal Peru, where the guano accumulates in great quantities and is gathered for fertilizer. In some forms it has a nitrogen content 33 times greater than farmyard manure. Some islands have a nesting population of more than five million cormorants, and at one time the annual sale of guano from one small group of islands averaged $20–30 million. Today the yearly take of this valuable substance is carefully regulated by the Peruvian government.

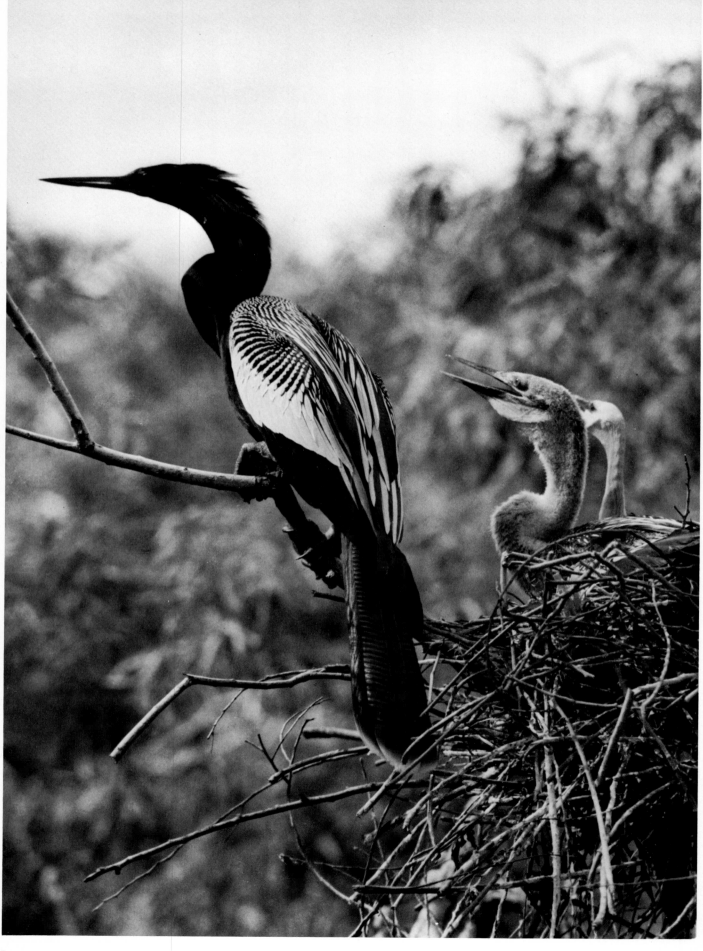

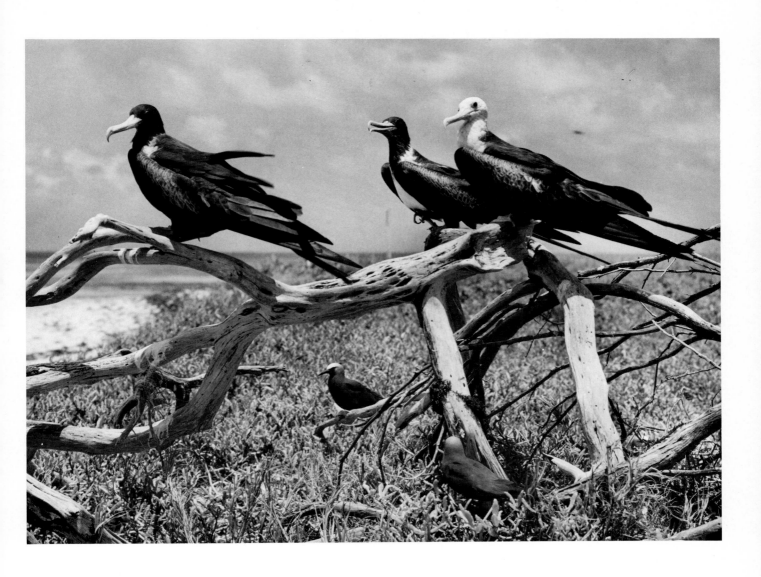

## ANHINGAS
*Anhinga anhinga*

There are four species of anhingas in the world, only one occurring in the Western Hemisphere. That bird, popularly known as the snake-bird or water-turkey, is confined chiefly to the tropics and subtropics. It breeds as far north as Arkansas and North Carolina, preferring to dwell in the protective isolation of extensive swamps. When danger threatens, the bird sinks quietly beneath the water, leaving only its long, thin, sinuous neck and narrow head above the surface. Then indeed it does look like a snake-bird.

## MAGNIFICENT FRIGATEBIRDS
*Fregata magnificens*

The frigatebird is so lacking in waterproofing of its feathers that if it settles on the water it becomes waterlogged and takes off with difficulty or may even drown. A most efficient glider, it soars for hours with no apparent movement of its narrow, seven- to eight-foot wings, the largest of any bird its size in the world. It weighs about three pounds, and its feathers actually make up about a quarter of that weight.

These immature frigatebirds were photographed on the Dry Tortugas where they lay in wait for nesting terns to bring food to the island. They are called man-o'-war birds by sailors and, as they streaked toward the terns and forced them to surrender their catch, that name was a fitting one.

## GREAT BLUE HERON (white morph)
### Ardea herodias occidentalis

With a wingspread of almost seven feet, this wary bird is the largest American heron. It is confined principally to south Florida and the Keys, where it nests in almost impenetrable thickets of mangroves. The young taken for food by the increasing human population on the Keys reduced the number of the great white birds alarmingly, and then the Labor Day hurricane of 1935 killed so many that it was estimated that only about 60 birds survived. Since then they have been rigidly protected and have made a remarkable comeback.

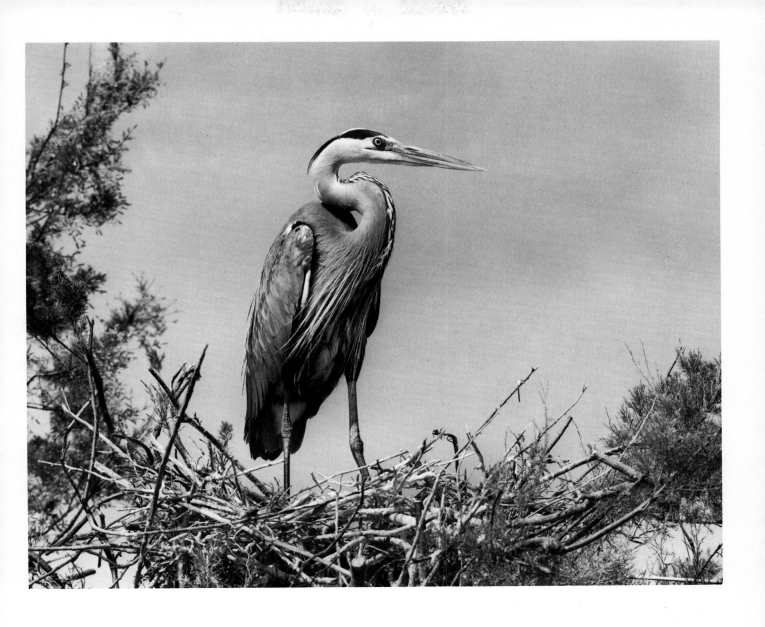

## GREAT BLUE HERON
### *Ardea herodias*

This is the largest of our dark herons and is common on both fresh and salt water. They fish with equal success by day or night. One technique they frequently employ is to stand motionless in shallow water and, with lightning-like thrusts, spear fish unlucky enough to venture within reach.

If the victim is small it is tossed into the air and invariably caught head first and swallowed. If large, the fish is vigorously slapped against the water or land until completely subdued, whereupon it too is shifted into the correct head-first position and bolted.

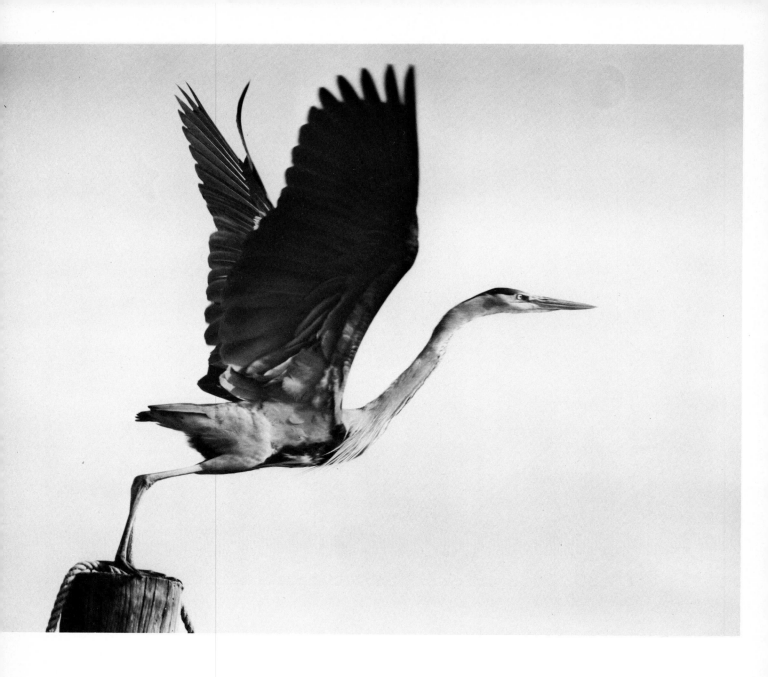

## GREAT BLUE HERON TAKEOFF
*Ardea herodias*

When unexpectedly frightened, a great blue heron generally makes a rather awkward getaway. It struggles into the air on hurried, ungainly wing beats, with its long legs dangling clumsily behind and its long neck extended at some ungraceful angle. Once under way, however, its flight is powerful and majestic, its long legs are held neatly together in the rear, and in the manner of all herons its head is gracefully folded back on its shoulders. My records indicate that these birds ordinarily fly at about 30 miles an hour.

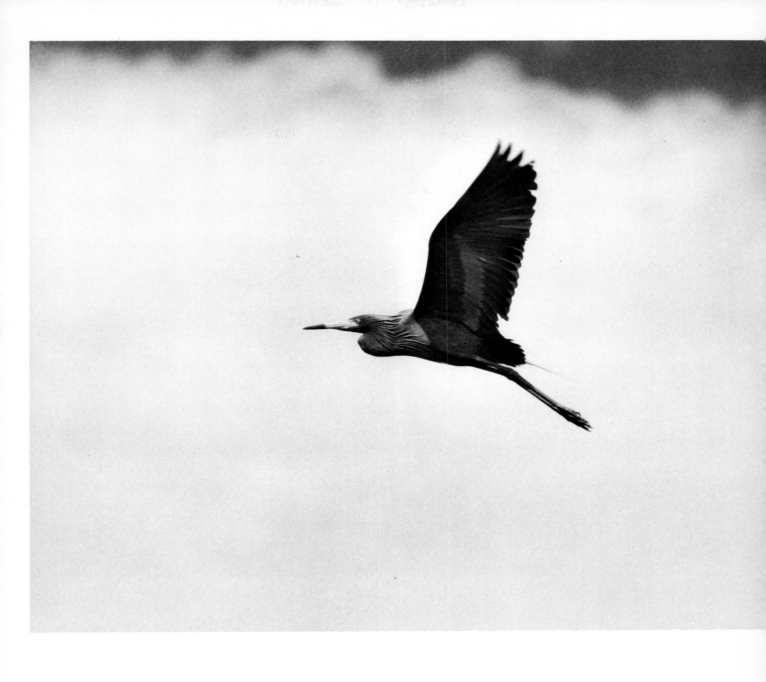

## REDDISH EGRET
*Dichromanassa rufescens*

One popular misconception encountered all over the country is the belief that any large bird with long legs is a crane. Therefore, most herons and egrets are frequently misidentified. A true crane flies with its neck fully extended. A member of the heron family, once under way, generally flies with its neck and head drawn back on its shoulders. With this in mind even a fleeting glimpse of this photograph is enough to tell one that the bird is in the heron family.

13

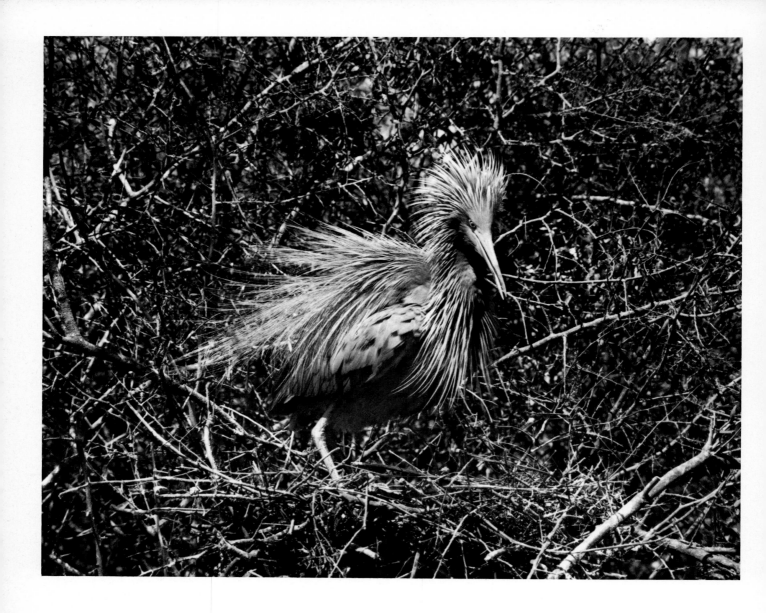

## REDDISH EGRET
### *Dichromanassa rufescens*

A favorite nesting place for reddish egrets is Green Island,
lying close to the southern end of Laguna Madre in Texas.
It is covered with extremely short, dense, thorny chaparral,
which thousands of the reddish egrets share with numerous
other nesting birds. This egret, with a two-toned bill of
rose tipped with black, is a graceful, handsome bird, but its
manner of greeting its mate is laughable. It lifts the reddish
plumes of its head and neck, swinging them forward until
they bristle like a shaggy mop. Once after a night of
terrible storms on Green Island I went out at dawn, fearful
of what devastation I might find. The colony was active
with its normal hubbub: the sturdy nests built in the almost
impenetrable tangle had given them protection from storms
that killed several people and damaged much property on
the mainland.

## GREAT EGRET
### *Casmerodius albus*

Distinguished by a yellow bill and shining black legs, this
large pure white egret is decked with long straight plumes
at breeding time. It occurs on every continent.

As this great egret approaches a perch, the complex
movement of both wing and tail feathers is evident; its
ankle joints are bent to cushion the shock of its landing.
When we compare the landing of the great egret with the
great blue heron's takeoff, it is clear that, though equal
physical effort may be involved, landing is the more in-
tricate process.

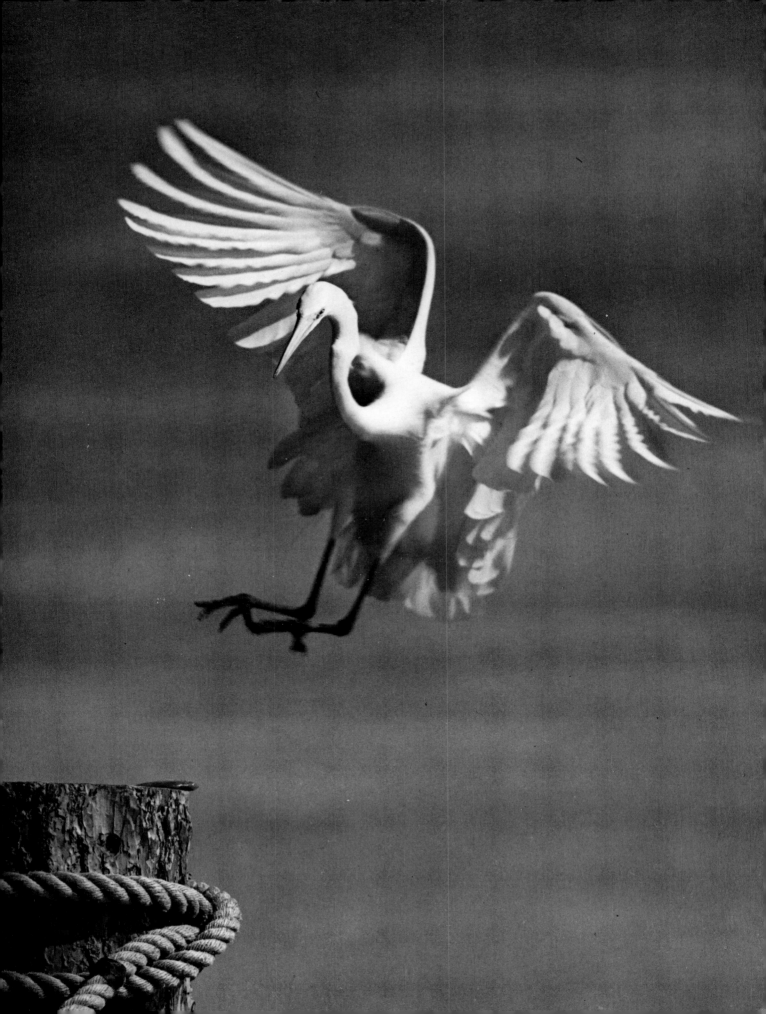

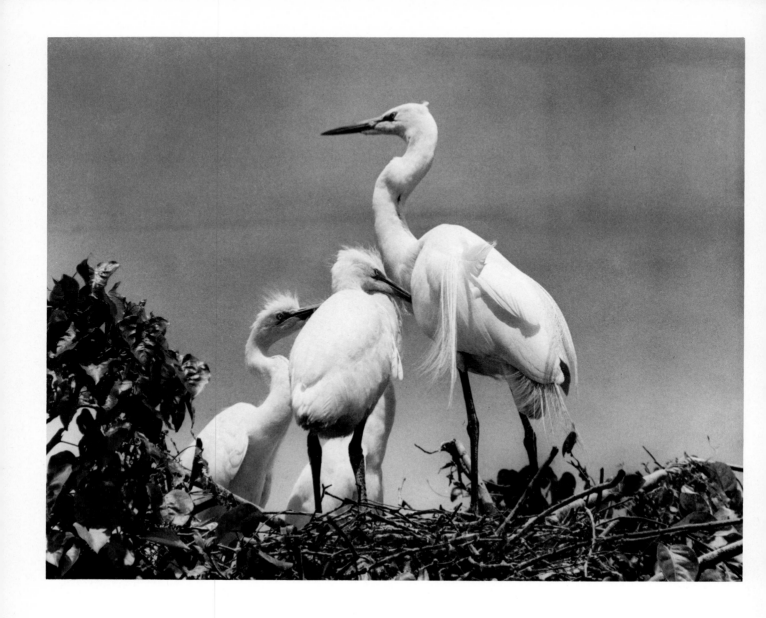

## GREAT EGRET
### *Casmerodius albus*

During the latter part of the nineteenth century and the beginning of the current one, when the millinery trade offered tempting money for aigrettes, plume hunters killed thousands upon thousands of great egrets annually. For perfect plumes the birds had to be shot during the breeding season. If there were eggs in the nest they were left to go to waste; if there were young they were left to starve to death. Entire colonies were wiped out and it looked as though the bird was on the way to extinction. American conservationists under the leadership of the National Audubon Society established sanctuaries, and public opinion brought about the enactment of laws just in time to save this egret from annihilation.

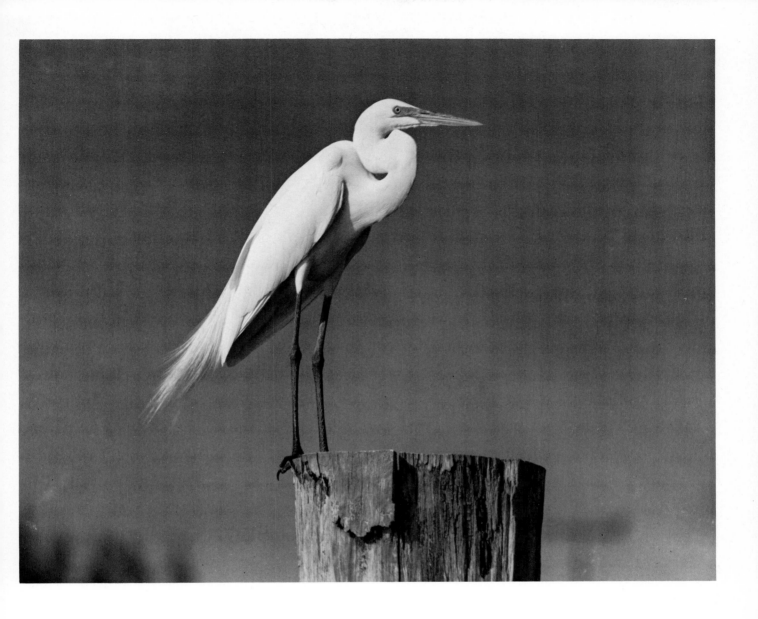

## GREAT EGRET FAMILY
*Casmerodius albus*

The keen-eyed young egrets, seeing one of their parents returning, rose with eager anticipation. As soon as the old bird landed they anxiously nibbled at its throat and bill. But when this begging brought no food, the excitement mounted, each youngster finally striving to get a firm grip on the adult's bill. Presently one of the young obtained the required hold and pulled with great vigor. This action produced the desired results, for a supply of fish slid down the bill of the parent and was instantly devoured by the ravenous young.

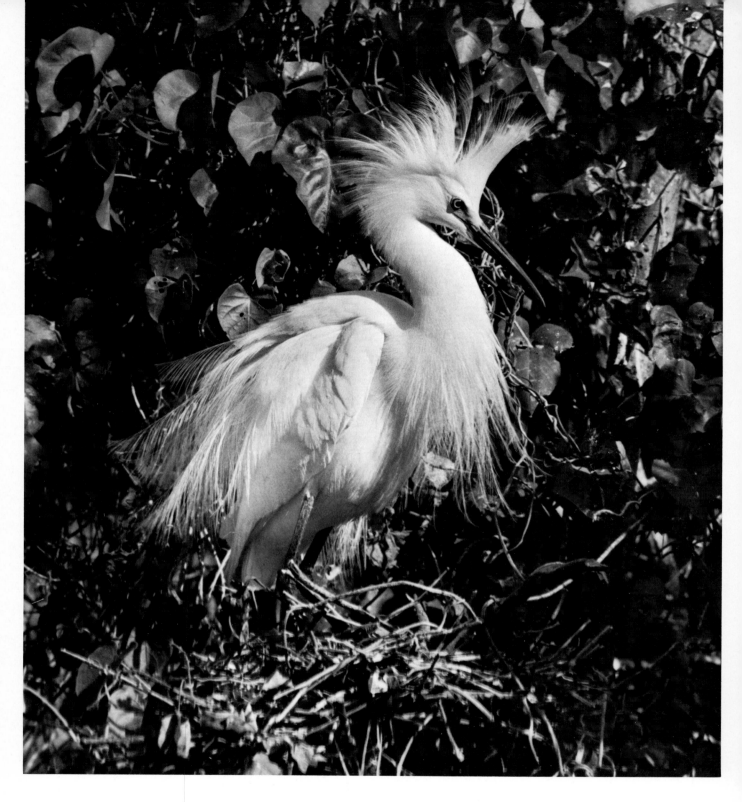

## SNOWY EGRET DISPLAY
*Egretta thula*

I crouched in my small well-camouflaged blind in the heart of the Florida Everglades, admiring this snowy egret calmly incubating its eggs. In about an hour and a half, its mate approached. The sitting bird immediately rose, erected its crest feathers, extended its breast plumes, and elevated its delicate recurved aigrettes. Presently both birds went through one of the most beautiful ceremonial dances I have ever seen. They bowed, crossed necks, rubbed bills, and continuously exchanged a series of soft cooing notes. Then the bird that had been incubating last flew off, leaving its mate to tend the eggs.

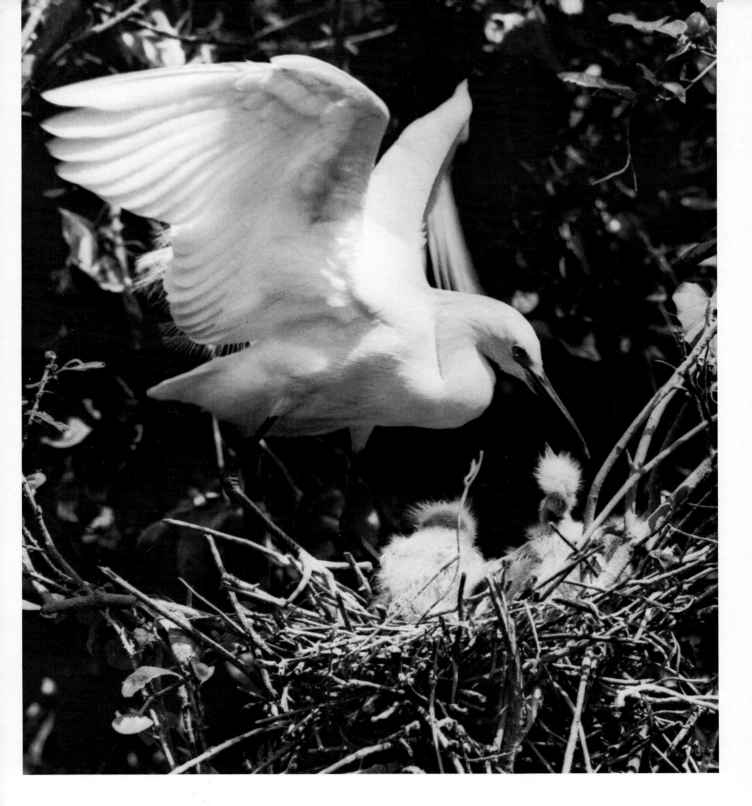

## SNOWY EGRET AT NEST
### Egretta thula

Only sane conservation laws backed by strict enforcement prevented the snowy egret from being wiped out of this country. When it was the fashion to adorn hats with aigrettes, those from the back of this species, being re-curved, were in much more demand than the long straight ones from the great egret. At one time these preferred feathers were sold at $32 an ounce—in other words, literally worth their weight in gold.

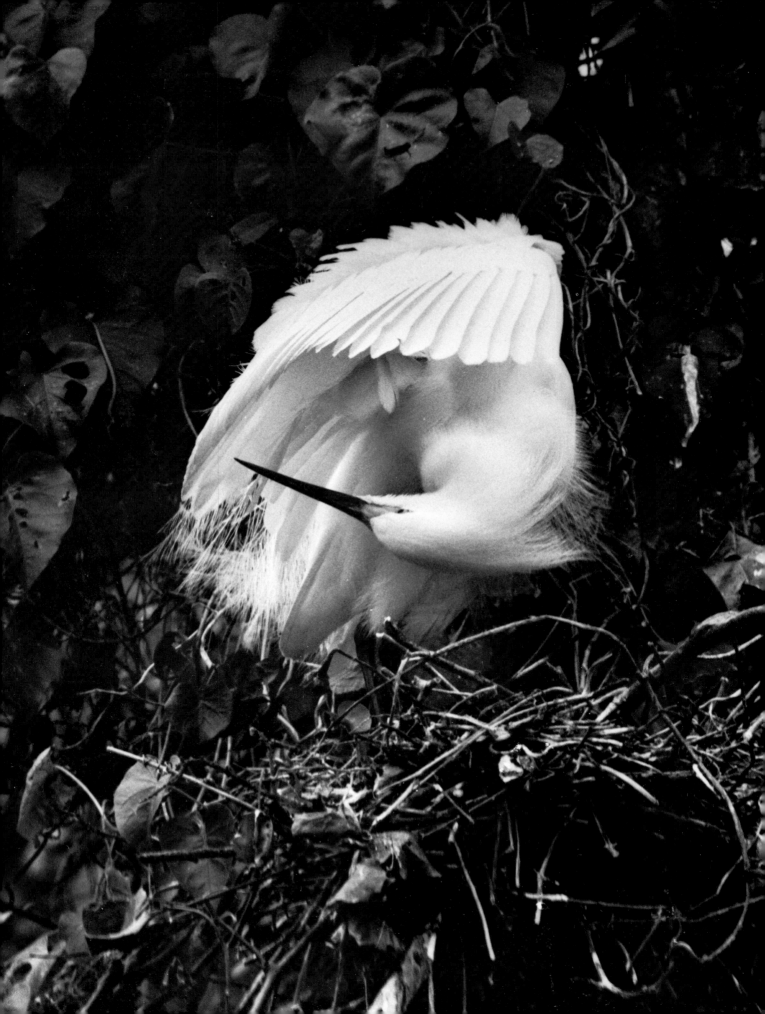

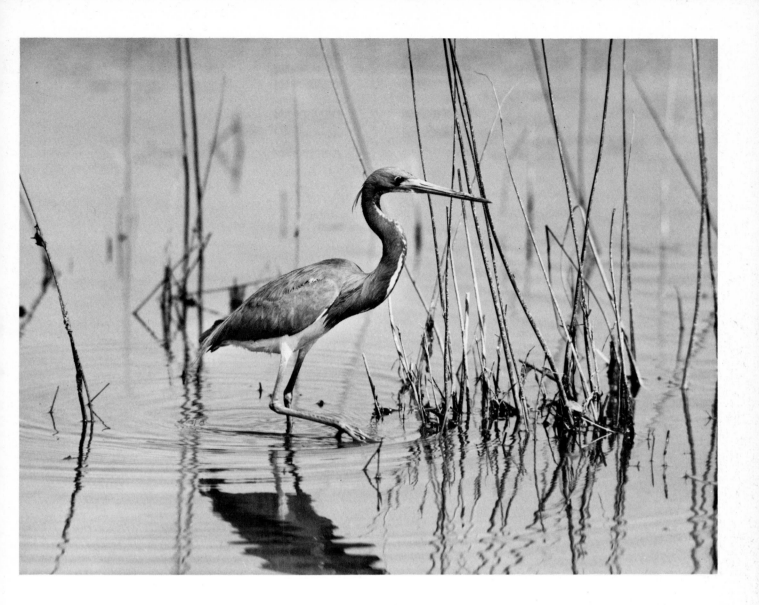

## SNOWY EGRET PREENING
### Egretta thula

After watching one of these dainty snow-white herons carefully and patiently preen its feathers, one might be tempted to conclude that the bird was well aware of its unexcelled beauty. With great concentration it goes over each major feather, nibbling, pulling, combing and oiling, until each is arranged to complete satisfaction. Certainly no well-groomed woman ever devoted more time and meticulous care to her toilette.

## LOUISIANA HERON
### Hydranassa tricolor

John James Audubon so admired this dainty heron that he called it "lady-of-the-waters." It is probably the most abundant member of its family in the marshlands of our South Atlantic and Gulf states. This photograph of the Louisiana heron wading came as a result of one of those lucky breaks that make bird photography so exciting. I was crouching in my blind trying for pictures of ducks in the great National Wildlife Refuge at Bull's Island, South Carolina, when this graceful heron glided into the cove. The bird was so intent on its search for food that it did not notice the blind. I slowly tilted the camera, focused sharply, and released the shutter. Thus I obtained an unexpected shot which vividly recalls the thrill of the moment.

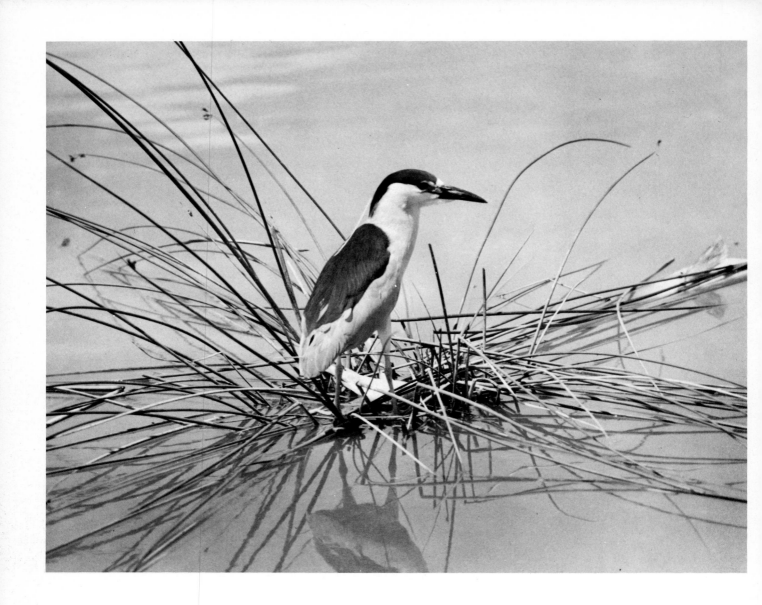

## BLACK-CROWNED NIGHT HERON
*Nycticorax nycticorax*

Black-crowned night herons occur in almost all parts of the world. As their name implies, they are active during the dark hours. They are not strictly nocturnal, frequently being active on cloudy days and during early morning and evening hours. Moreover, those along the coast, like fishermen living there, must shift their hours of work to correspond with favorable tides. An amazing superstition persisted for years that a night heron could throw out a light from its breast with which to attract and see its prey. Even today some person may insist he has observed a night heron produce this luminous glow. These stories can be attributed either to the glow of irritated plankton forms in the water or to a very fertile imagination.

## YELLOW-CROWNED NIGHT HERON
*Nyctanassa violacea*

Working with birds is often very exciting. No matter whether your interest lies in bird-watching, banding, photography, working as a field scientist or studying in a laboratory, it will surely lead to some truly memorable experiences. On Long Island near Massapequa back in 1938 I had one of those exciting moments. I had pushed my way through the tangle in a swamp when I saw two pairs of yellow-crowned night herons high in a maple repairing old nests. At that time yellow-crowned night herons were considered casual visitors from the south. Four days later, on April 18, I returned to inspect the nests. Each contained two eggs: I had found the first definite breeding record of those herons in New York State. I had the pleasure of following the activities at one of those nests until the young yellow-crowns fledged. Since birds are forever shifting ranges and even modifying ancestral habits, no matter how much is learned about them there is always something new to be discovered.

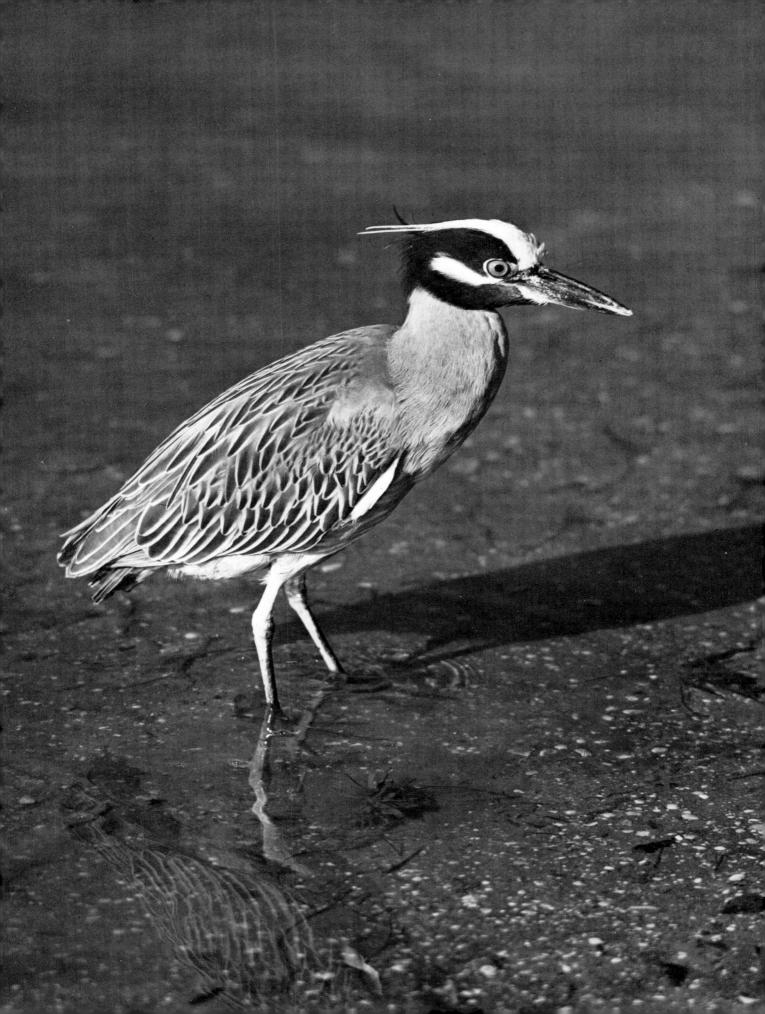

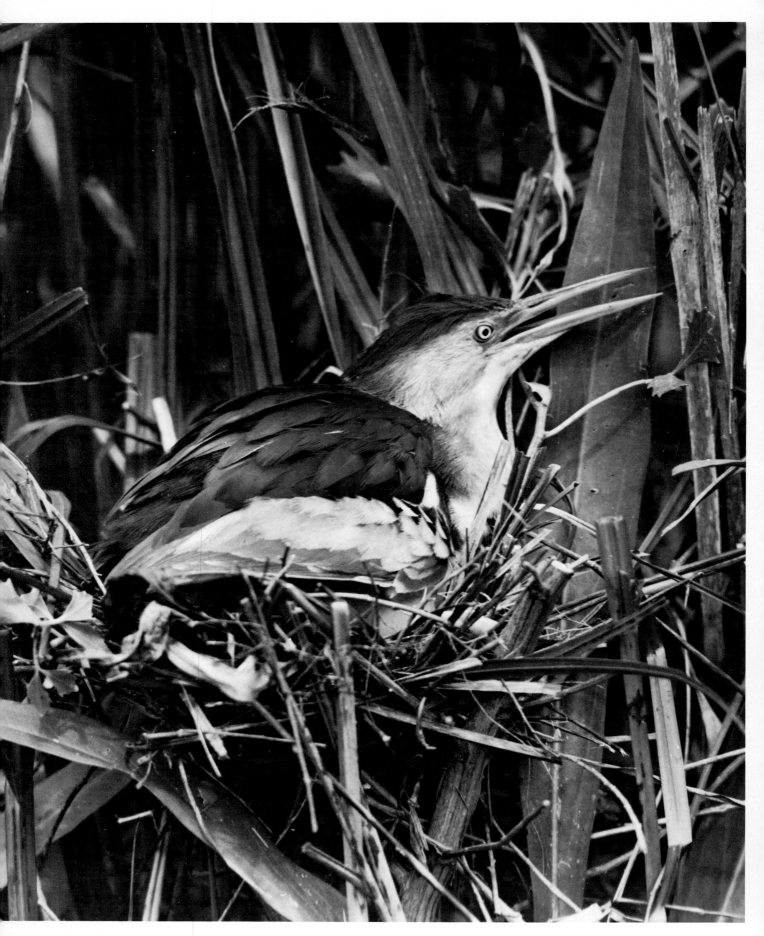

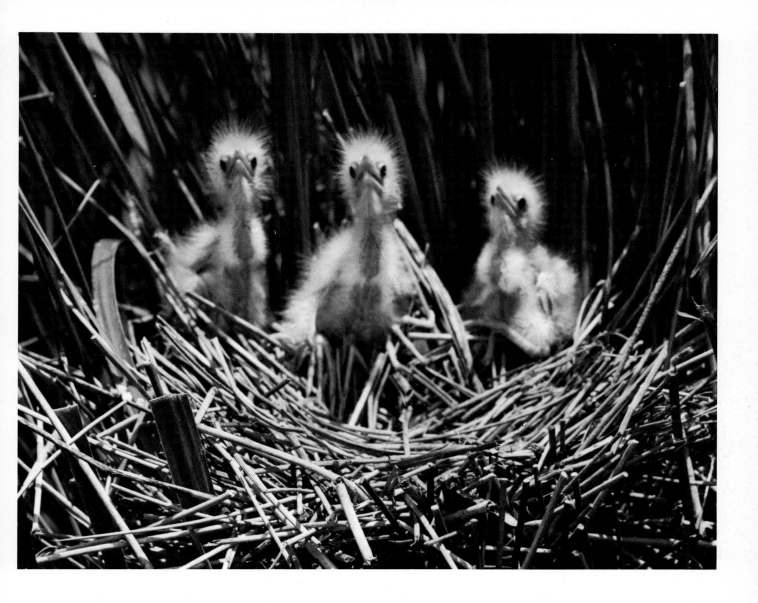

## LEAST BITTERN
*Ixobrychus exilis*

The least bittern is our smallest heron and stands scarcely a foot high. Here it incubates three greenish eggs in a nest tied to vegetation about a foot above a marsh near the St. Mark's lighthouse on Florida's Gulf coast. Unlike most of the heron family, it is reluctant to fly when alarmed. Instead it points its bill straight up and becomes as rigid as if it were frozen. Once some of us were crossing a marsh in New Jersey on a boardwalk under some high-tension wires when we heard a shout from the great ornithologist Dr. Robert Cushman Murphy. He held up a bittern by its bill! So sure was the bittern that it was invisible that it had remained perfectly still until the instant Dr. Murphy reached for it. Since three of us, all good birders, had passed within an arm's length of the bittern without seeing it, surely its method of concealment by blending into the marsh and becoming motionless is usually a safe one.

## LEAST BITTERNS
*Ixobrychus exilis*

These least bitterns are three days old. They are covered with pale yellow down and the skin surrounding their eyes is as blue as the sky. It takes about two weeks for them to begin to blend into the marsh vegetation, but already they have developed the trait of freezing with their bills pointed straight upward when alarmed. Note that both eyes are visible: they can look down without lowering their heads. This is a special characteristic of the bitterns, whose eyes are slung lower than those of any of their relatives.

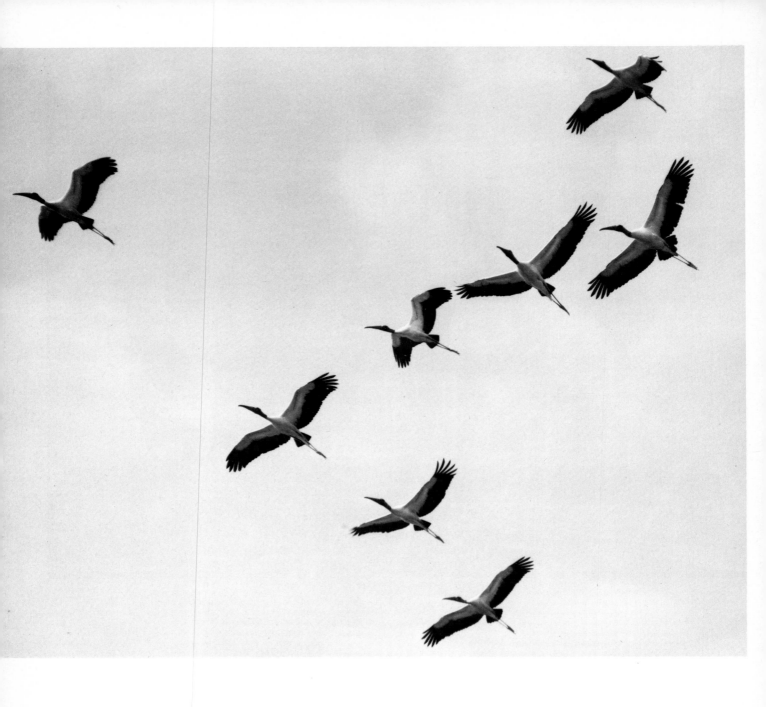

## WOOD STORKS
### *Mycteria americana*

Wood storks may look very awkward on land but once in the air they are examples of outstanding grace and beauty. To see some of these birds demonstrating their unusual ability as aerial performers is certainly to witness one of the unforgettable sights of nature. One minute they are circling upward on motionless wings, the next they are zigzagging, spinning, and occasionally volplaning in their rapid breathtaking plunges to the earth a thousand feet below. They are the only birds I have even seen perform perfect loop-the-loops.

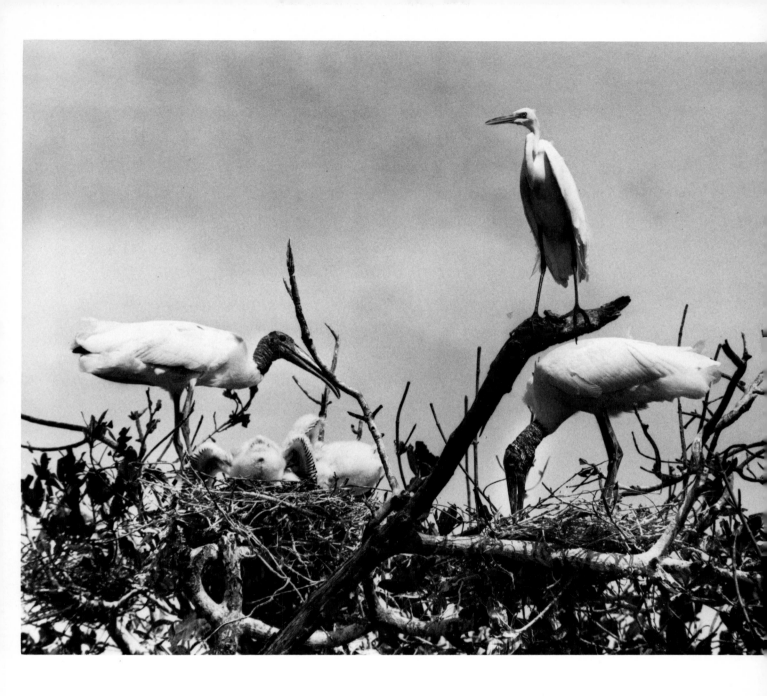

## WOOD STORKS AND GREAT EGRET
*Mycteria americana*
*Casmerodius albus*

By far the best way to gain a real understanding of the home life of any bird is to hide in a well-camouflaged blind in the vicinity of a nest and carefully observe everything that takes place. Naturally, a hideout in a colony of gregarious species, such as the wood storks and great egret shown here, offers the most opportunities. Here in a relatively short time one may observe courtship, nest building, incubation rhythm, feeding of young, ceremonial behavior of a pair, and many other bits of avian behavior which combine to give one an intimate knowledge of a species.

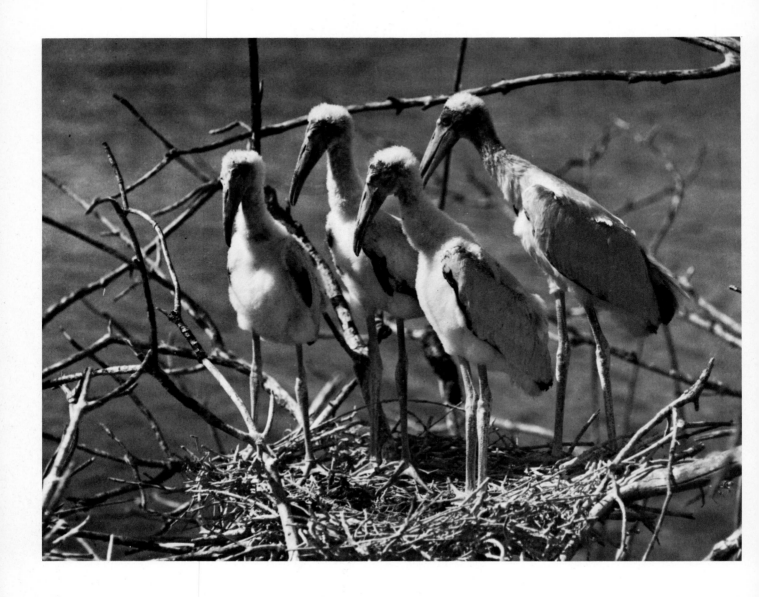

## WOOD STORKS
*Mycteria americana*

Though there are 17 species of storks in the world, we in North America have only one, which was for several centuries misnamed wood ibis. Storks have been associated with the coming of spring for countless ages, and it is possible that the tradition that newborn babies were brought by storks comes from the association of spring with the feast of the Annunciation of Christ on March 25.

These solemn young wood storks facing the world with dignity will soon be on the wing. They will fly with their necks fully extended, and as they mature their heads will become naked and wrinkled.

## GLOSSY IBIS
*Plegadis falcinellus*

In tropical and subtropical regions of Europe, Asia and Africa the glossy ibis is widely distributed. Bartram did not record the species in his 1760–1778 exploration of Florida, and Audubon wrote from St. Augustine in 1832 that the "glossy ibis is of exceedingly rare occurrence in the United States where it appears only at long and irregular intervals like a wanderer who has lost his way." Until late in the 1930s it was still regarded as a rare species, but now it nests as far north as New York and after the breeding season it is a regular visitor to southern Canada.

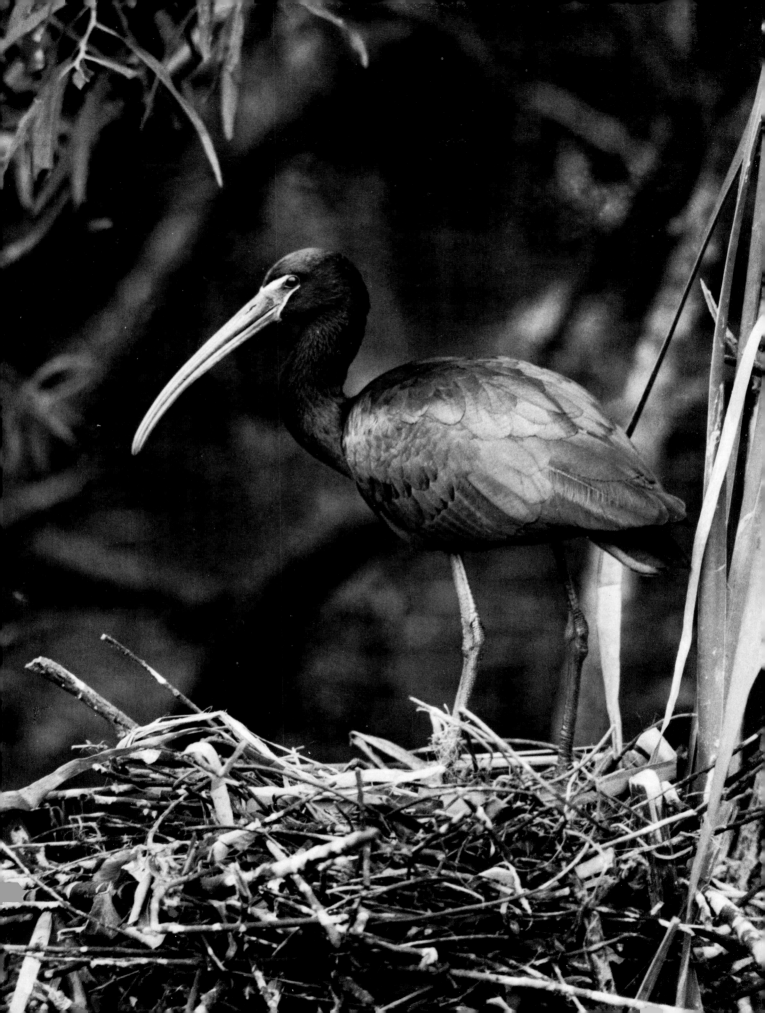

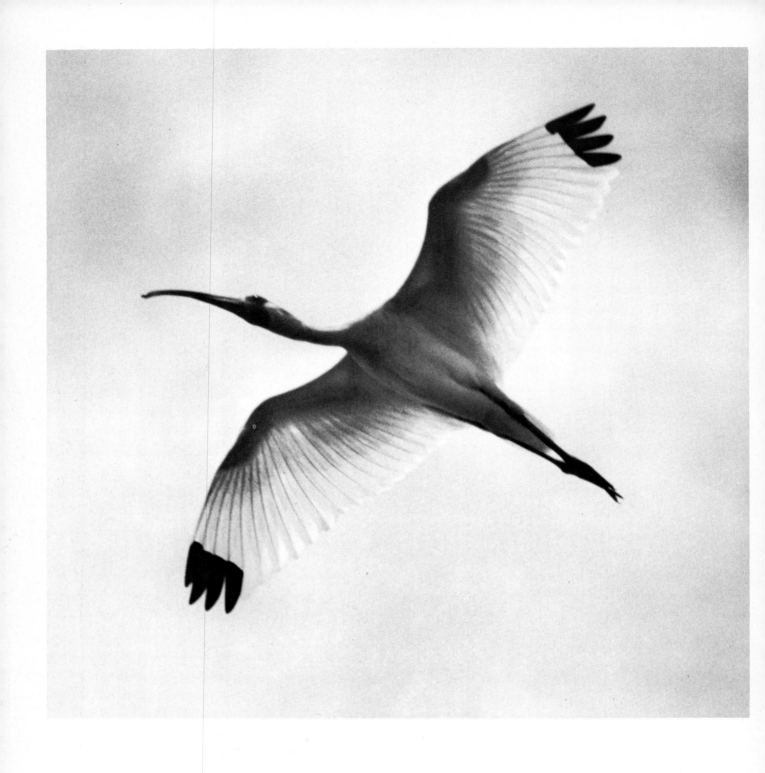

## WHITE IBIS IN FLIGHT
*Endocimus albus*

Throughout Florida this inhabitant of southern swamps is known as the white curlew. Like many members of its order, its fleshy parts assume added brilliance during the courtship season. Its bill, face, gular pouch and legs, which during most of the year are a dull flesh color, become brilliant red. This added splash of vividness on such a graceful snowy bird is enough to make it one of the gems of our avifauna.

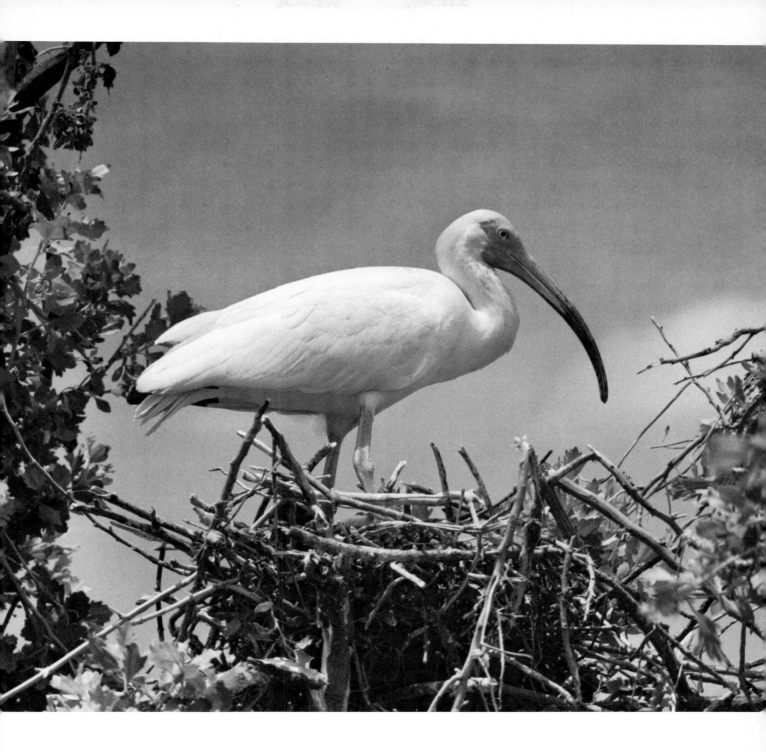

# WHITE IBIS
## *Endocimus albus*

Ibis are exquisite additions to the bird life of any region. They deserve rigid protection wherever they occur, for they are not only strikingly beautiful but decidedly beneficial. They devour large numbers of crawfish, cutworms, grasshoppers, beetles, fiddler crabs and even small, poisonous cottonmouth moccasins. One species was considered sacred by the ancient Egyptians. The sage leaders of that time gave it complete protection by honoring it with religious symbolism and declaring its flesh taboo.

31

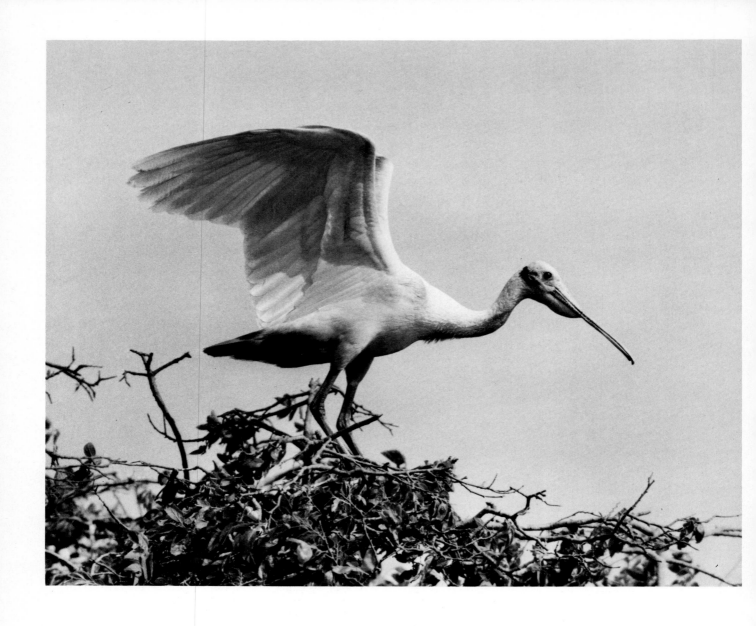

## ROSEATE SPOONBILL
*Ajaia ajaja*

This brilliantly colored wader is a rare and very local bird along the southern rim of the United States from Florida to Texas, being virtually confined to the coastal areas of the two states mentioned. Its beauty was almost responsible for its undoing, for at one time thousands were shot and their lovely pink feathers made into fans and millinery decorations for the market. Although the spoonbill is now protected by law in the United States, and has recently shown a promising increase in Texas, it still remains to be seen whether the few birds left in Florida can reestablish the species there.

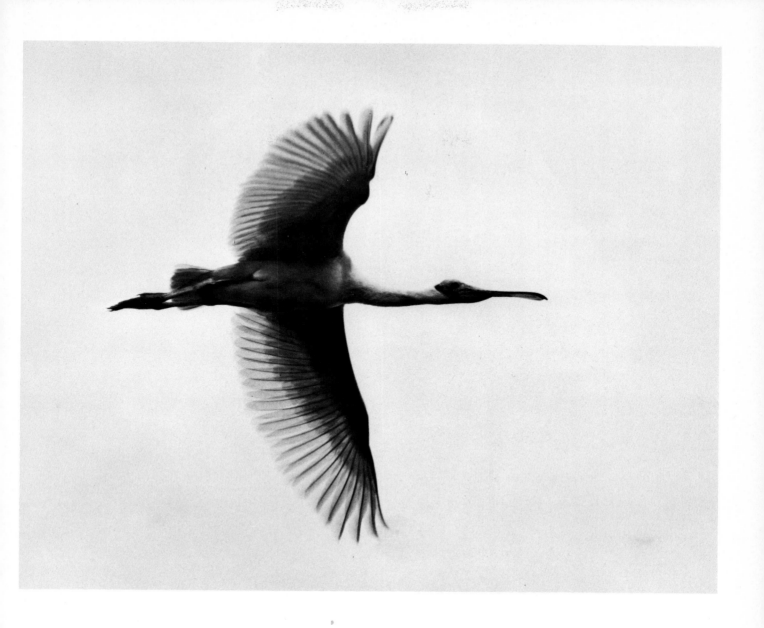

## ROSEATE SPOONBILL FLIGHT
*Ajaia ajaja*

Spoonbills, like ibis, storks and cranes, fly with their long necks fully outstretched and their legs extended behind. In the full adult breeding plumage, this American species, with its gorgeous pink coloration, carmine wing coverts, orange tail, and bloody-looking patch of stiff curly breast feathers, is one of the most spectacular birds in the world.

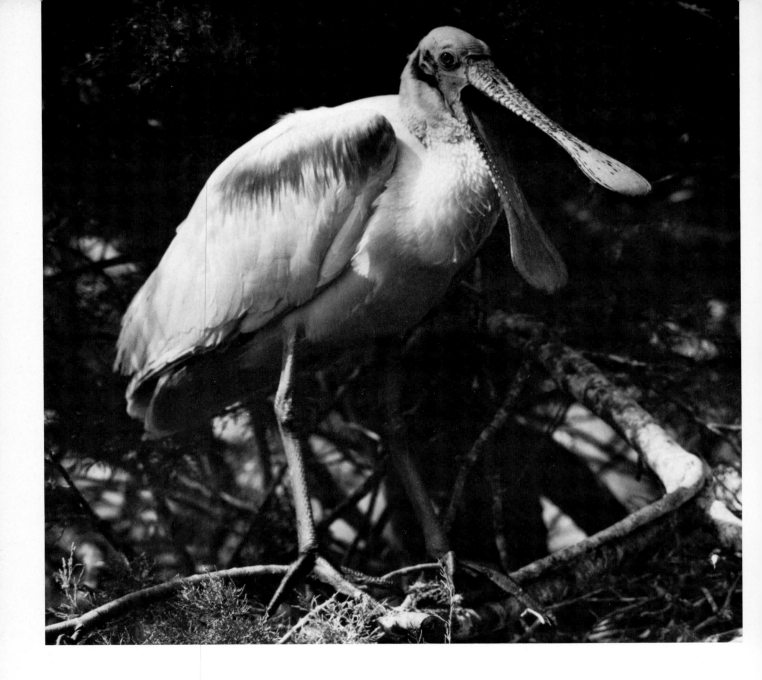

## ROSEATE SPOONBILL
*Ajaia ajaja*

Thievery is a way of life in a bustling bird colony. If a nest is left unguarded, neighbors help themselves to sticks, which are always at a premium. Sometimes I take a bundle of small sticks with me when I am photographing an island nesting colony, and by tossing these near my blind I have been able to obtain some interesting shots of characteristic behavior as nesting birds battle for the best material. Here a roseate spoonbill noisily claps its bill with a wooden sound as another spoonbill attempts to steal a stick.

## AMERICAN FLAMINGOS
*Phoenicopterus ruber*

Flamingos are fantastically exotic, and of the four living flamingo species in the world the American is the most brilliantly colored. They are skittish birds and if a plane flies over their tower-like mud nests the whole flock is likely to desert both eggs and young. American flamingos often dance on their food before swallowing it and, oddly enough, they always turn their thick, bent bill inward and hold it upside down when eating. Many birds habitually rest on one leg with the other tucked out of sight in their feathers, and the flamingo, with a body as large as a goose, somehow balances on a toothpick-like red leg. Both their necks and legs are longer in proportion to their bodies than those of any other species in the world.

34

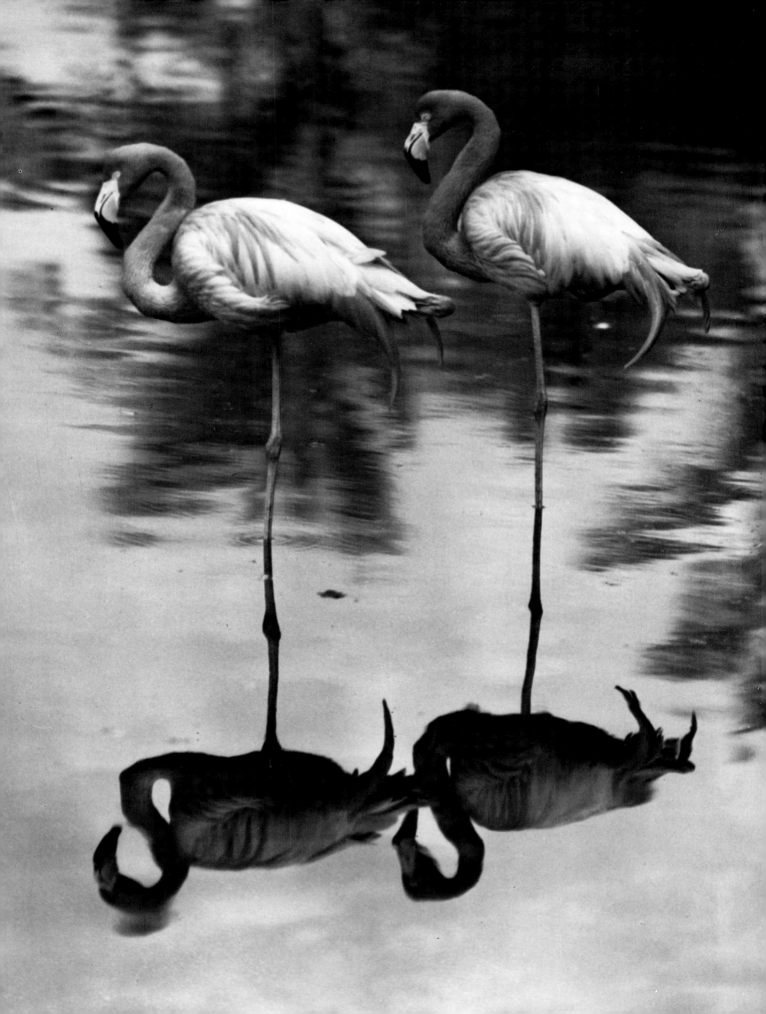

## TRUMPETER SWANS
*Olor buccinator*

The trumpeter, weighing about 30 pounds and with a wingspread of nine feet, is the largest swan in the world. Brought to the brink of extinction due to unrestricted hunting for skins, feathers and meat during the 1800s, rigid protection now seems to give the species a fair chance to survive. A blind placed close enough to study trumpeters at the nest is usually accompanied by discomfort from cold and wet, for they nest in very early spring while melting snow still swells streams and pours into lakes and marshes. But it is worthwhile to watch the congenial behavior of the large birds as they work together to build a nest on a small island, a beaver lodge, or a mud bar in a swamp. While the pen incubates her large, dull white eggs, the cob patrols the area to drive away predators. The sight of a trumpeter swan is always a delight, not only because they are so beautiful and so deserving of their reputation for grace, but because they are usually found in a situation of wild beauty—as in this photograph where a pair swims behind a lordly moose in a remote northern mountainous area.

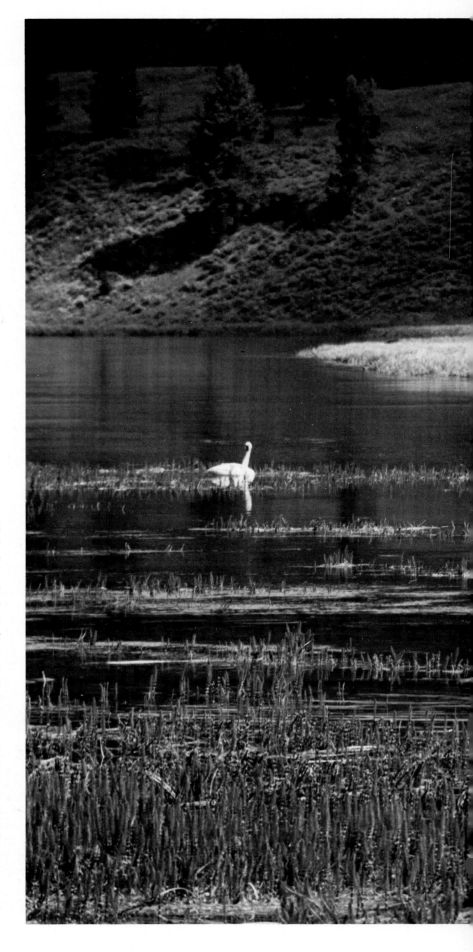

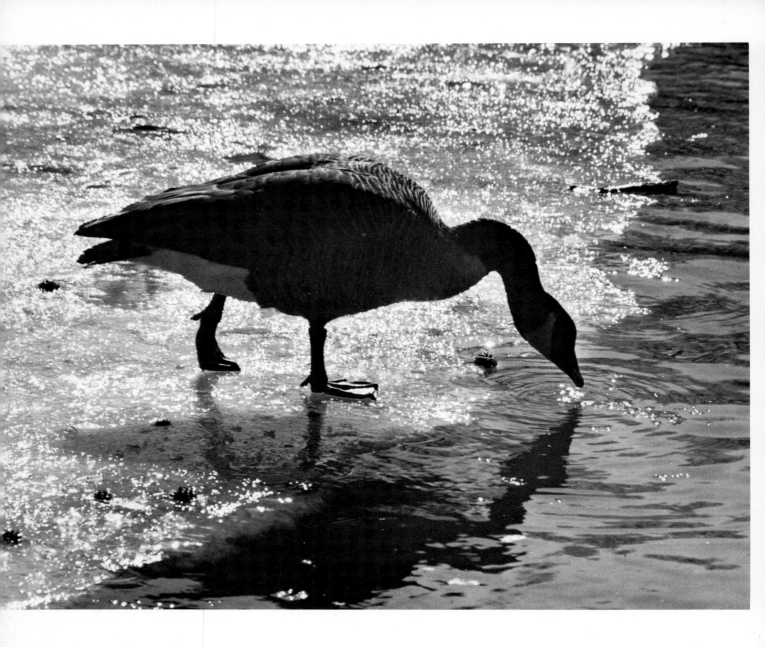

## CANADA GOOSE
### *Branta canadensis*

Every year the robin receives most of the publicity for ushering in the spring, in spite of the fact that the Canada goose more rightly deserves to be called the harbinger. As soon as the first sustained thaw takes place and the ice begins to break, Canada geese start north, their great skeins and wedge-shaped flocks decorating the late winter sky, their deep sonorous honking coming out of the depths of the dark.

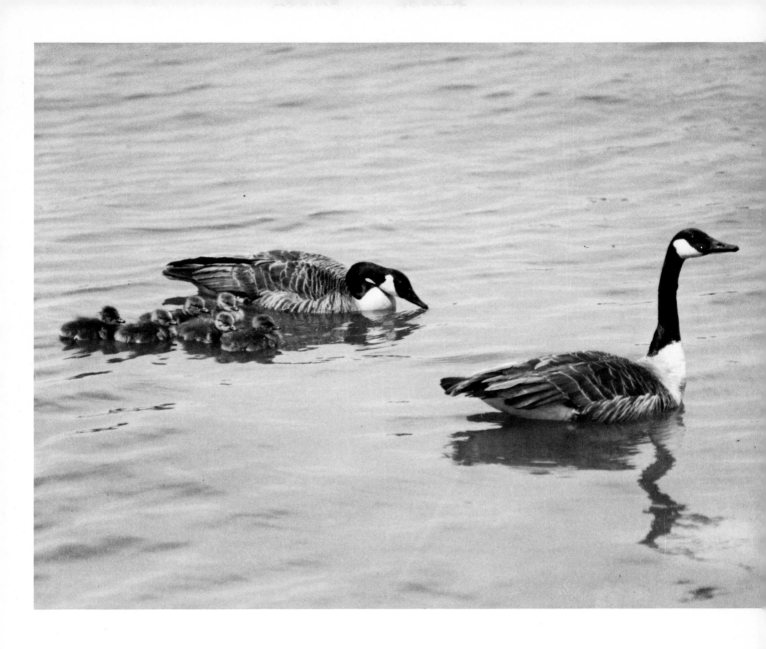

## CANADA GOOSE FAMILY
*Branta canadensis*

The common "wild goose" of most of North America is a model of fidelity. Unlike most waterfowl, which seek a new mate each year, the Canada goose mates for life. Although the gander never incubates the eggs, he remains near the nest, ever ready to protect his mate and her treasures. Both parents take care of the young. The proud, alert gander usually leads the group, the goslings follow and the goose brings up the rear. The parents are stalwart defenders and if necessary are willing to give their lives to protect the offspring.

39

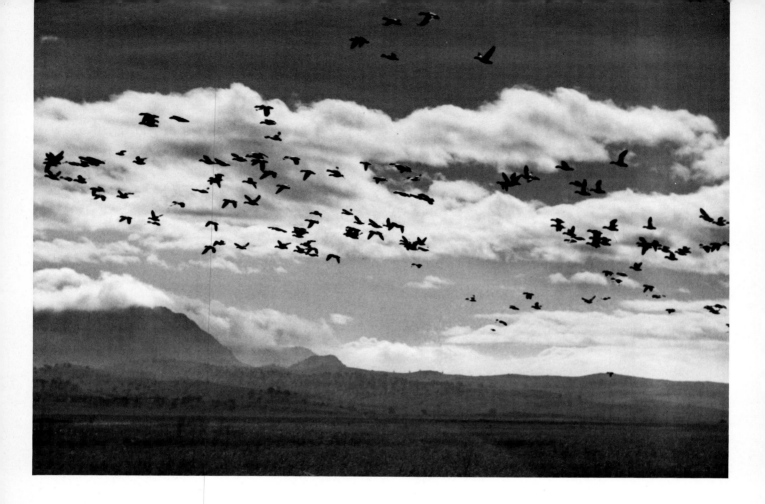

## SNOW GEESE
### *Chen hyperborea*

This photograph of snow geese was taken near the Sutter Buttes in the Sacramento Valley of California. At the time thousands of geese were scattered across the sky, some so high that they looked like mere specks. Binoculars revealed other flocks beyond my normal vision; how high they were I dare not venture to guess. Aviators have seen geese at an altitude of 9,000 feet, and one scientist while photographing the sun obtained a picture of geese at an estimated height of 29,000 feet. If his calculations were accurate these geese were traveling 5½ miles above sea level.

## THE SOUND OF MANY WINGS

Three hundred years ago this continent was truly a paradise for waterfowl; some people have estimated that five hundred million of them once occupied suitable American habitats. Then the white man came. Bays once crowded by waterfowl were taken over by shipping. Clear waters became dangerous as sewage, oil and dangerous chemicals poured into them. Marshes, essential habitats for waterfowl, were drained. In the final quarter of the nineteenth century incredible numbers of waterfowl were killed by market gunners and sold in cities. In 1887 one gunner alone killed 1,880 ducks in a single day. Shooting went on throughout the year, and few ducks hatched to replace those that were killed. Just in time, conscientious hunters and conservationists managed to have sane hunting laws passed, and legal bag limits are now adjusted annually according to nesting success or failure. International migratory bird treaties were ratified. Refuges and sanctuaries were established for waterfowl and these benefitted both game and non-game species. Though great flocks of waterfowl like this one, photographed at Sutter National Wildlife Sanctuary in California, are confined to limited areas today, similar sights may be enjoyed all across the land where refuges offer controlled hunting for sportsmen and year-round pleasure for bird-watchers.

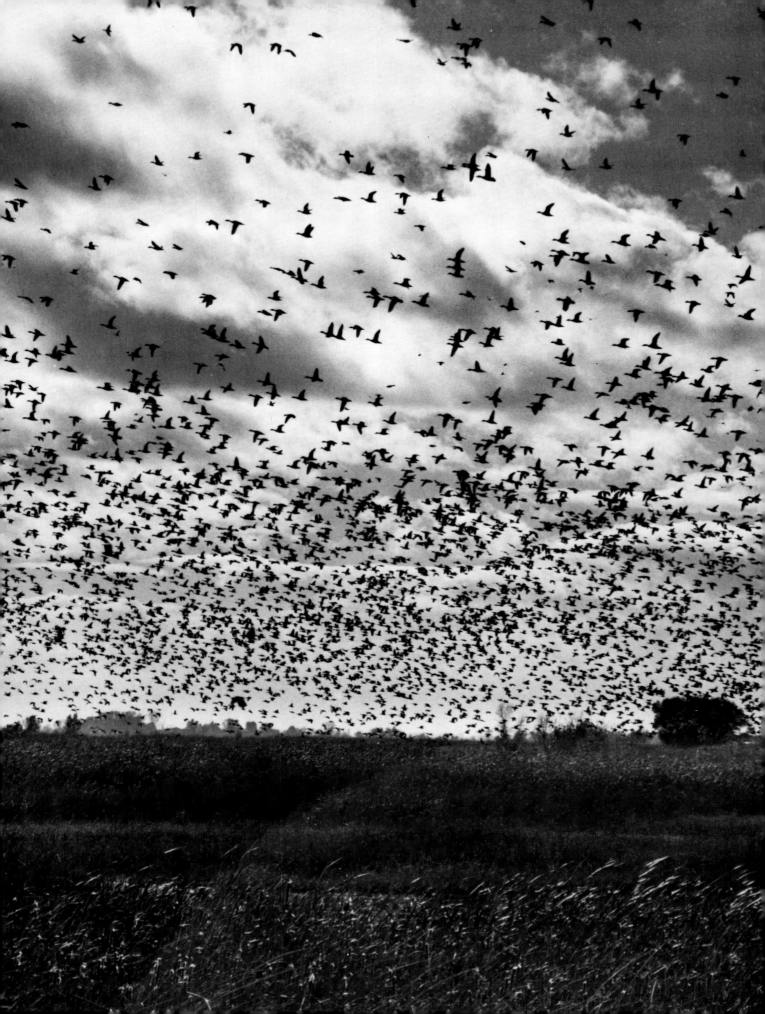

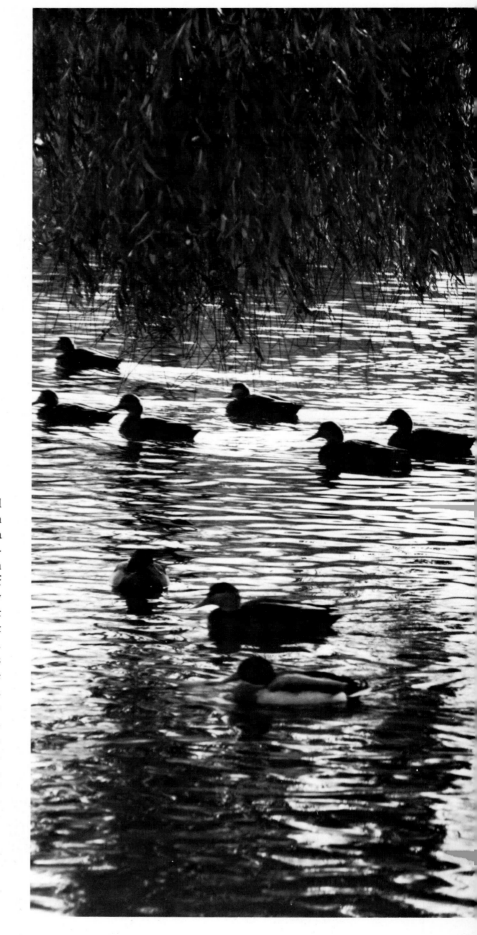

## WATERFOWL REFUGE

This continent was once so rich in natural resources that our forefathers thought them inexhaustible. But by 1900 herds of bison once numbering in the millions had dwindled to less than 300 wild individuals. In 1808 Alexander Wilson watched a flock of passenger pigeons near Frankfort, Kentucky which he estimated at two billion—but that race became extinct in 1914 when the last one died in a cage in Cincinnati, Ohio. Other species of both birds and mammals were declining sharply. But in 1902 the National Audubon Society began warden protection for birds and at present has extended such protection over more than a million strategically placed acres. In 1903, President Theodore Roosevelt established the first federal refuge on Pelican Island, Florida. This became the forerunner of the present great chain of National Wildlife Refuges stretching from the Atlantic to the Pacific. In addition, most states, many national and local organizations, and individuals maintain refuges and sanctuaries. Without these, it is doubtful that such pleasant and peaceful scenes as in this photograph could exist today.

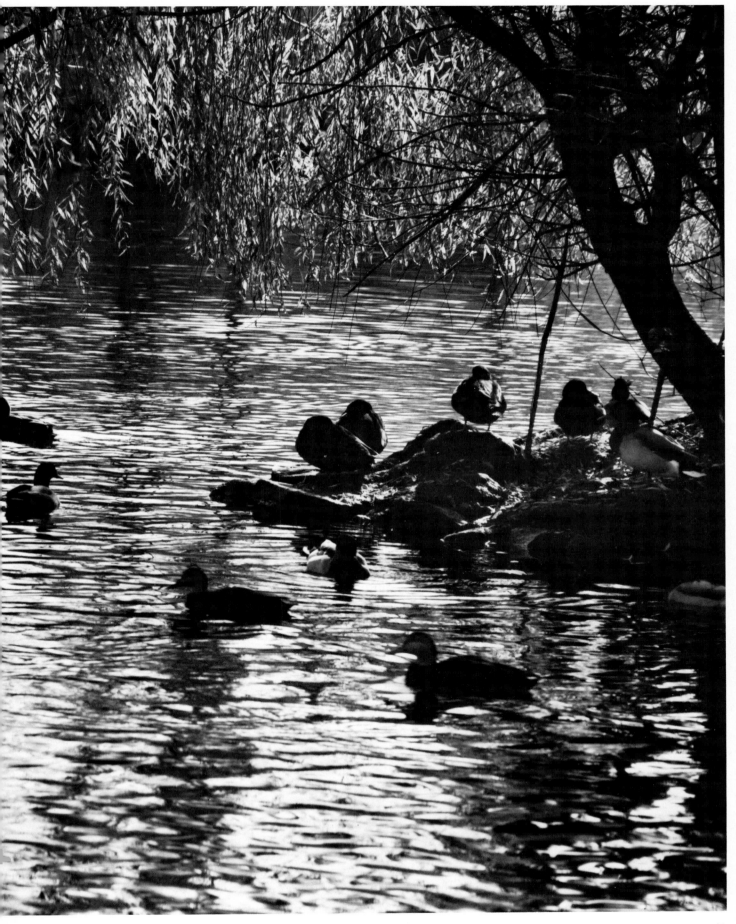

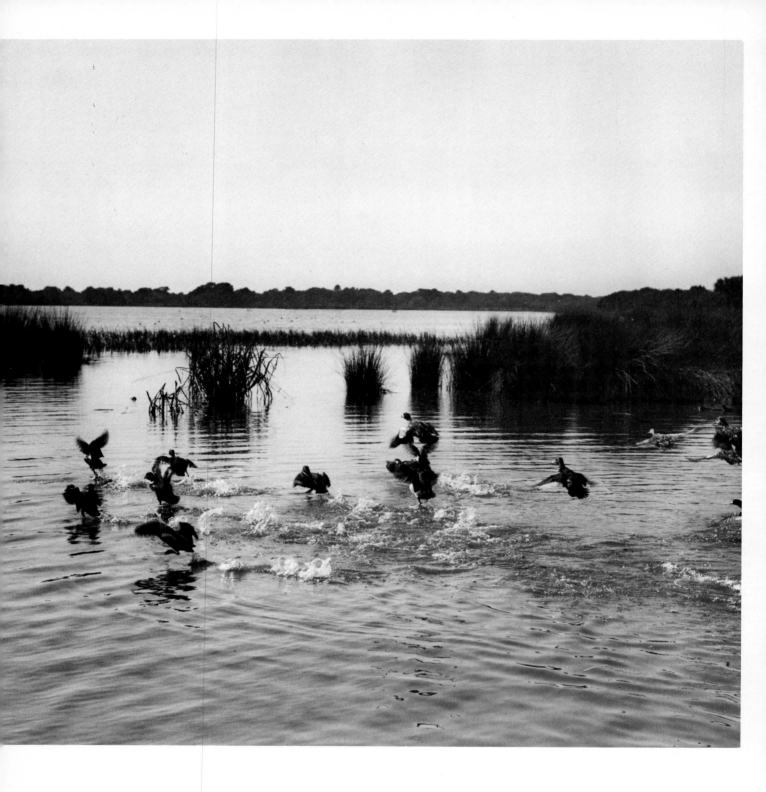

## DUCK ALARM

Ducks, geese and swans belong to the same family, a family that has approximately 200 species distributed throughout the world, one fourth of them indigenous to North America. Each year, usually soon after the breeding season, members of this family lose most of their flight feathers all at once and consequently are unable to fly for some time. During this period they must seek protection either by skulking in the concealing depths of the marsh or, in the case of deep-water ducks, by being unusually alert and diving beneath the surface to avoid attacks.

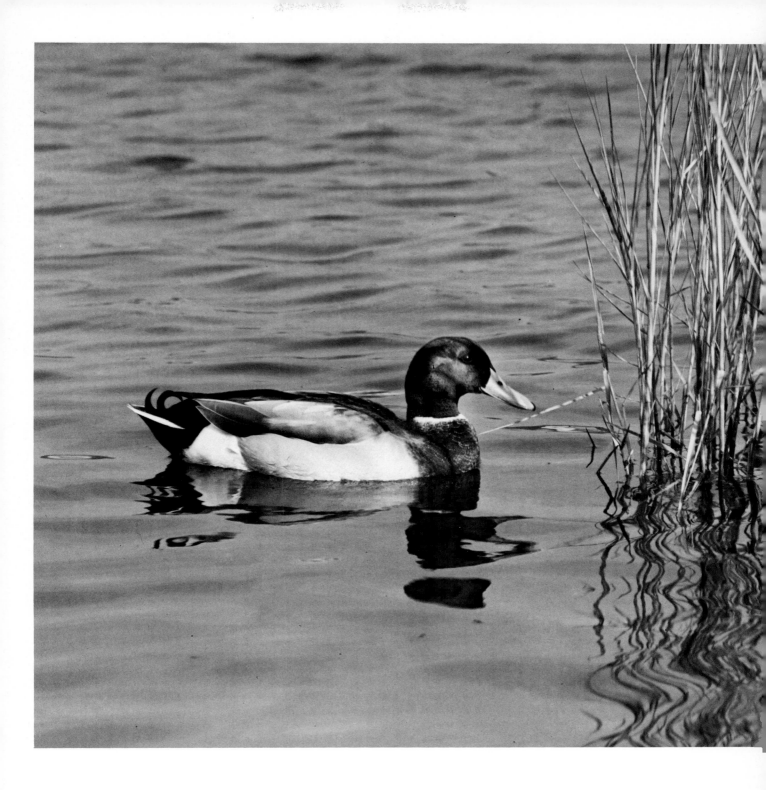

## MALLARD
### *Anas platyrhynchos*

The mallard occurs over most of the North Temperate Zone and, since it is a common bird in many sections of its wide range, it is probably the most abundant duck in the world. It certainly is the most widely known species in the United States. Its success in this highly competitive world can be attributed to its adaptability. I have found mallards nesting in the heart of a flooded wilderness, near a tiny waterhole in an otherwise dry sageland, on a sandy brush-covered hill, and even in a crowded city park.

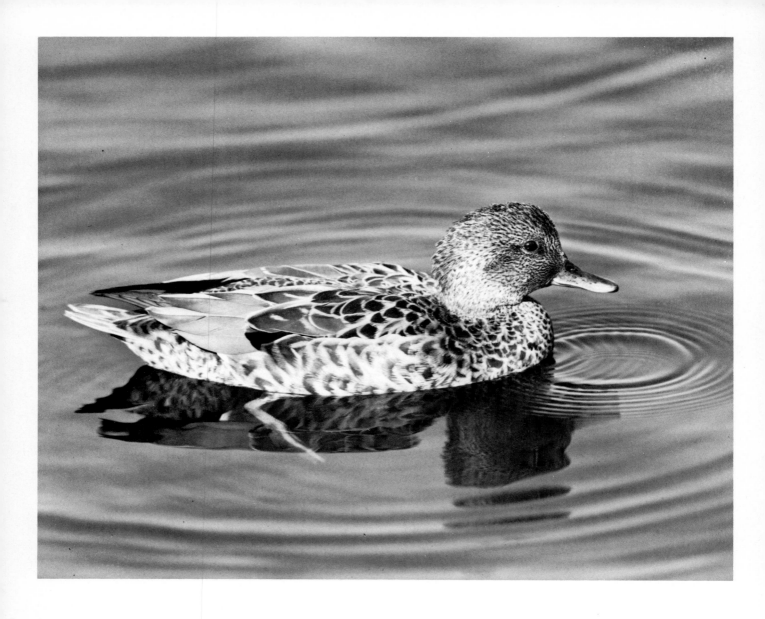

## GADWALL
### Anas strepera

Because male ducks are so handsome, photographers tend to concentrate on them. But they are far more difficult subjects than females, which are near nests in which the male has no interest. But this female gadwall, floating lightly within concentric circles with added circles where she has dipped her bill, makes a truly beautiful subject. My experience suggests that the gadwall is the champion egg layer: I found 26 eggs in one gadwall nest at the huge Bear River Migratory Bird Refuge in Utah.

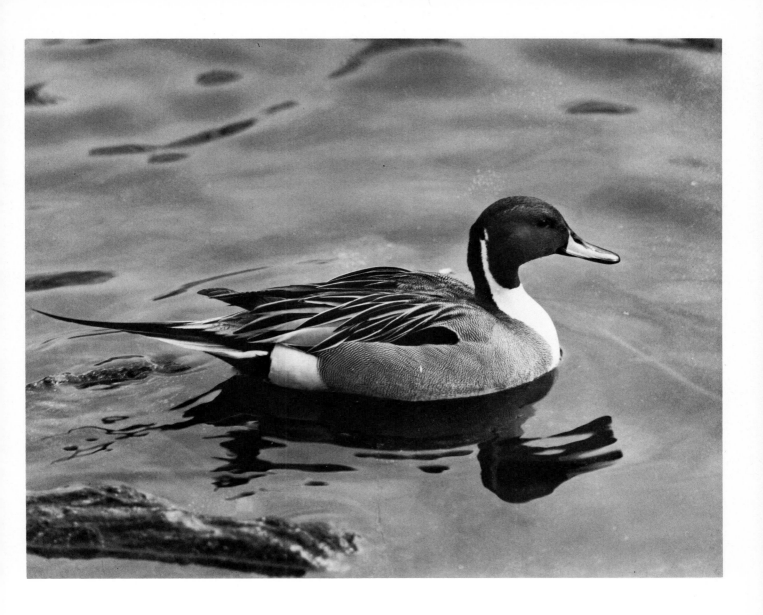

## PINTAIL
*Anas acuta*

The pintail or sprig is one of the most abundant, most widely distributed and best-known ducks in North America. It is one of the first freshwater ducks to appear in the north each spring. Many flocks, like those of Canada geese, follow closely on the heels of the retreating ice. The drake, with its well-proportioned body, its long streaming tail, its slender curving neck and its delicate vermicular plumage, is one of the most elegant ducks in the world.

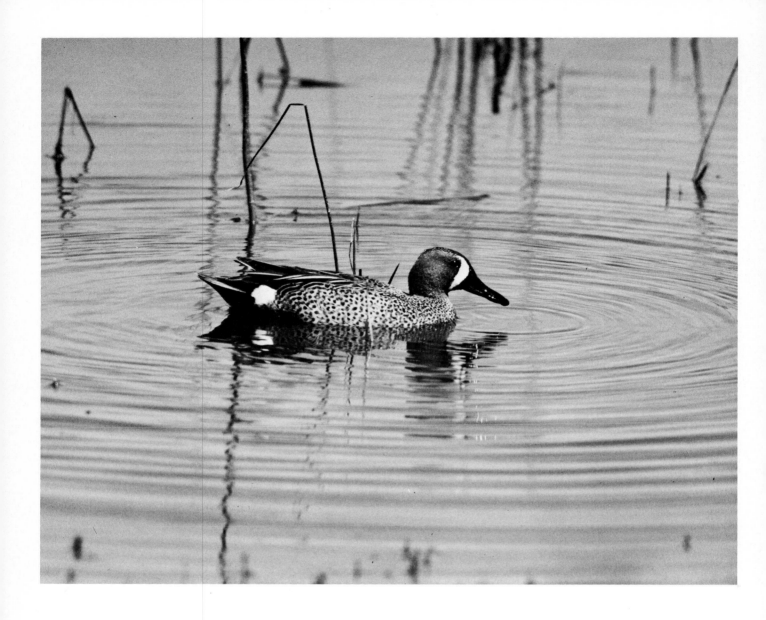

## BLUE-WINGED TEAL
### Anas discors

One summer at the Lake Bowdoin National Wildlife Refuge in Montana, multitudes of ducks were nesting on the short grass prairie. Little blue-winged teal incubated their eggs in grassy, down-cushioned nests while their mates whiled away the days. It happened that I placed my blind close to the edge of the lake when millions of damsel flies began to crawl from the water. They clung to grasses, to rocks and to my blind while they pulled themselves out of their nymph skins and began to stretch their newly developed wings. In no time knowledge of this abundant food spread among the birds. Gulls, shorebirds, magpies and blackbirds all gathered to feast. Among them was this handsome male blue-winged teal, normally a shy duck, but so eager to eat damsel flies that it disregarded the blind and camera.

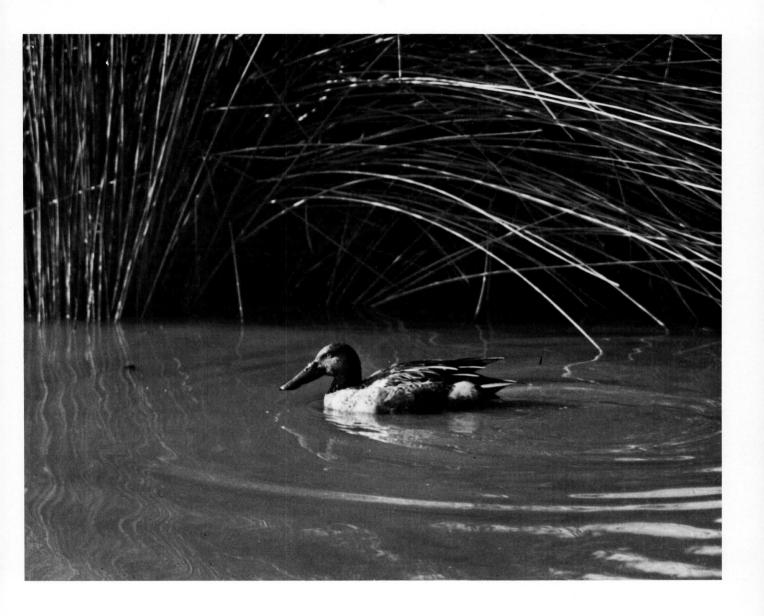

## NORTHERN SHOVELER
*Anas clypeata*

Occurring on every continent, the shoveler or spoonbill is one of the most widely distributed ducks in the world. The drake, with its bold pattern of colors and its huge spatulate bill, can be confused with no other species. The oversized bill may look awkward, but it is a highly specialized in-strument possessing interlocking comblike "teeth," which make it wonderfully adapted for straining out snails, insects, crustaceans, fish and vegetable food from the muddy shallows of ponds and marshes.

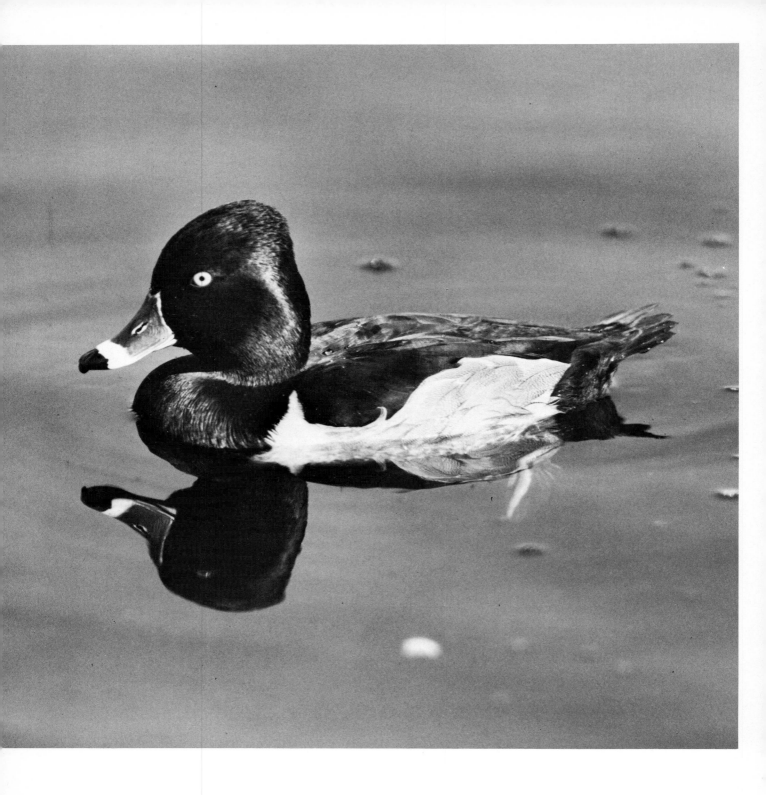

## RING-NECKED DUCK
### *Aythya collaris*

This essentially freshwater species is closely related to the tufted duck of Europe. In spite of the fact that it lacks the definite head tufts of the latter, Alexander Wilson, one of our earliest and most famous ornithologists, let it pass as the same. The name ring-billed duck would be much more appropriate, for whereas the ring on the bill is quite evident, only under the most fortunate conditions can a field student see the narrow chestnut collar on the neck.

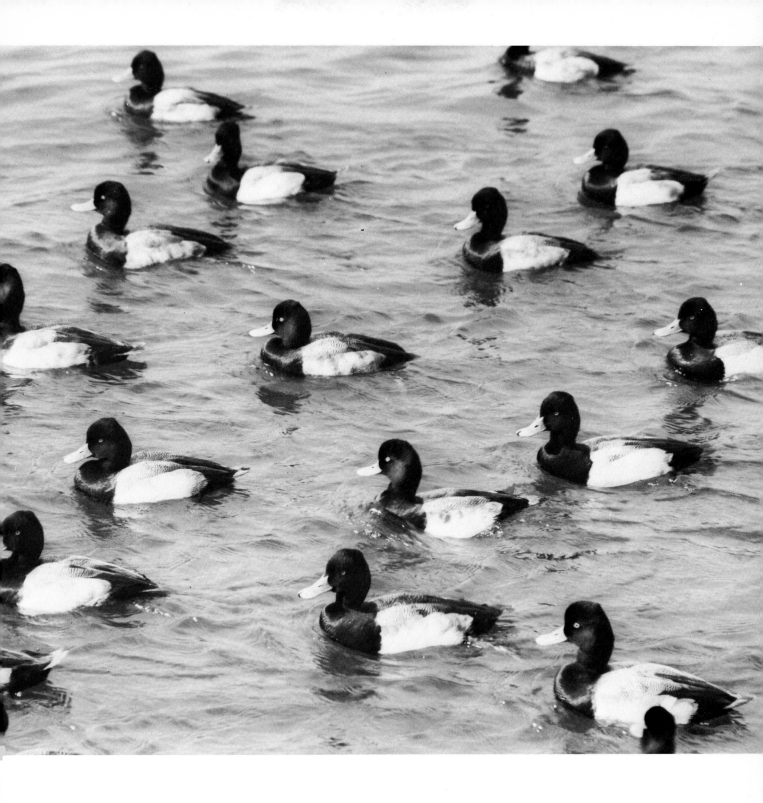

## LESSER SCAUP
*Aythya affinis*

Because lesser scaup habitually gather on the water in extensive, closely bunched flocks, they are one of the species most often referred to as raft ducks. Like all diving ducks they are unable to spring directly into the air but must first run along the surface of the water to pick up sufficient speed.

The peculiar name "scaup" comes from its European relative. That relative, in turn, undoubtedly derived the name from its habit of frequently feeding on mollusc concentrations commonly known in the Old World as scaup beds.

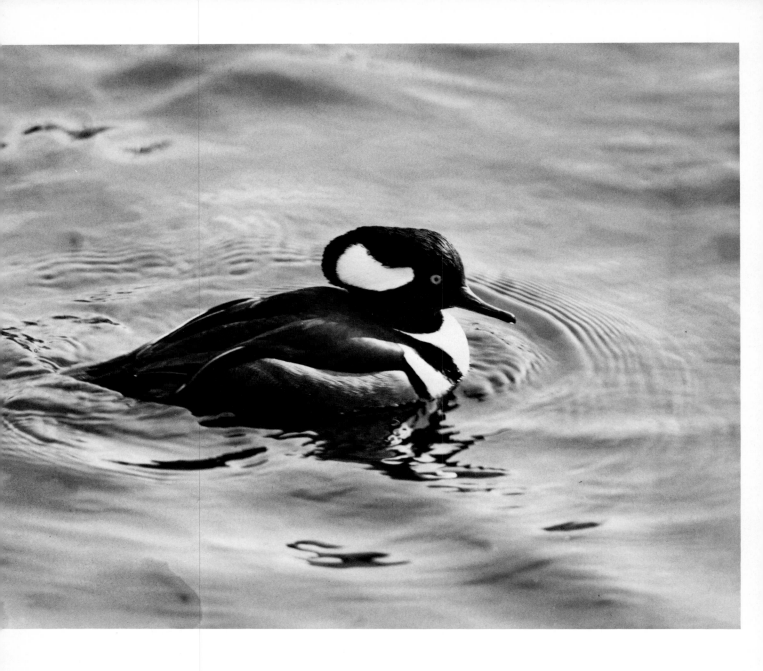

## HOODED MERGANSER
*Lophodytes cucullatus*

Mergansers, or shelldrakes, are such powerful swimmers that they are able to pursue and catch fish beneath the surface. Their rounded saw-toothed bills are especially adapted for grasping slippery prey. The hooded merganser is exclusively a North American duck. It is partial to secluded woodland lakes and usually nests in the cavity of a tree, often 40 to 60 feet above the ground. I have frequently watched entranced while an ardent courting drake elevated and depressed his spectacular crest before a coy female.

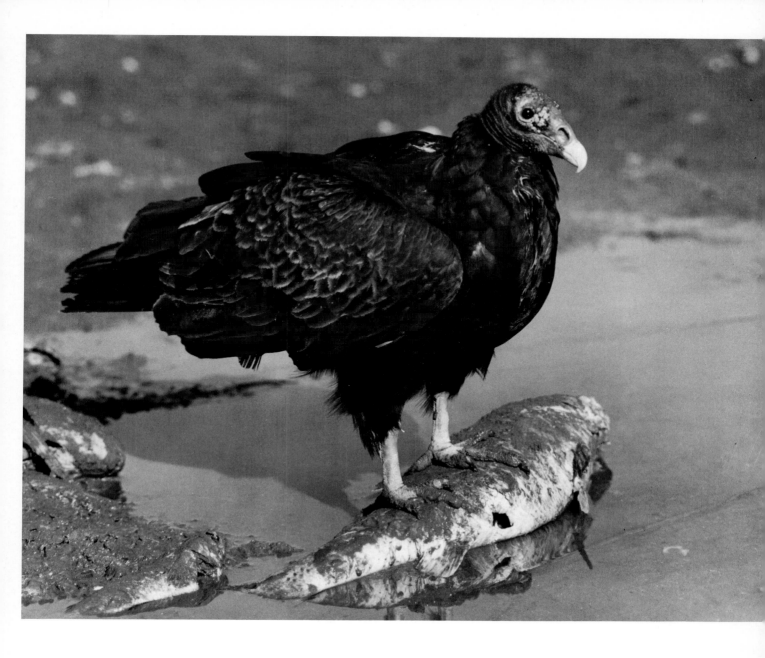

## TURKEY VULTURE
### Cathartes aura

Over a large part of the United States, especially in the South, turkey vultures are among the most conspicuous of nature's master gliders. They are very large birds with an impressive wingspread of approximately six feet. Once on the wing they are creatures of admirable beauty, soaring and gliding as gracefully as any gull. With amazing skill they utilize the air currents to float hour after hour on what often appear to be motionless wings. Ordinarily they move rather leisurely. But during a strong wind at Daytona Beach I kept directly under a fast gliding bird for more than two miles by driving my car at a steady 44 miles an hour.

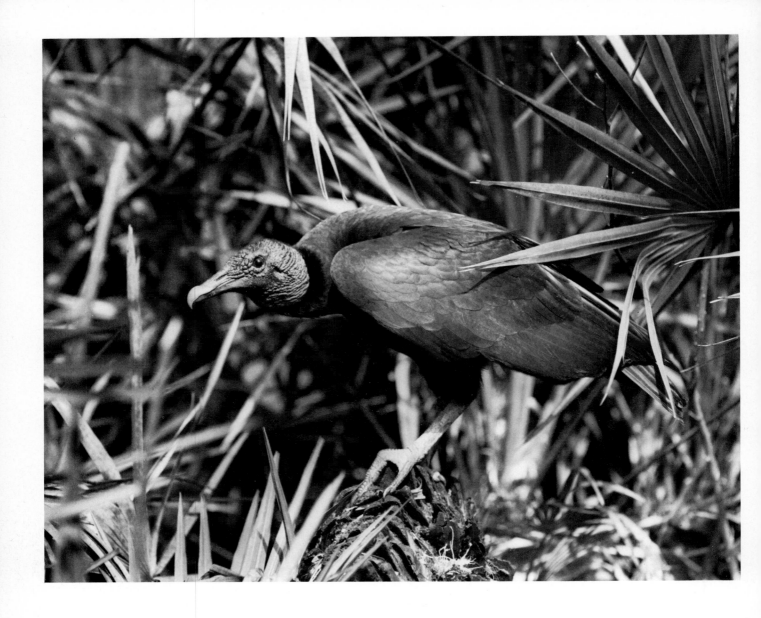

## BLACK VULTURE
*Coragyps atratus*

This well-known carrion eater is heavier and more power-ful than the turkey vulture. Having shorter wings and tail than its relative, it is much less graceful; its flight is more labored and it has to flap much more often. An experienced observer can easily differentiate between the two species in the air at a distance of more than half a mile. Both of these large birds are called buzzards throughout the South even though, being vultures, they belong to an entirely different family from the true buzzards.

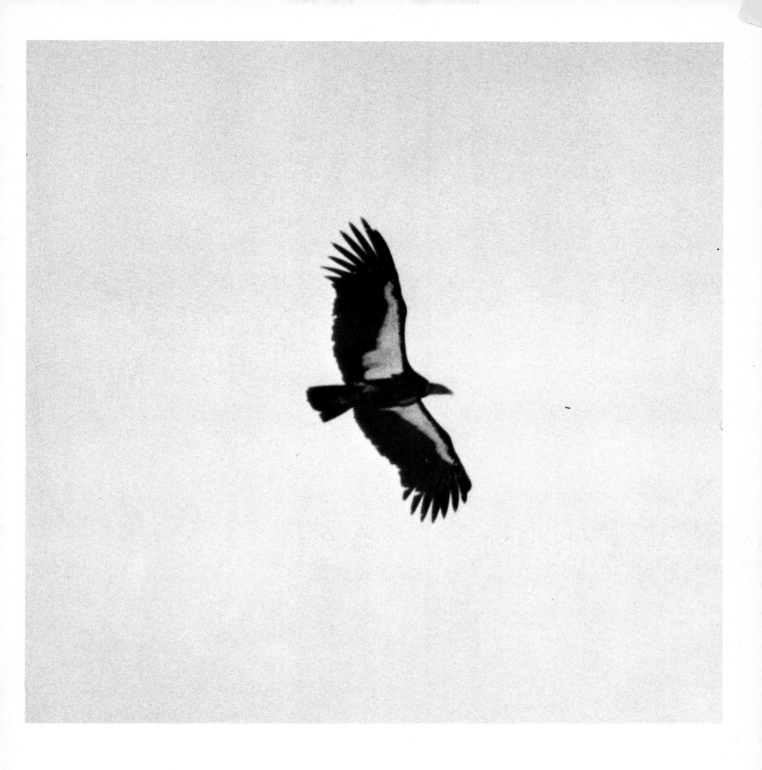

## CALIFORNIA CONDOR
### *Gymnogyps californianus*

It is a breathtaking moment when one of these largest of North American soaring birds sweeps overhead. Its bare head is bright yellow, and as it soars on its ten-foot wings it reveals a striking underwing pattern. But the condor is close to extinction; probably less than 60 survive today. California condors do not begin breeding until they are six years old and then lay but one egg every other year. Their great size makes flight seem slow but a distant black speck rapidly grows as it speeds closer. Fossils reveal its presence long ago in Florida, but after the Ice Age it apparently retreated westward. It remained a common bird in the wild mountains of southern California until Gold Rush days. Man has always been the chief enemy of this harmless and magnificent bird, for little else can prey on so large and swift a species.

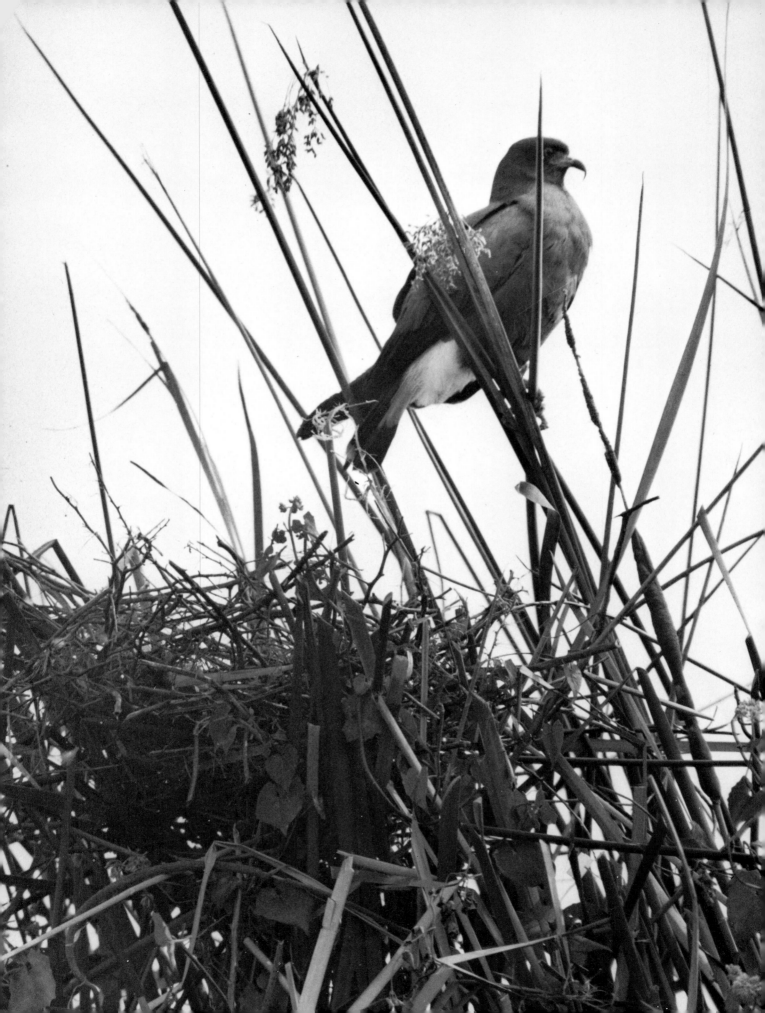

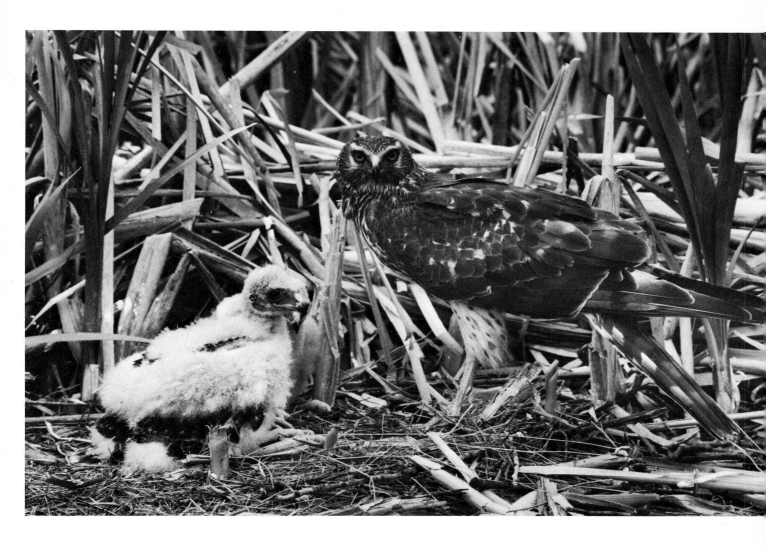

## EVERGLADE KITE
### Rostrhamus sociabilis

The Everglade kite is one of the rarest birds in the United States. In this country it is confined exclusively to peninsular Florida. Snail hawk is a most appropriate nickname, since the bird lives almost exclusively on large freshwater snails, and because of its specialized food requirements it is restricted to freshwater marshes. Unfortunately, a major factor in the depletion of this unwary species is the senseless shooting of it by those thoughtless individuals who use any large bird as a target.

## MARSH HAWKS
### Circus cyaneus

People often generalize excessively in descriptions of bird behavior. Books tell us that marsh hawks, harriers with long narrow wings and a white patch on the rump, nest in marshes, and it is true that this photograph of a marsh hawk and its young in the nest was made in a wet cattail swamp in Montana. Not five miles away on the National Bison Range, though, I found another nest on a dry hillside.

During the winter months, marsh hawks are fairly common in many parts of the South. On Sherwood Plantation in Georgia, where quail were reared in large numbers for sport shooting, marsh hawks were systematically killed as a grave danger to the sport. Then Dr. Herbert Stoddard made a scientific study of the situation. He found that the chief food of the marsh hawks on the plantation was the cotton rat that preyed on nesting quail. In killing marsh hawks the club had been working against, not for, the quail. Research usually reveals the fact that a bird's behavior is far more complex and varied than is generally believed.

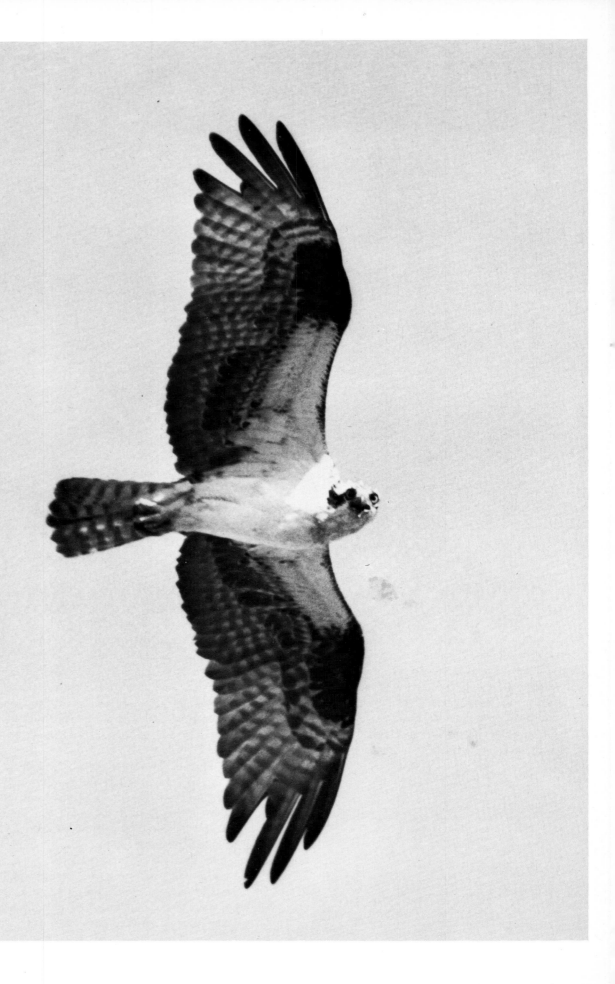

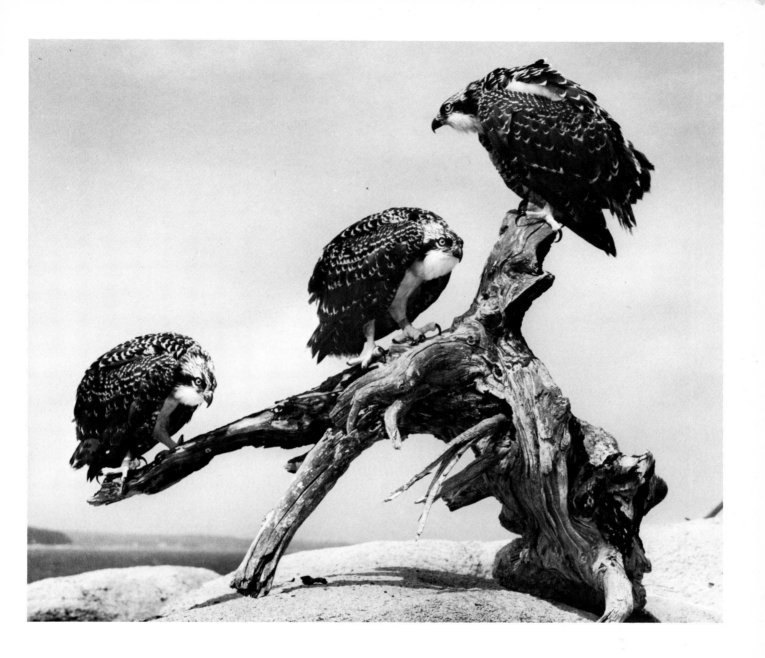

## OSPREY
### Pandion haliaetus

Although the osprey or fish hawk usually weighs but three to four pounds, it sometimes has a wingspread of six feet. It is one of the most widely distributed birds of prey in the world. Unlike most hawks, it lives chiefly on fish, and its tough oily plumage is well suited for plunges in the water. Occasionally a bird will misjudge the size of its prey and be pulled under the surface and drowned. There are now several records of dead ospreys found washed up on shore with their talons sunk into fish that were too heavy for the unfortunate birds to lift.

## YOUNG OSPREYS
### Pandion haliaetus

The undersurface of an osprey's foot has a series of sharp rigid spines which, in conjunction with its long powerful claws, enable it to hold a slippery fish. It is the only hawk able to reverse its outer toe so as to have two claws in front and two in the rear. Knowing how expert these birds are at obtaining food, eagles habitually watch for a chance to steal some of the catch. I have frequently seen a bald eagle swoop down at an osprey, frighten the smaller bird into dropping its fish, and then dash rapidly downward to catch the prize before it reached the water.

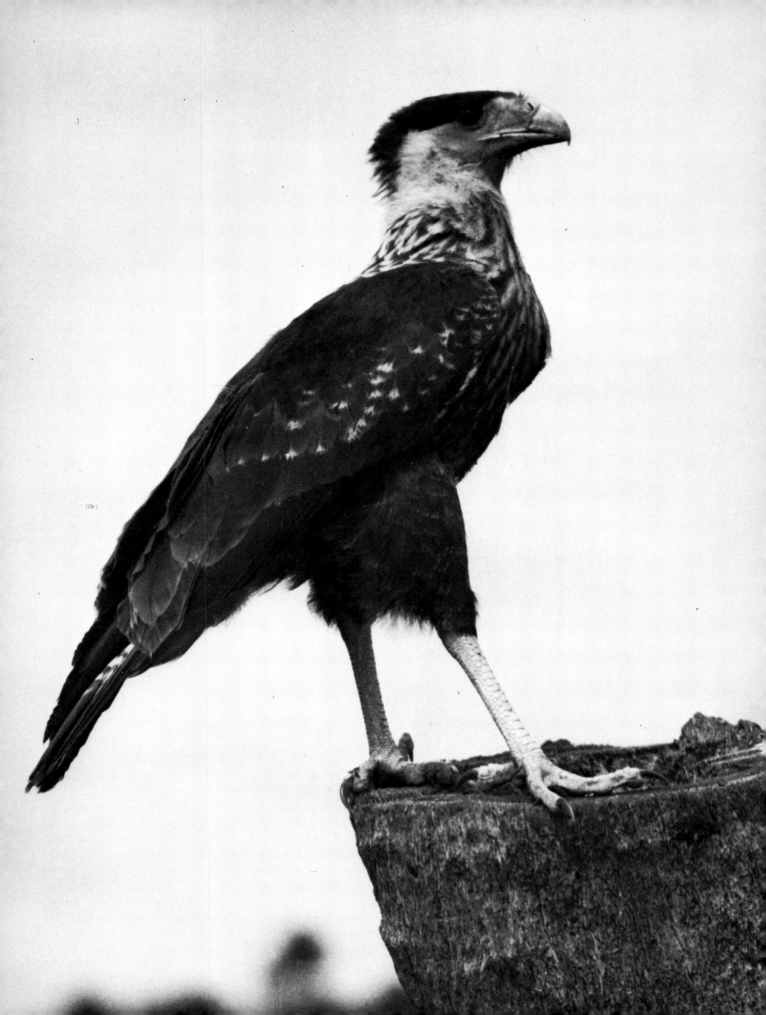

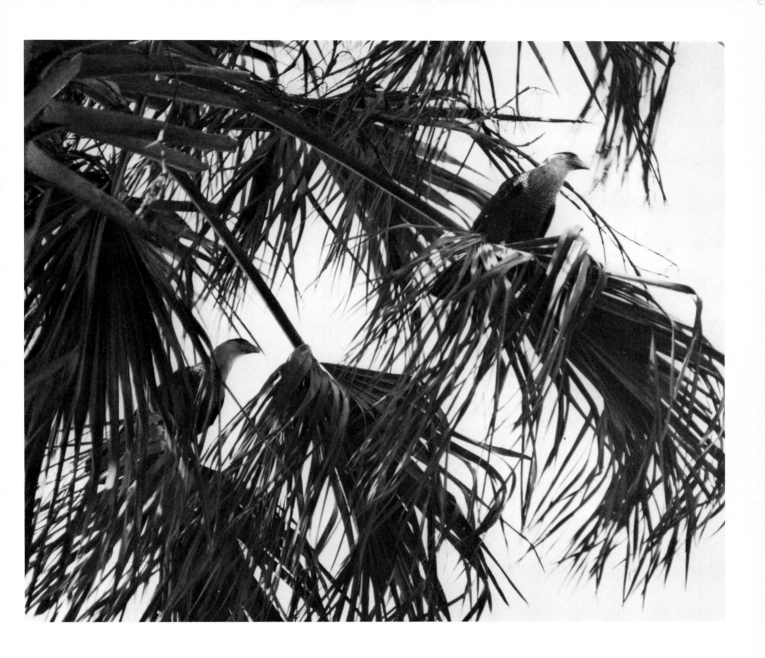

## CARACARA
*Caracara cheriway*

The caracara appears on the Mexican coat of arms, and even in America it is widely known as the Mexican eagle. John James Audubon collected the first known specimen near St. Augustine on November 24, 1831. In our country it is sparsely and locally distributed from Florida to southwestern Arizona. Though structurally related to the falcons, it is more like a vulture in its food habits, frequently associating with those birds to feast on carrion.

## CARACARA HOME
*Caracara cheriway*

In my mind caracaras are indelibly associated with the great Kissimmee Prairie of south-central Florida. As a matter of fact, this is the only area in the eastern United States where one can go and be confident of seeing one of these unique birds. They are especially fond of tall cabbage palmettos, and 17 of the 18 nests that I have seen were built in the dense rounded tops of these trees.

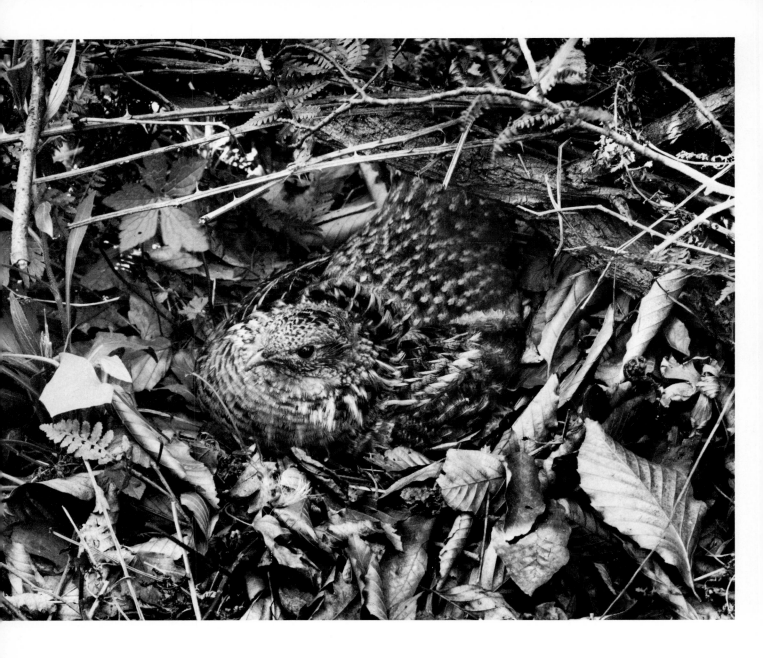

## RUFFED GROUSE
*Bonasa umbellus*

Some 30 species of grouse inhabit the northern parts of the Northern Hemisphere. Among them are many of the most highly prized game birds of the world. The ruffed grouse, commonly though erroneously called partridge, is considered by many hunters to be the king of all North Ameri- can upland game birds. One glance at the accompanying photograph, showing a female incubating its dozen eggs, will indicate how protectively colored these birds are for their life in the dense undergrowth of the forest.

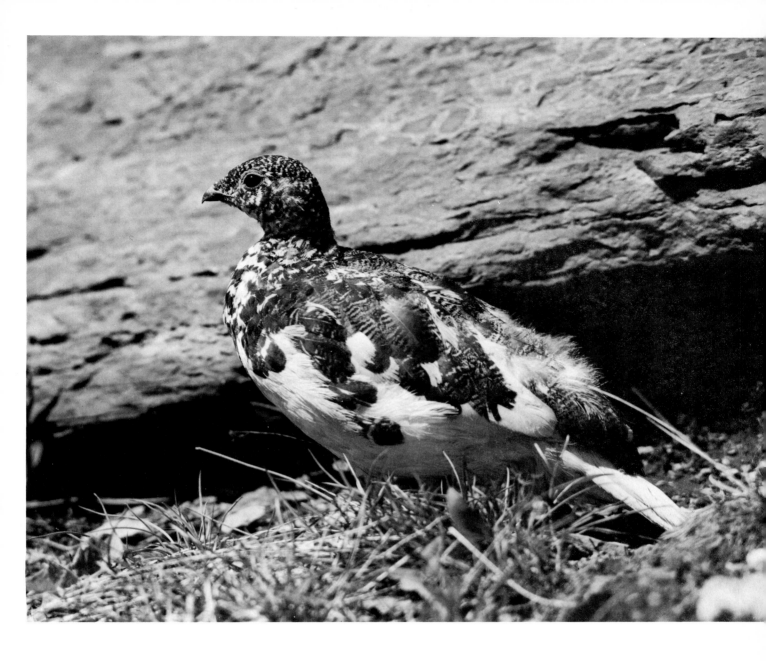

## WHITE-TAILED PTARMIGAN
*Logopus leucurus*

Of the four species of ptarmigan in the world, three occur in North America (two of these being circumpolar), but red ptarmigan are found only in the northern British Isles. Ptarmigan are unique in that their legs are feathered all the way to their toenails, perhaps for ease in walking on soft snow. This white-tailed ptarmigan, a bird that lives on mountains above the tree line, has changed from pure white winter garb into its mottled summer dress. This helps to make it inconspicuous on mountain meadows, where snow fields alternate with clear areas. It was nestled close to a rock when found; it nervously began to nibble the flowers of some spring beauties, then stood up and walked away as sluggishly as the proverbial molasses flows in January. In summer the female is all mottled brown and is almost invisible until she moves. When the young hatch, it is easier to locate her for she clucks steadily to keep her little family together. The young ptarmigan do not seem to like the hot days that occur now and then even high in the mountains. When standing close to them then with my back to the sun, I have had them come to me and settle gratefully in my shadow.

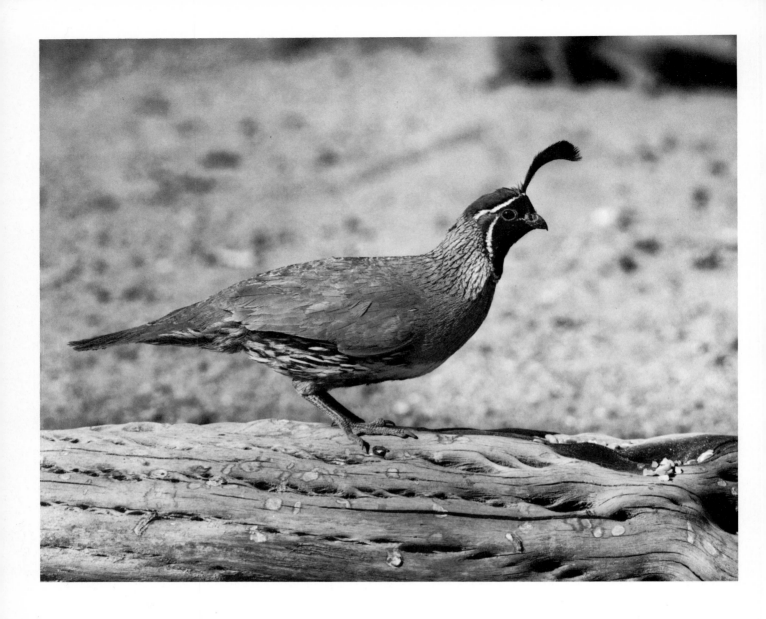

## GAMBEL'S QUAIL
### *Lophortyx gambelii*

Several species of our western quail have truly comic head decorations that bob wildly as they trot about. While that of scaled quail looks like a tuft of cotton, the mountain quail has a long thin plume standing upright; both California and Gambel's quail have a teardrop plume that curves forward above their faces. Gambel's quail prefers dry chaparral country, and we often see them in spring dress running about flowering cacti, palo verde and other lovely plants on the Arizona desert. They have anywhere from ten to 20 eggs. This prolific egg production is a good thing for the species since the adults are shot heavily during the upland game season and both eggs and baby quail are an important source of food for hawks, owls, roadrunners, snakes and so on. Herbert Brandt, who spent much time studying birds in Arizona, tells of finding a pack rat nest in which he noticed a quail egg. Ripping the rat nest apart, he found 14 fresh quail eggs in it. Apparently the pack rat had only collected the hard-shelled eggs to add bulk to its nest, for there was no evidence that it had eaten any.

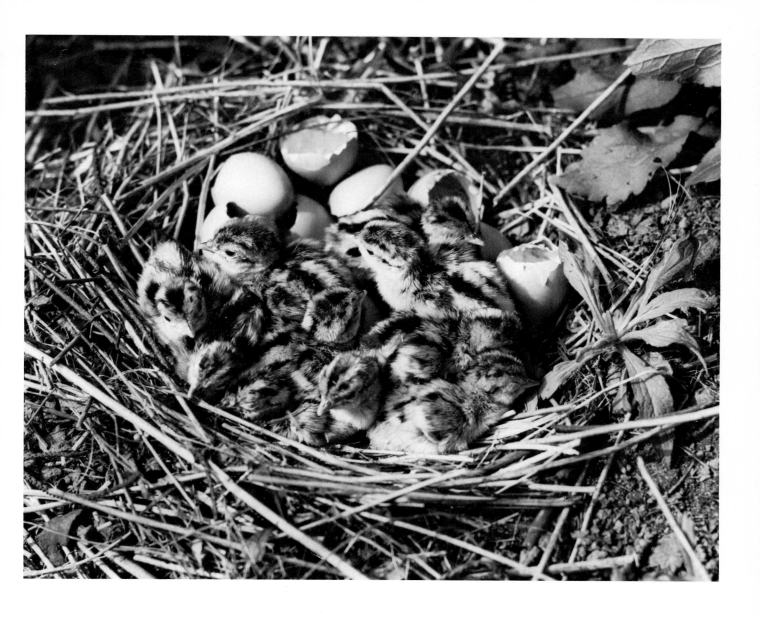

## RING-NECKED PHEASANTS
### *Phasianus colchicus*

All pheasants came originally from Asia and its islands, and legend has it that the Argonauts first introduced them to Europe. In this family, which includes the peacocks, are some of the most spectacular birds in the world. Many species have been introduced into the United States as potential game birds, but with little success except for the chuker, gray partridge and ring-necked pheasant. The latter has multiplied until now when millions are shot each hunting season. With their popularity as game birds it is fortunate that each clutch contains somewhere between ten and 18 eggs. Here 11 young birds have just hatched and five

more eggs beneath them are pipped.

The male is handsome with a streaming tail that stretches his length to almost three feet. Always beautifully colored about the head, during the breeding season its red caruncles become swollen and brilliant. It is said that ring-necked pheasants respond to earthquakes by crowing and that they foretell heavier shocks to follow in this way. In England during World War I they were regarded as important sentinels by some people who felt that they crowed when Zeppelins approached the coast.

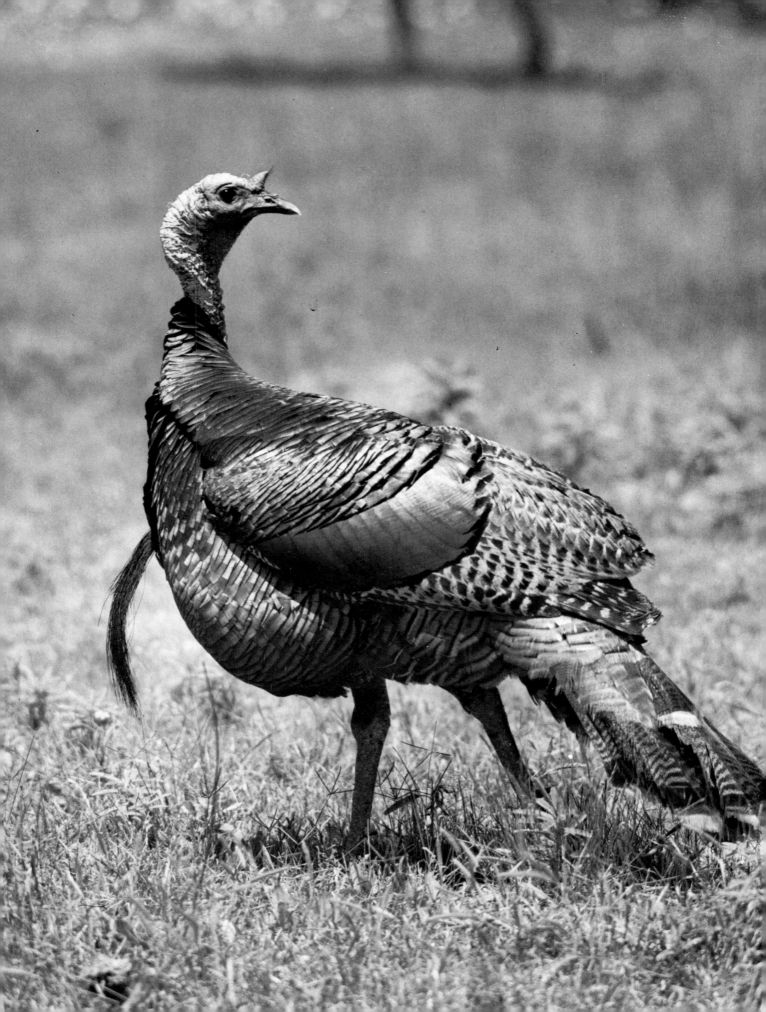

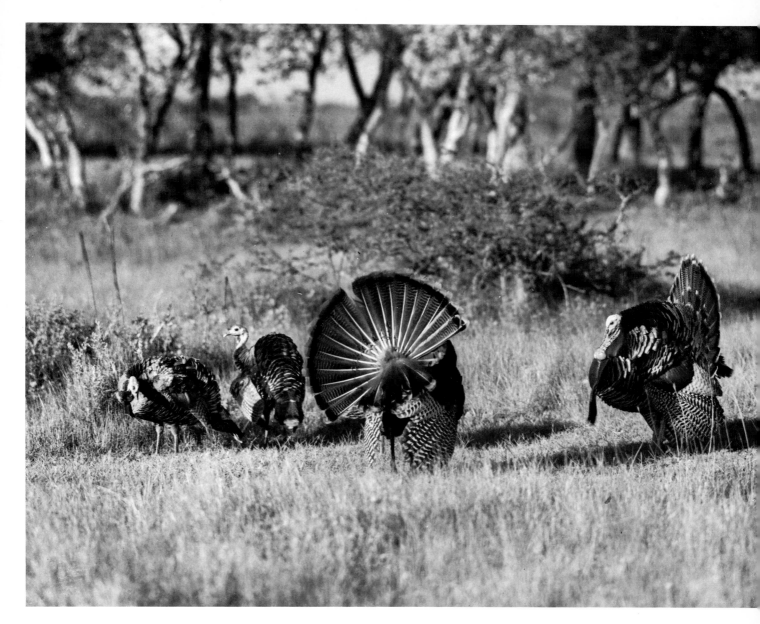

## TURKEY
*Meleagris gallopavo*

The turkey is distinctly American and all domestic varieties come from American ancestors. It is slimmer than its barnyard relative and has a rust-colored, not white, tip to its tail. Turkeys roost in trees, and in the previous century Bartram described their manner of saluting each other at dawn from high in the cypress trees along the St. Johns River in Florida. He told of the high forests ringing with their calls from March until the end of April, their cries caught and repeated from one to another for hundreds of miles around. Now they are gone from much of their original range, but may still be found locally, especially in oak groves and forest clearings.

## TURKEYS
*Meleagris gallopavo*

One spring at the Aransas Refuge in Texas, a group of turkeys came by my blind each day, the hens ignoring the dancing toms that usually performed. Feather malformations made it easy to know them as individuals. As hens came to eat grain in front of the blind, the red-faced toms strutted on stiff legs, tails spread; then came a pause followed by a click and a boom made by vibrating their downheld wings. Gradually one tom reached the point of exhaustion and its naked face first became flecked with cream and then grew pale. Immediately the other tom stepped forward with renewed vigor until it, in turn, fell behind with exhaustion. This seesaw dance went on hour after hour, day after day. I saw no consummation of the courtship before I had to leave but it must have taken place, for, returning a month or so later, I saw a number of hens, followed by their poults, skulking away through the brush.

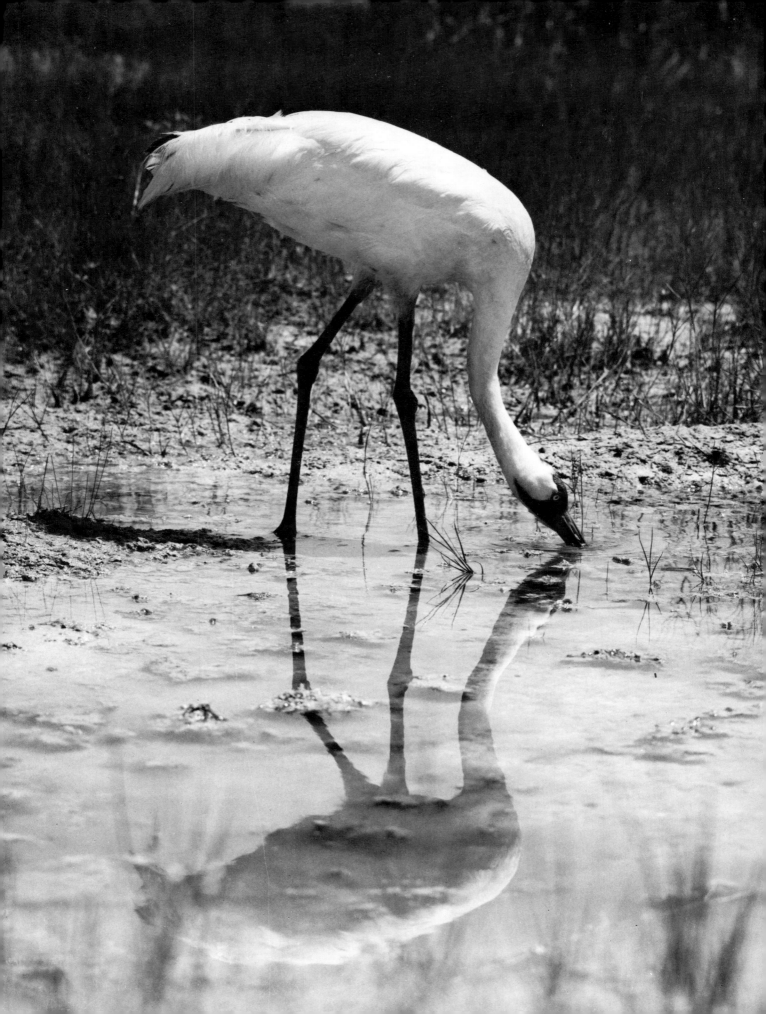

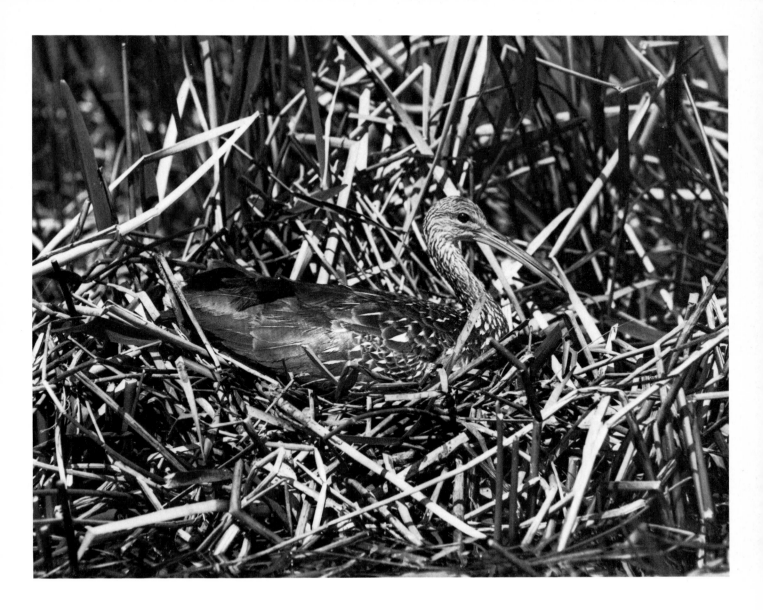

## WHOOPING CRANE
### Grus americana

It is an intensely emotional moment when so rare and so beautiful a bird as a whooping crane, unconscious of your presence, approaches your blind, so close that you see the pebbled red skin on its crown, face, and behind the bill. Its brilliant yellow eyes appear to see everything taking place around and above it. Then its snowy plumage and the soft feathers drooping over its tail can really be enjoyed. Only when the crane flies are the black wing tips conspicuous.

An observation tower has been built at Aransas Refuge where hundreds of people annually scan the wide area before them in the hope of spotting a whooping crane. Repeatedly comes the cry "There is a whooper!" but more often than not it is a great egret or a white pelican. Whooping cranes always fly with their heads held far forward on their long necks. All the heron tribe, as well as white pelicans, fly with the neck folded and the head lying between the shoulders.

## LIMPKIN
### Aramus guarauna

Limpkins impress me as being an impossible hybrid cross between rails and cranes. There are two species in the world: one confined to South America, the other ranging from Central America to Florida and extreme southern Georgia. Because of their loud, melancholy calls, which suggest someone in agony or dire distress, they are known to Floridians as "crying birds." Living to a large extent on freshwater snails, they are confined to freshwater marshes and swamps. Consequently they are steadily decreasing as excessive drainage in Florida continues.

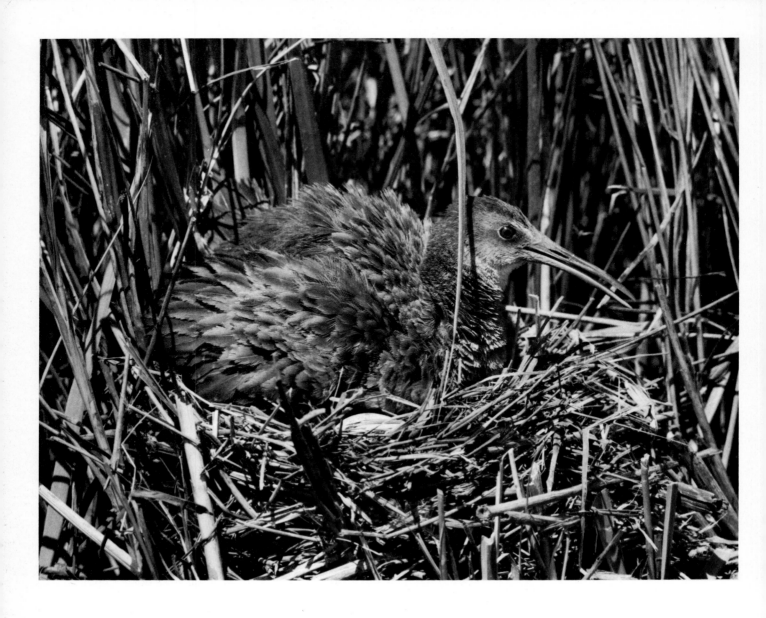

## CLAPPER RAIL
*Rallus longirostris*

Vast saltwater marshes are the preferred habitat of these birds. They are almost impossible to flush and, were it not for their loud clattering calls, they might well go unrecorded for years even in regions where they are common. The tidal movements they like so well often destroy many nests. One day at the mouth of the Suwannee River, while I was trying for photographs of the Florida clapper rail, a particularly high spring tide came in and completely submerged the 11 eggs. The bewildered rail stood idly by while the water ascended more than eight inches above the original level of its nest.

## VIRGINIA RAIL
*Rallus limicola*

This small reddish mud-hen is distributed in fresh and brackish marshes all over the United States. Like most rails it is shy and secretive, skulking in the seclusion of its flooded haunts. The accompanying photograph was taken from a blind in the heart of a cattail marsh on Long Island. The bird was apparently not satisfied with the presence of my hideout. It assumed a series of ludicrous poses, peering intently as though trying to figure out whether or not it was safe to remain in the area.

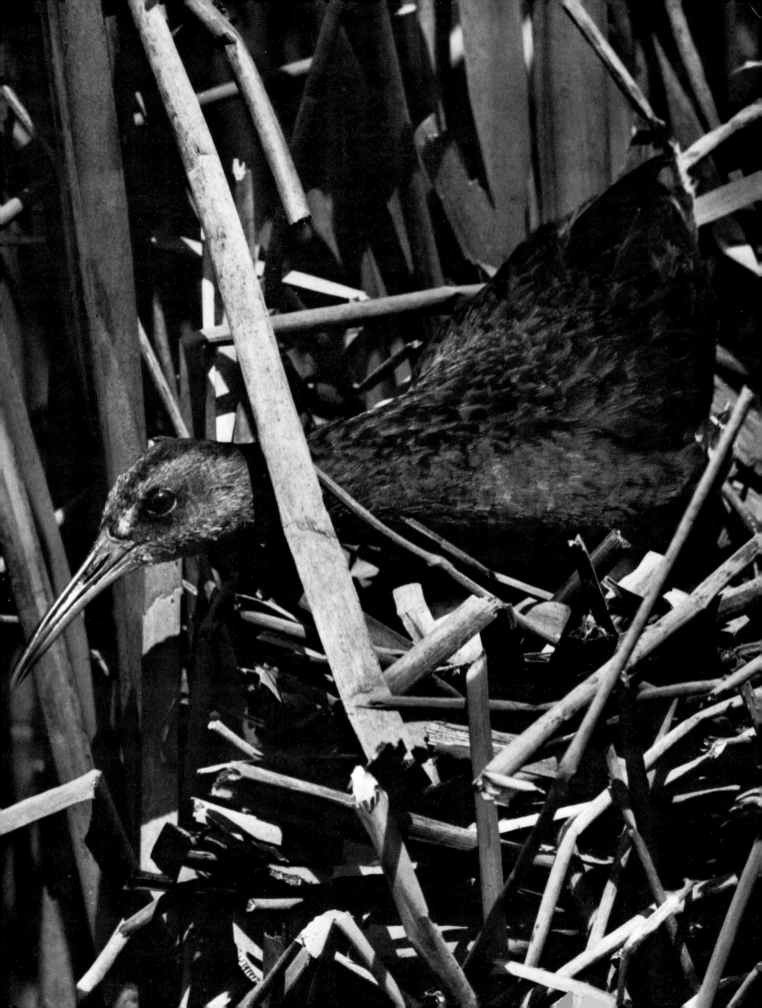

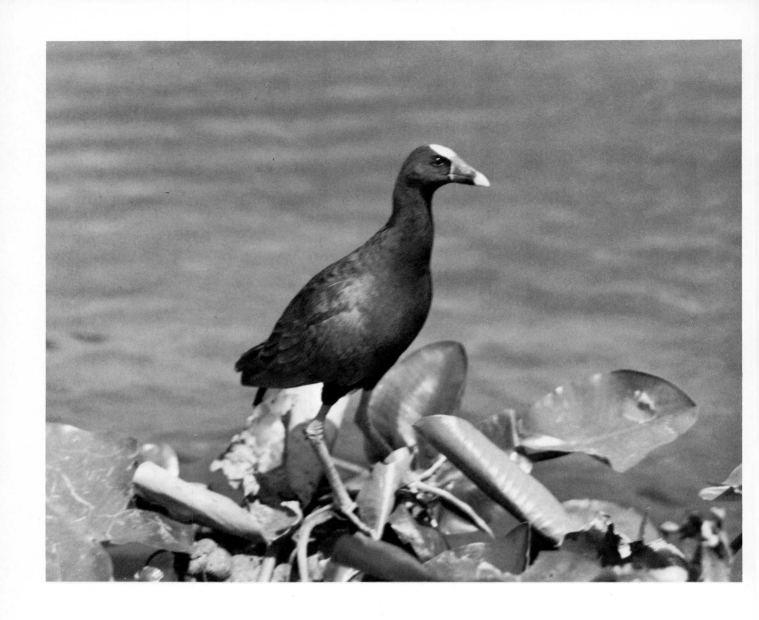

## PURPLE GALLINULE
*Porphyrula martinica*

Just a glance at an exotic purple gallinule arrests the attention. Its green back and purple head and underparts are strange enough, but added to these unusual colors are the brilliant red bill tipped with intense yellow and a blue shield between red-brown eyes. Its yellow legs end in tremendously long toes that let the gallinule trot easily over the uncertain footing of lily pads and bonnets. It often feeds among pickerel weeds, where the blue flowers partly conceal its bright plumage. As it walks about it continually flicks its white tail, nodding and bowing at the same time. While actually a bird of the American tropics, it nests in many of our southern states. Its powers as a flier are evidenced by its occasional presence on Tristan da Cunha, an island in the Atlantic Ocean halfway between South America and Africa.

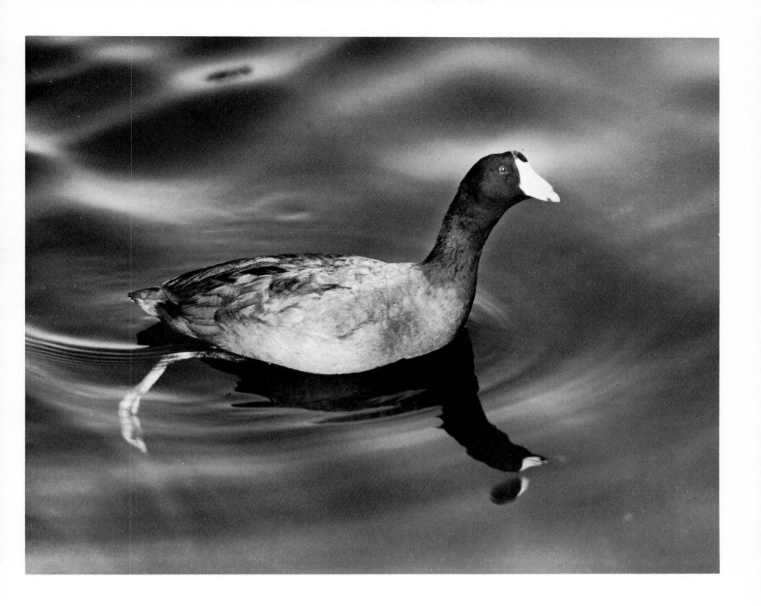

## AMERICAN COOT
*Fulica americana*

Coots are more aquatic than most members of the rail family. In fact, they spend so much time on the water that many people think of them as ducks. They are famous for their colossal feet. Each toe has a series of scalloped lobes, which make the pedal extremities absurdly large. But these specialized feet are used with skill. One minute they are paddling the coot through the water with great rapidity, the next propelling it down to the bottom, and a few seconds later astonishing all onlookers by enabling the bird to actually run along the surface of the pond.

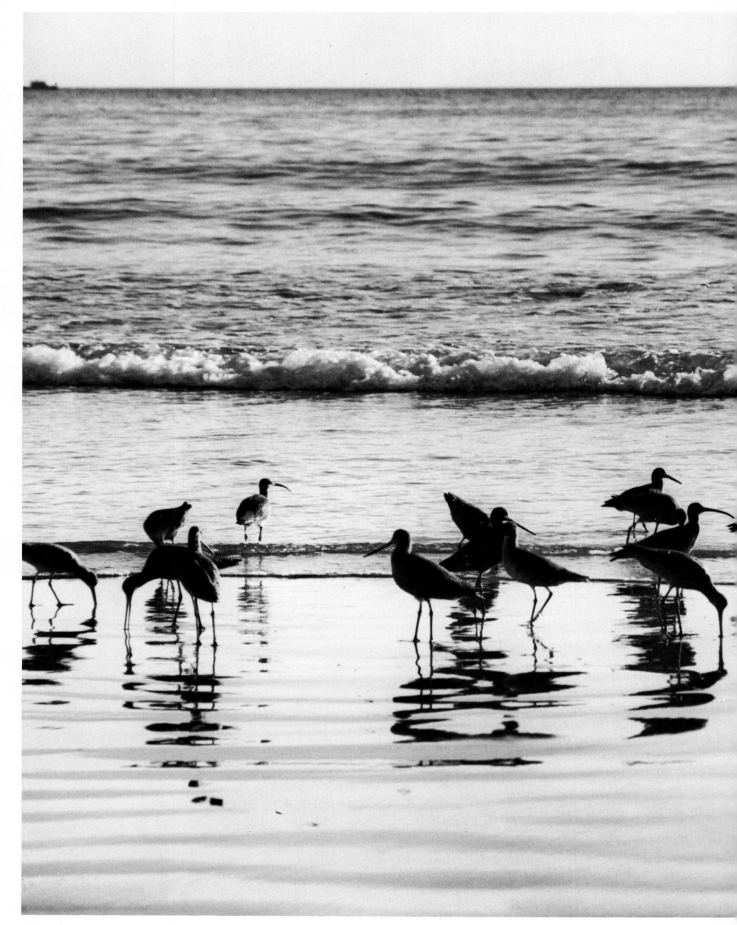

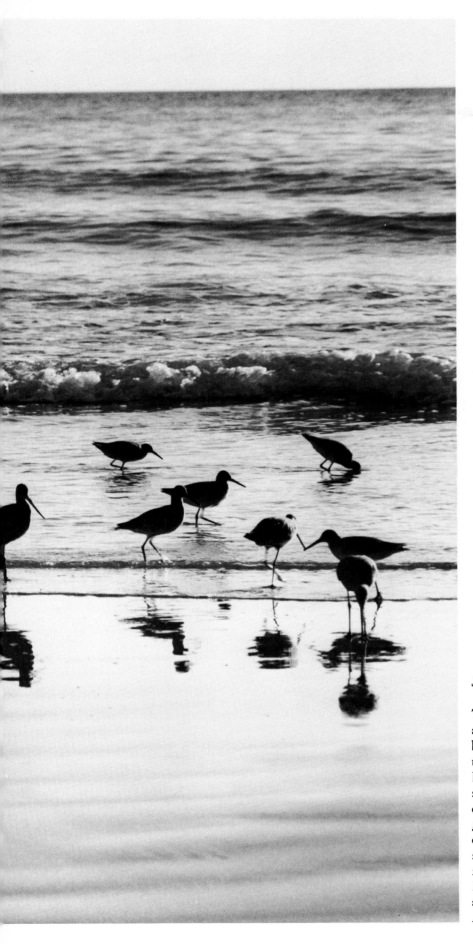

## SHOREBIRDS

Today great flocks of shorebirds migrate across the United States between their main breeding grounds in northern Canada and their chief wintering grounds south of our borders. Yet less than half a century ago the same species were low in numbers. Because of their habit of bunching together on the ground as well as in flight, as many as 65 of these birds were sometimes killed by a single discharge of a shotgun. This country may well be proud of the fact that it enacted laws in time to save these birds, which must always be part of a rich and beautiful America.

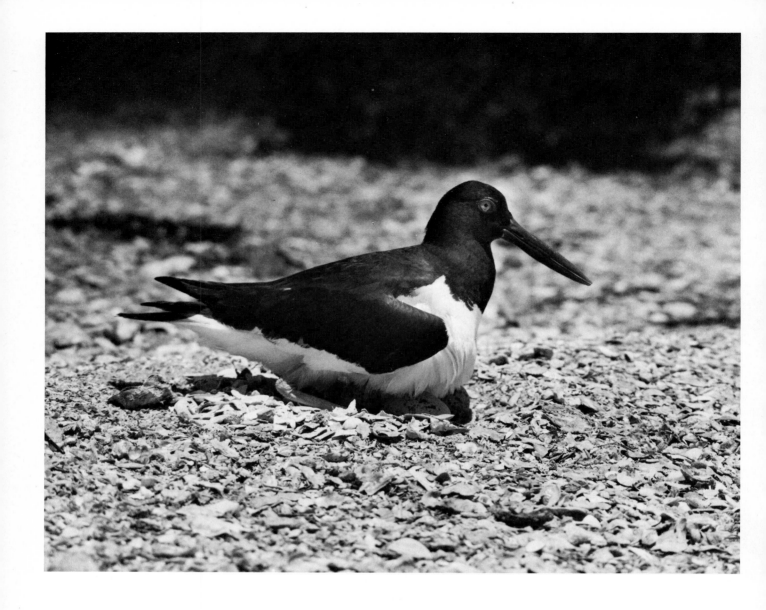

## AMERICAN OYSTERCATCHER
### Haematopus palliatus

This wary, striking, chunky black-and-white shorebird runs about on pink legs. Its glaring yellow eyes are rimmed with a thin red line, but most astonishing is its bill, which resembles a red-hot poker. This bill is flattened vertically and is used as dexterously as an experienced fisherman uses his two-edged knife. With it the oystercatcher opens bivalves easily—a feat difficult for many people. It is also used to probe in the mud for choice morsels and to pry off limpets and other shelled creatures that cling firmly to rocks. It is said that occasionally an oyster closes on the hard bill of the oystercatcher. Then, instead of enduring this helplessly, the bird uses its bill like a baseball bat to shatter the oyster against a rock.

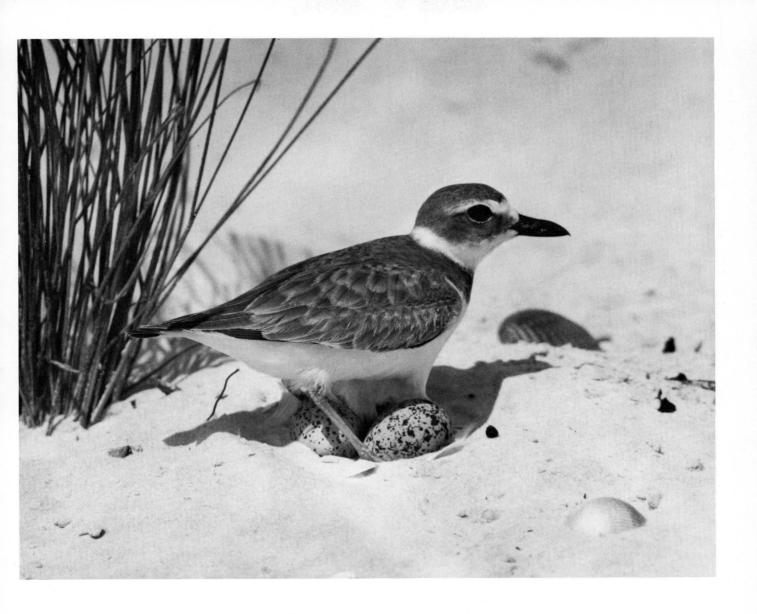

## WILSON'S PLOVER
### Charadrius wilsonia

I have observed this small, gentle, large-billed plover throughout its entire breeding range in the United States from southern New Jersey to Texas. It is generally confined to sandy reefs, shell-strewn beaches, and the margins of adjacent inlets and tidal flats. In fact, the species is so partial to an oceanside habitat that it is very rarely recorded beyond the sound of surf and only casually beyond the farthest reaches of the tide. It is indeed one of the original beachcombers.

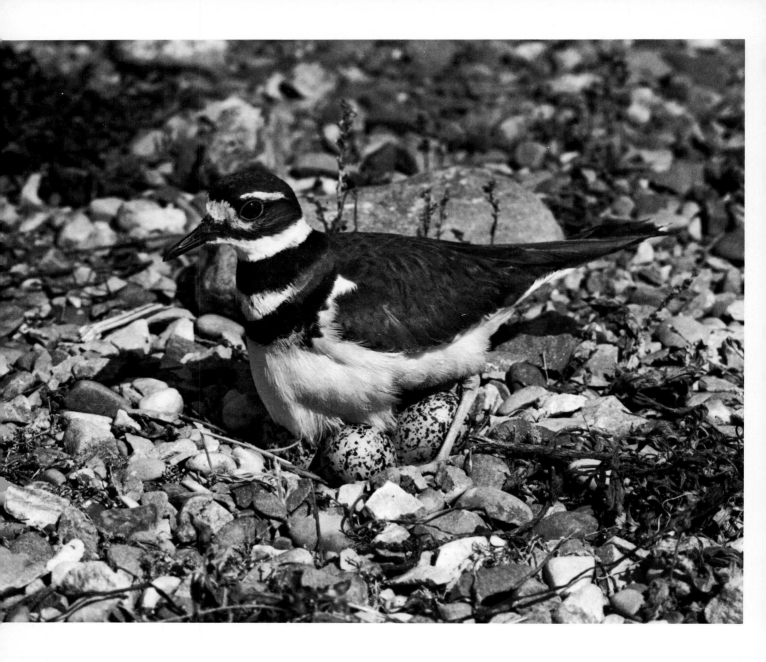

## KILLDEER
*Charadrius vociferus*

The killdeer belongs to the group of shorebirds known as banded plovers. Unlike the Wilson's plover, however, the killdeer, found over much of North and South America, is often seen far from water in pastures, golf courses, baseball fields, airports, lawns, and even on gravel roofs. Its noisy calling of its name, "killdee, killdee," coupled with its acceptance of so many habitats close to man's activities, makes it one of the best-known shorebirds. Like most shorebirds, it has a habit of bobbing when nervous, and it puts on a "broken-wing" act when anything comes too near its nest or young. The reason for this is still being debated by scientists. Is the killdeer trying to draw the intruder away from its nest, or is it having some sort of fit because it is torn between protecting its nest and fleeing from danger? Whatever the reason, the killdeer's act is dramatic as it flutters with outspread wings, its orange rump feathers fluffed and its colorful tail widely fanned.

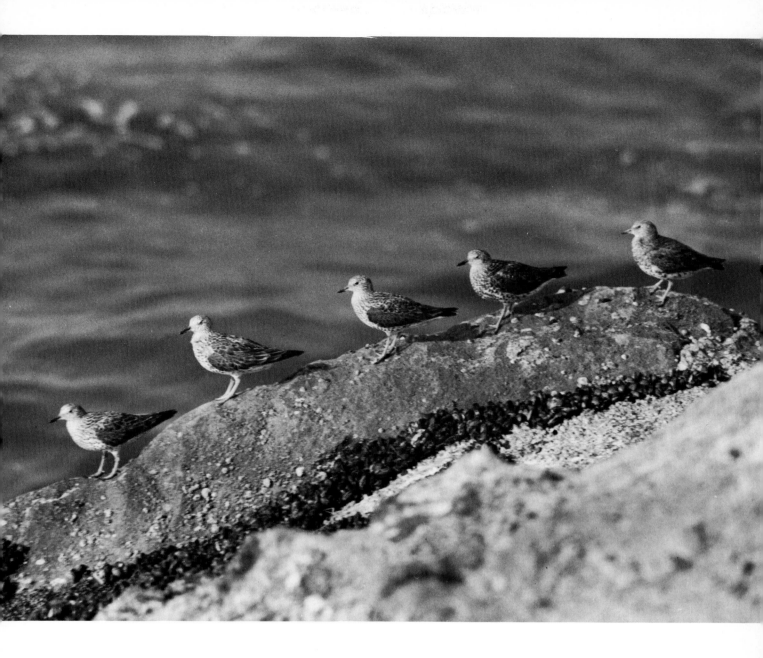

## SURFBIRDS
*Aphriza virgata*

This stocky, grayish, and rather phlegmatic bird with yellow legs is shaped much like a turnstone. Unlike many birds that seem to have been named by either a colorblind person or a laboratory scientist who has never seen it in its natural habitat, the surfbird is appropriately named. All but six or seven weeks of its year are spent close to the rocky Pacific coast, from southeast Alaska to the Straits of Magellan. Not until 1926 were its nest and eggs discovered high above the tree line in Alaska's rugged McKinley National Park. This wild and rocky nesting ground which it shares with white Dahl sheep bears some resemblance to the rocks and reefs where it spends most of its life. Shorebirds such as this, which make some of the longest migration flights of any species, always appeal to the imagination.

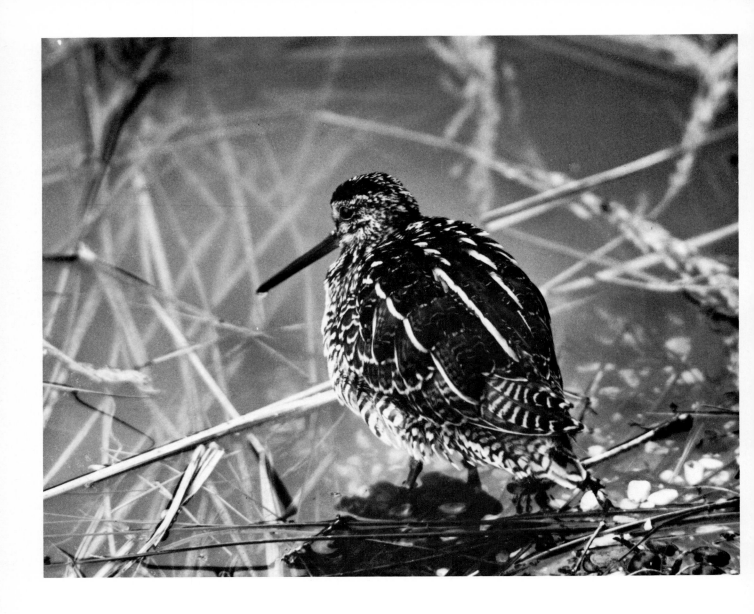

## COMMON SNIPE
### Capella gallinago

A snipe "sings" with its tail. On rapidly vibrating wings it delivers its flight song high above the marsh. It circles round and round, intermittently darting downward and giving forth its eerie ventriloquistic sound with each descent. The more musical twittering notes of the woodcock are delivered during a somewhat similar performance. For years the origin of both these sounds was a mystery. It is generally agreed that some notes of the woodcock are produced by air passing through the stiff, attenuated outer wing feathers. The consensus of opinion is that the entire flight song of the snipe comes from air whistling past the rigid outer feathers of the bird's tail.

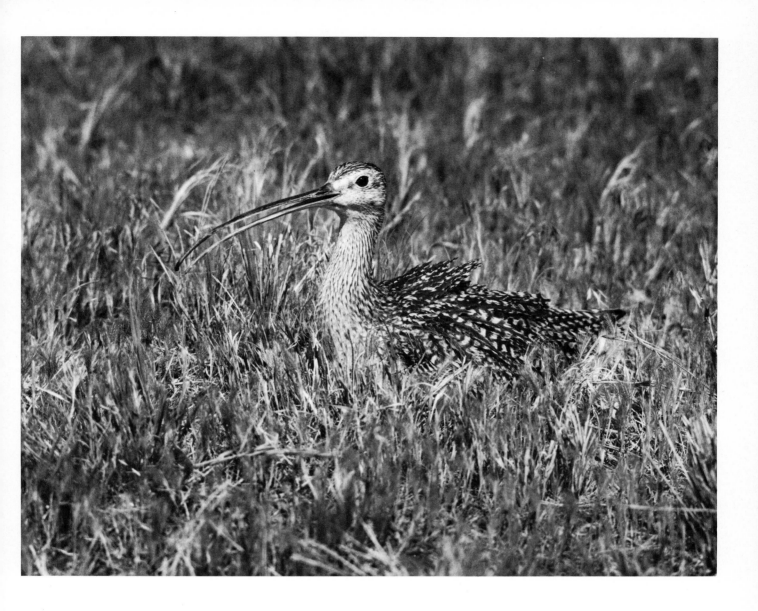

## LONG-BILLED CURLEW
*Numenius americanus*

During the winter, the long-billed curlew, the largest species of its family, disperses widely and appears not only on the Atlantic and Pacific coasts but as far south as Guatemala. I have even watched them feed busily on the grassy median of interstate highways in Texas. When nesting time comes they scatter to the grasslands of the interior. As these lands have disappeared so have the long-billed curlew, which have also been a target for hunters. The young, as is true of all shorebirds, are precocial; that is, they hatch covered with down and able to run about as soon as they are dry. Several times I have held a young long-billed curlew and immediately been attacked by both adults that circled upward and then plunged, screaming, as if they meant to impale me on their down-curved, eight-inch bills. As soon as the young bird was released, the parents ceased the attack and led it away.

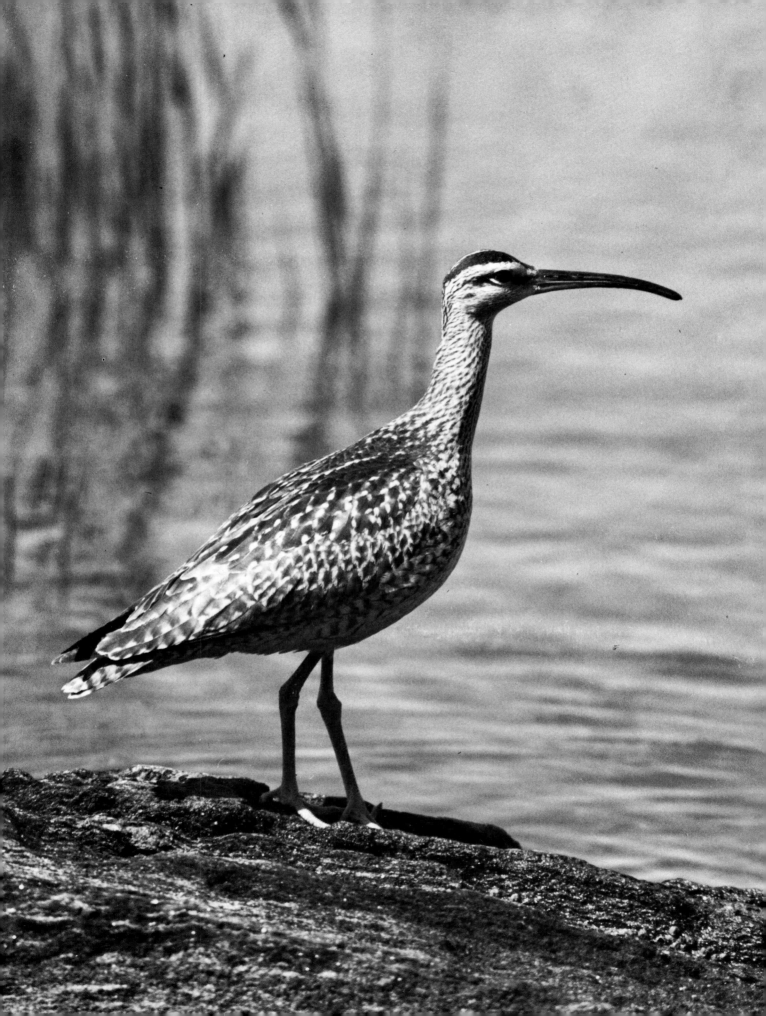

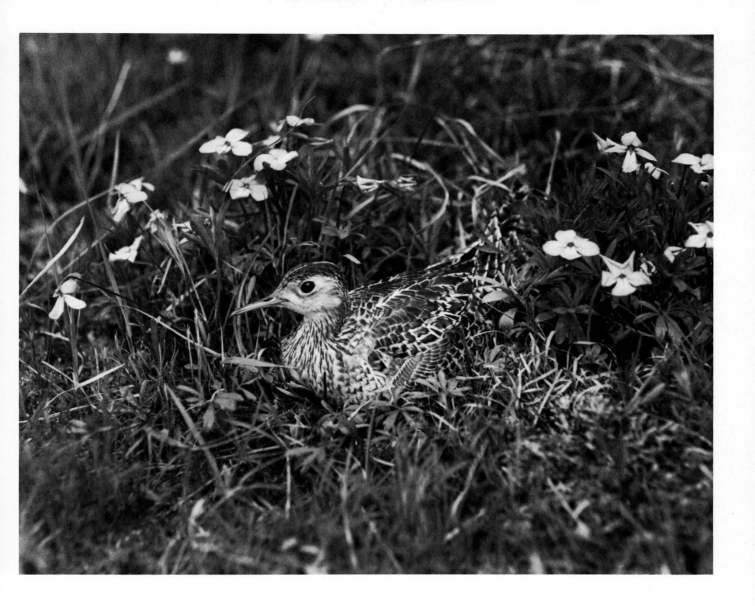

## WHIMBREL
*Numenius phaeopus*

While on the Mount Everest Expedition of 1921 Dr. Wollaston identified curlew and godwits flying at an altitude of 20,000 feet. The large handsome species that appears here is known in the United States as the whimbrel. It breeds in Alaska and northern Canada and winters chiefly south of our borders. If sane conservation laws had not been passed just in time to save this species, it probably would have followed its smaller relative, the Eskimo curlew, into near annihilation or even extinction.

## UPLAND SANDPIPER
*Bartramia longicauda*

This picture was taken from a blind set among the bird-foot violets of Long Island's Hempstead Plains. The upland sandpipers are long gone from the area and the bird-foot violets have been replaced by a huge housing development. The bird demands little water on its preferred fields, pastures or prairie land.

In shape, posture and actions it more closely resembles a plover than a sandpiper. Its distinctive song is one of the most stirring sounds in nature; words cannot adequately describe the sad, mellow call, comparable only to the wail of a distant wind.

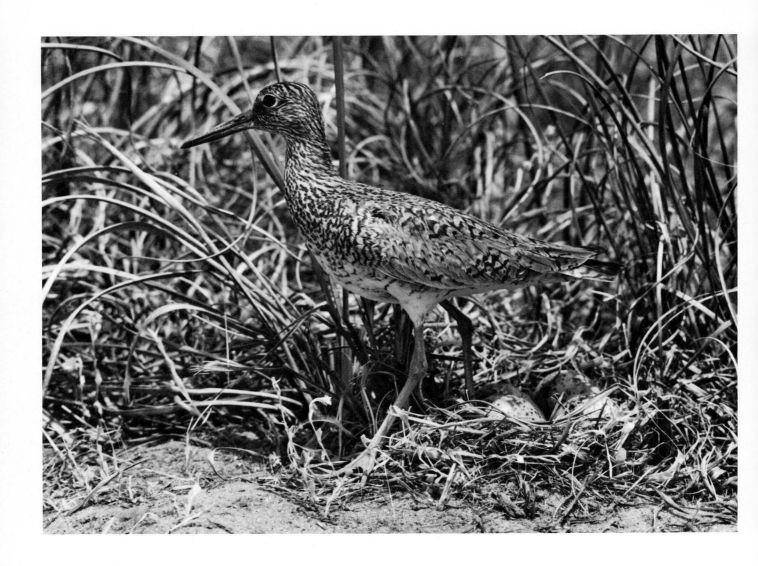

## WILLET
### *Catoptrophorus semipalmatus*

About the size of a greater yellowlegs, this plump shorebird has a thicker bill. It is brownish gray, without distinction until it flies. Then the dramatic black-and-white wing pattern transforms the willet into one of our most striking birds while its loud "will-will-willet" draws attention to itself. In the East the willet nests in salt marshes fringing the coast while the western race seeks the shores of lakes that are often alkaline.

Presently the population of willets is satisfactory but that was not true at the beginning of this century. Its two-inch eggs were then regarded as delicacies and relentlessly stolen from the nests. There was no closed season and the birds were shot in great numbers. Hunting was easy, for, when one nest is approached, the telltale cries of the alarmed pair often attracts all the other willets within hearing distance. On flashing wings they fly to the threatened area, gathering in a noisy commotion above the intruder and making easy targets for those who hunt nesting birds.

## GREATER YELLOWLEGS
### *Totanus melanoleuca*

Over the greater part of the United States this large handsome shorebird is known only as a transient. It breeds in Alaska and Canada and winters chiefly south of our borders, many individuals going as far south as Patagonia in southern Argentina. It is partial to the shallow margins of lakes, marshes, pools and tidal flats, where it feeds primarily on tiny fish, molluscs and insects. At the slightest sign of danger, yellowlegs give forth loud ringing alarm notes, which put every bird in the locality on the alert. Because of this they are popularly called telltales or tattlers.

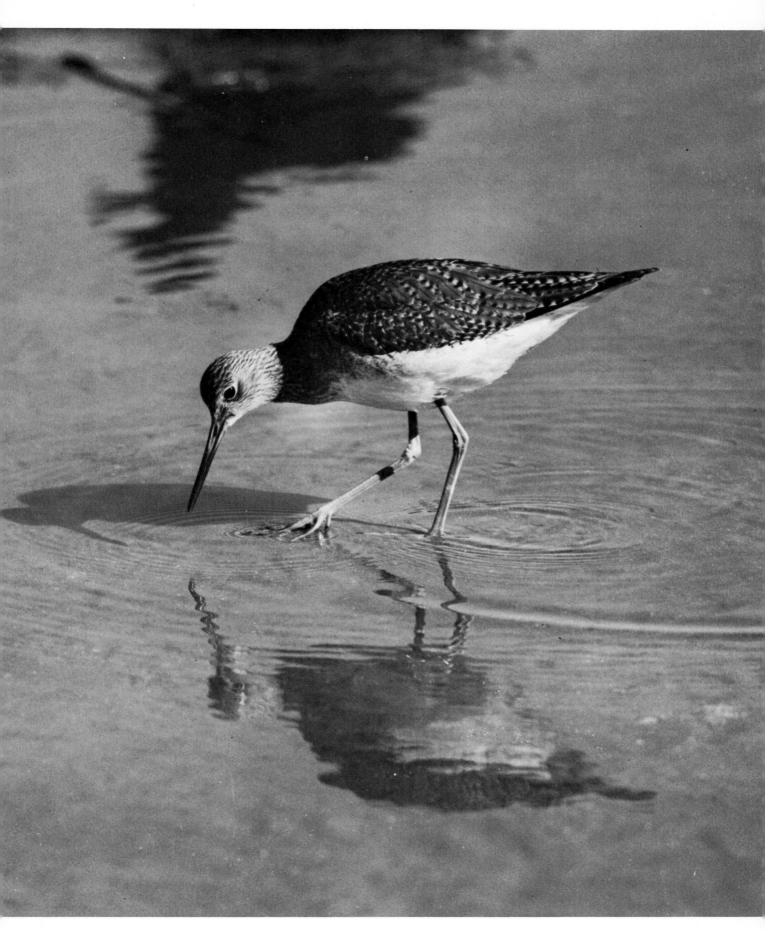

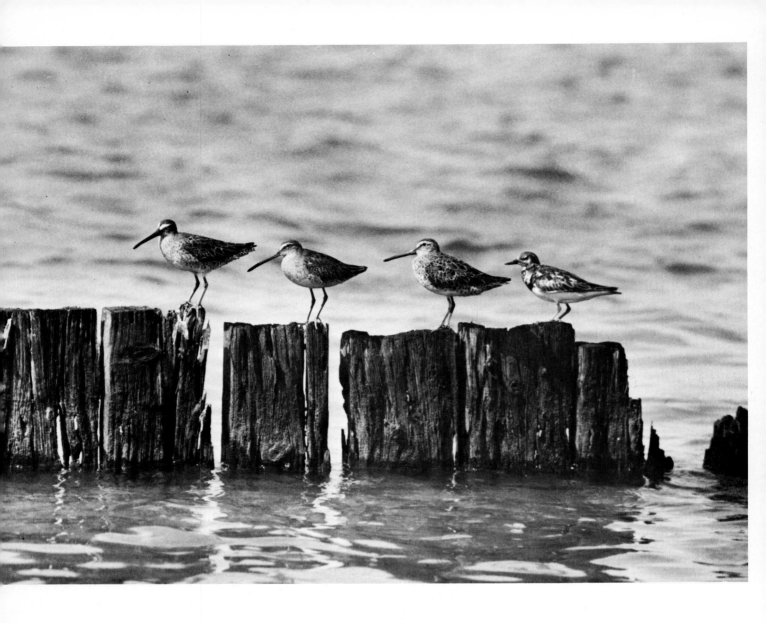

## SHORT-BILLED DOWITCHERS AND
## RUDDY TURNSTONE
*Limnodramus griseus*
*Arenaria interpres*

One of my most enjoyable pastimes is trying to estimate how fast various species of birds fly. By driving a course parallel to flocks flying along ocean beaches, I have been able to gather considerable data. Even though calm days are generally selected for this sport, the records may be slightly inaccurate. But when one obtains more than six records for any one species, the median should be fairly reliable. On the basis of my data I believe that dowitchers ordinarily travel at between 36 and 44 miles an hour.

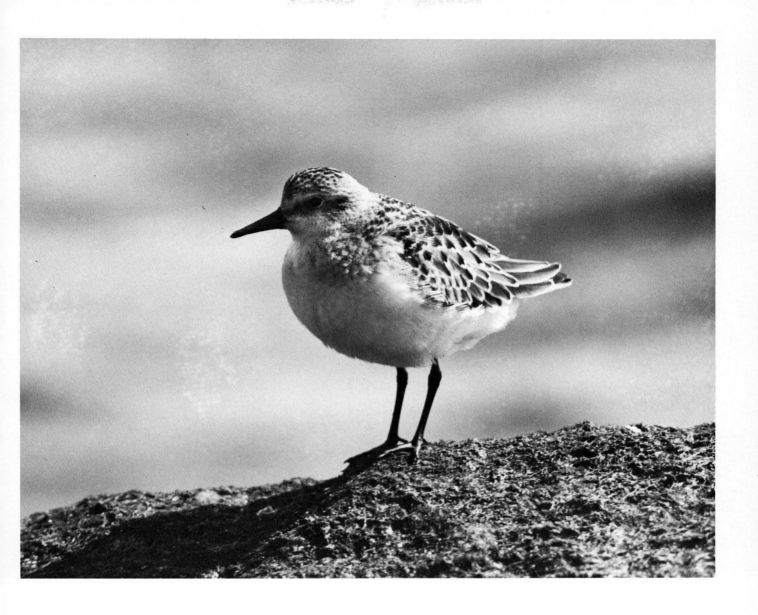

## SEMIPALMATED SANDPIPER
*Calidris pusillus*

As its name implies, this small sandpiper has half-webbed feet. Like most birds it has keen vision and acute hearing but a poor sense of smell; it breathes rapidly, has a body temperature higher than man's, and possesses more red corpuscles per ounce than any other animal.

Since resting birds invariably face into the wind, they are good weather vanes. This is especially true of shorebirds, which are so sensitive that even during the most gentle air movement they point their bills in the direction from which the breeze is coming.

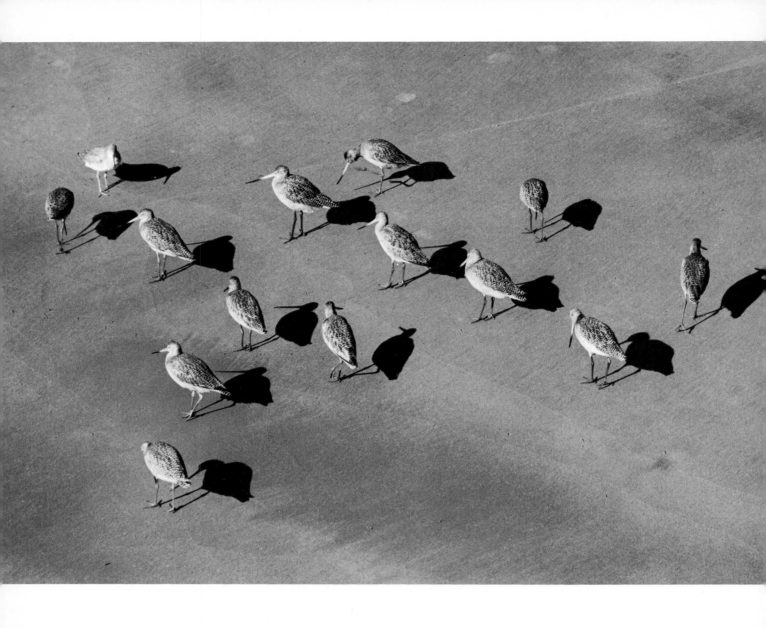

## MARBLED GODWITS
### Limosa fedoa

Accidental associations often prove to be lasting. It is now impossible for me to think of these large handsome shorebirds without recalling the Japanese attack on Pearl Harbor. I was on the coast of southern California that day when the news flashed over the radio and everyone was placed on the alert. No enemy planes appeared, but for three hours following the report flock after flock of marbled godwits passed over the beach, imparting a feeling of tranquil peacefulness that made any thought of war seem entirely out of place.

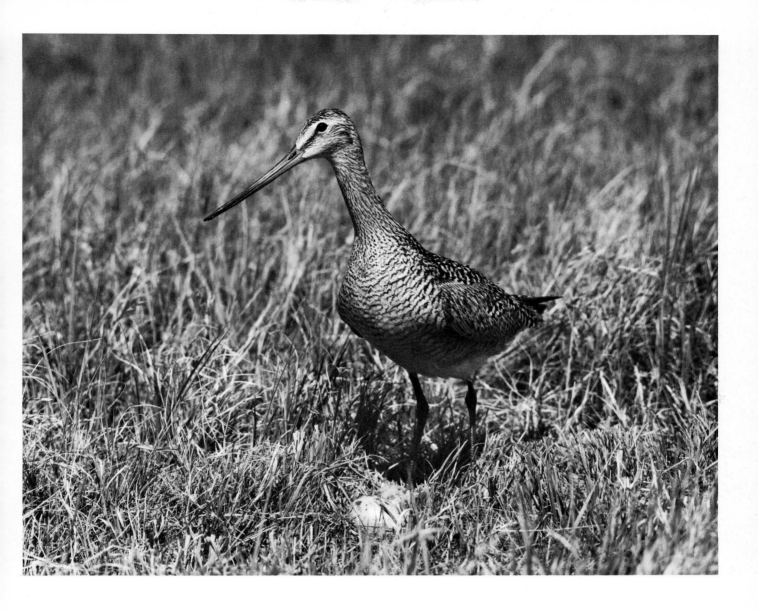

## MARBLED GODWIT
*Limosa fedoa*

This marbled godwit nesting on the prairie grasslands of Montana exhibited no concern when a blind was placed close to her nest. She returned immediately and stood briefly over her spotted, olive eggs. Once she settled on them she blended so closely with the short tawny grasses that she was almost invisible, and even her slender dark-tipped pink bill was difficult to see. Soon I found that a blind was not needed to photograph her. She even let me lift her gently to check the eggs. But once the young hatched she changed completely. With hysterical excitement she flew about calling frantically, her cinnamon-lined wings flashing in the sun. As soon as the young were dry she led them from the nest area and never again exhibited any of the confiding behavior that so astonished me while she incubated.

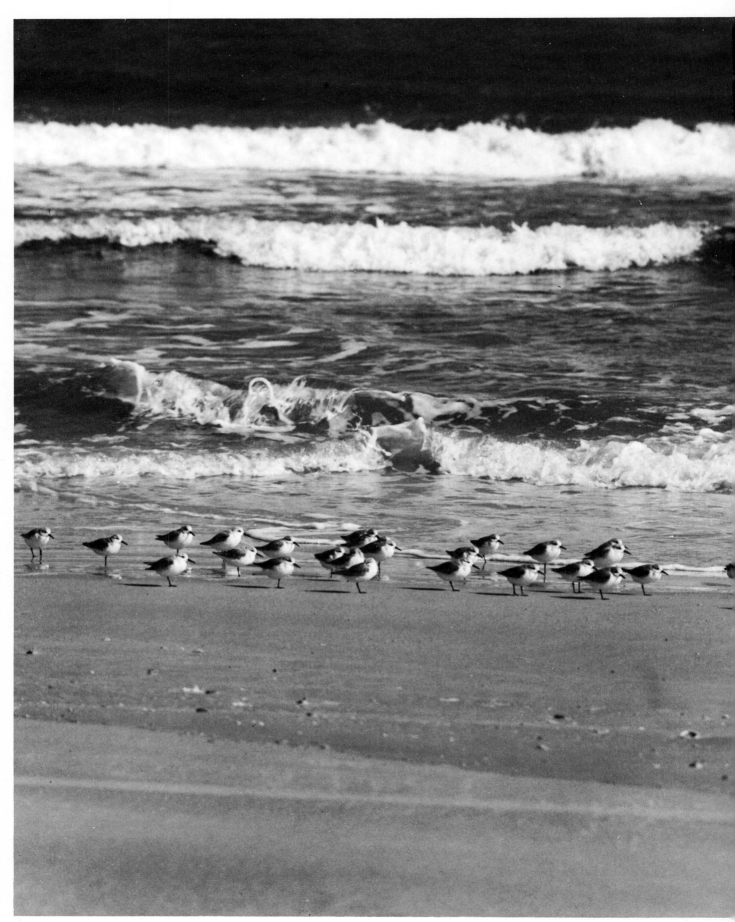

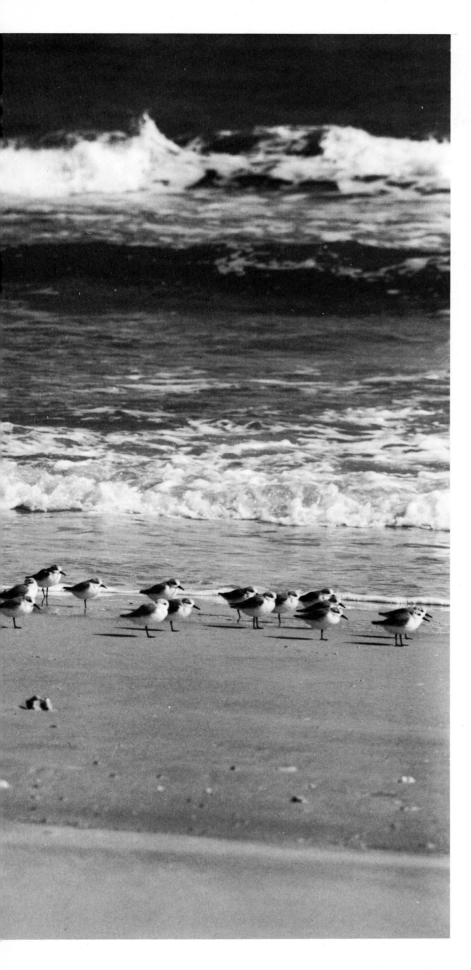

## SANDERLINGS
*Calidris alba*

In the spring sanderlings nest on Arctic islands all around the earth. At other times of the year they are great wanderers. They have been recorded on almost every beach in the world and make frequent appearances inland. In the Western Hemisphere, sanderlings migrate all the way to Argentina for the winter but many remain behind, scattered widely along both our Atlantic and Pacific coasts. There they chase the receding waves and scamper ahead as the water foams back up the beach.

Their summer dress is largely a rusty brown but the rest of the year they are pale gray or white. They often gather to rest in small companies where every bird in the whole flock may stand on one leg. Many birds dislike storms but sanderlings become especially active when waves thundering on the beach bring an abundance of food.

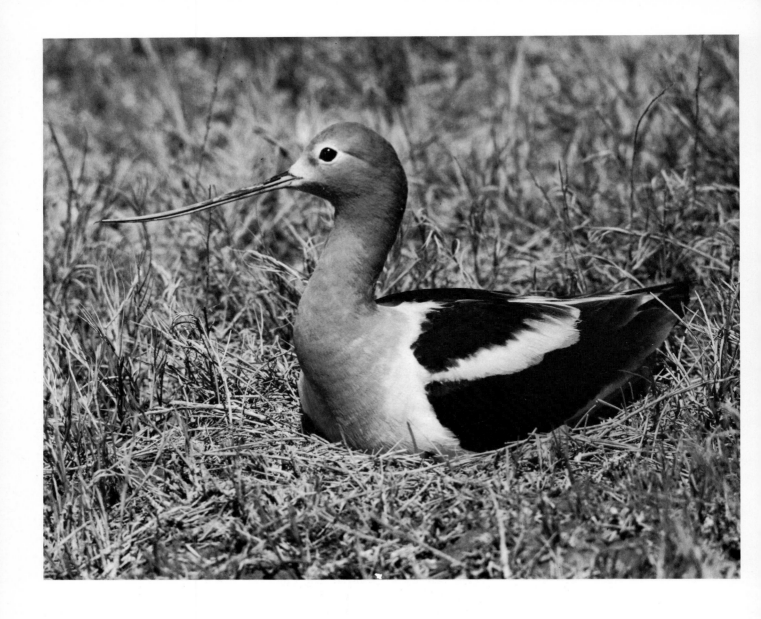

## AMERICAN AVOCET
### Recurvirostra americana

Wherever they occur avocets are conspicuous, both because they stand tall on very long bluish legs and because their pattern of white and black stands out sharply against land or water. When breeding a lovely rich pinkish cinnamon color spreads over the head and neck. Their long thin bills curve upward, but only in photographs have I been able to see the thin downward turn at the tip. This is so slight that it is invisible even from a blind only ten or 12 feet away.

I know this bird best from the hot, sunbaked Bear River Migratory Bird Refuge in Utah where large numbers of them nest. It is not unusual to see a dozen or more form a compact line and advance through shallow water, swinging their long bills from side to side in unison as they move forward. This sweeping motion is similar to that of a roseate spoonbill as it feeds.

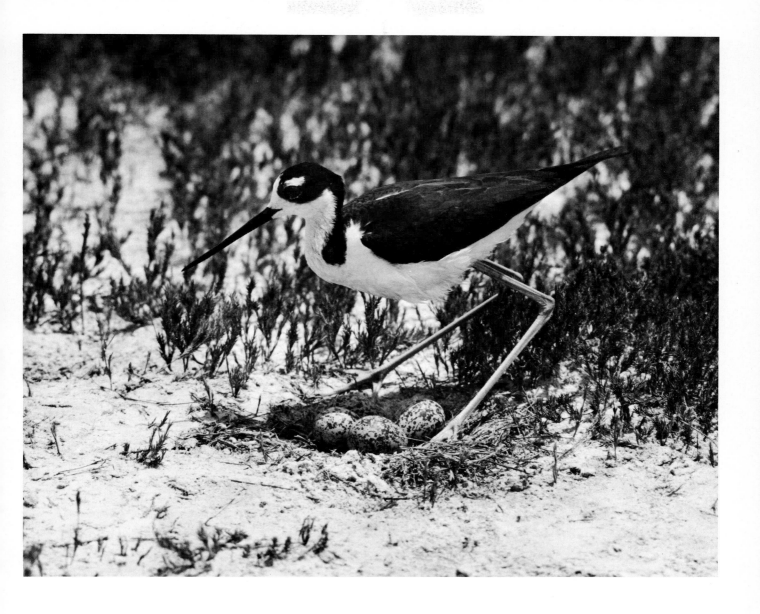

## BLACK-NECKED STILT
*Himantopus mexicanus mexicanus*

With red eyes and legs and a slender black-and-white body, the black-necked stilt has the longest legs of any bird its size in the world. Stilts deserve the term "wader" as few birds do, for their long legs are ideal for wading to feed. The legs are not so perfect on land for there they must be bent for the stilts to pick up insects. They nest all the way from Brazil to southern Canada, choosing marshy places where eggs are often lost by flooding. Both sexes take turns at incubating. At many nests I have photographed, the male has been most reluctant to surrender nest duties to his mate, but she may leave without ceremony when he approaches. Much is made of the responsibility male phalaropes take for caring for the eggs and young, and I wonder if stilts are moving in the same direction. If it is true, it appears to be a decision of the male, determined to take and keep charge of the nest.

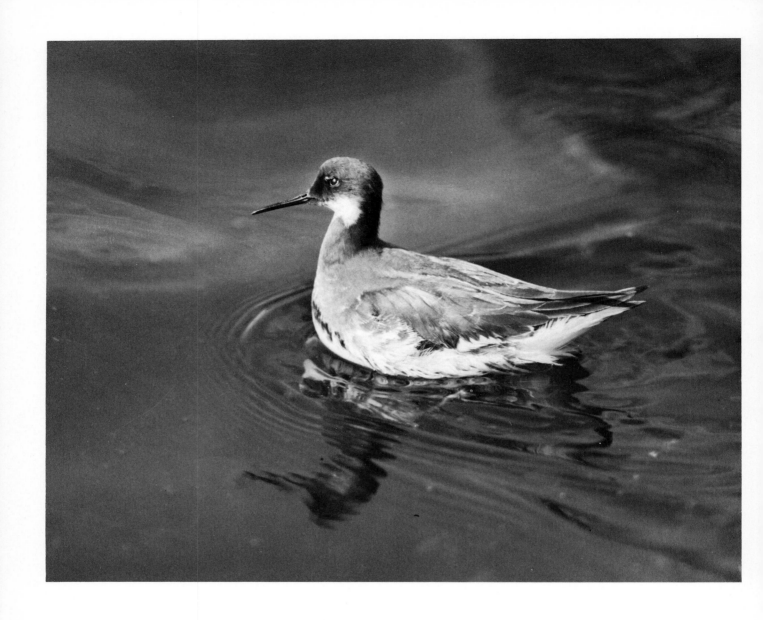

## NORTHERN PHALAROPE
*Lobipes lobatus*

In most birds when the sexes differ in color the male has brighter plumage. He is the dominant individual and the one responsible for most of the advances in courtship. In the phalaropes, however, conditions are reversed. The fe-male is more brightly colored than the male, and she takes most of the initiative in pairing. After egg laying she generally deserts her mate and turns over to him the complete responsibility for incubating the eggs and raising the family.

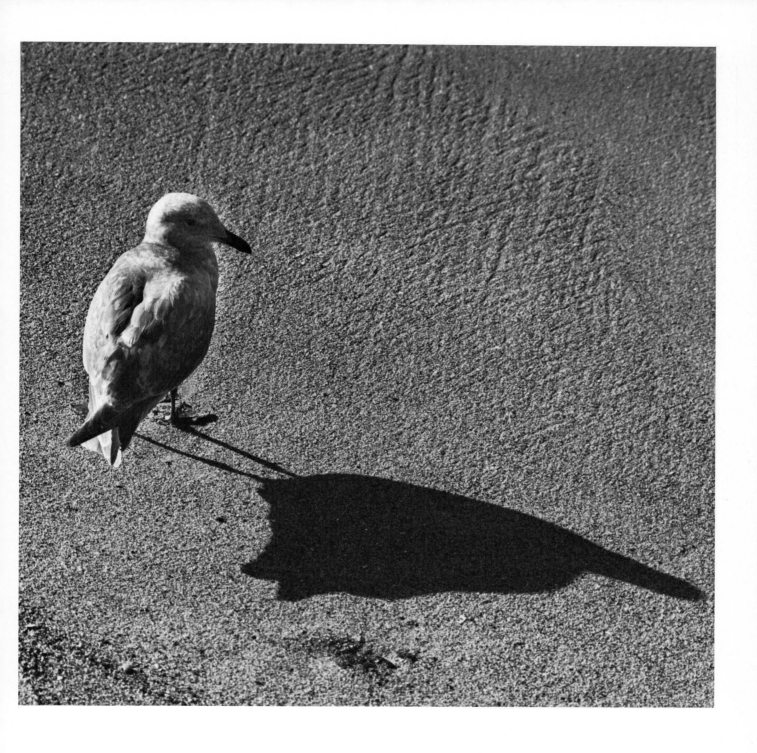

## GLAUCOUS-WINGED GULL
### Larus glaucescens

The glaucous-winged is the most abundant and widely distributed gull on this continent's North Pacific coast. It breeds from Washington to the Bering Sea, wintering as far south as Lower California. Ordinarily in order to obtain good close-up portraits of birds, it is necessary to hide in a blind and wait long hours. Not so in this case. By sitting at the edge of the Santa Monica pier and tossing small fish on the sand, I was able to entice many gulls to gather around me. The result was this photograph of a magnificent glaucous-winged gull casting its long shadow on the beach.

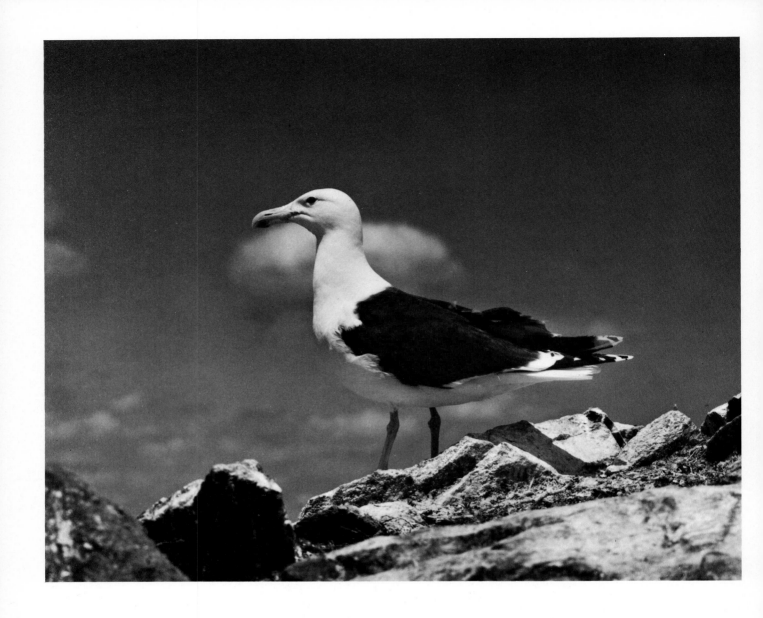

## GREAT BLACK-BACKED GULL
*Larus marinus*

Though always closely associated with the ocean front, this bird's numbers have grown enormously in recent years, and more great black-backed gulls are now observed on inland lakes and rivers. It is the largest, most powerful gull in the world, though its counterpart in the Southern Hemisphere, the kelp gull, not only looks like the great black-back but is about the same size. I have watched it force an osprey to drop a fish it has caught, a feat only eagles usually are aggressive enough to attempt. Its great size, black back and snowy body make it an arresting sight among the less distinctively patterned gulls with which it associates—like most gulls, it is very gregarious. Black-backs prey on the eggs and young both of other gulls and of ducks, and they even catch the adults of such small species as terns and petrels. As their numbers increase, they are occupying islands for nesting and forcing out species that have nested on them for centuries.

96

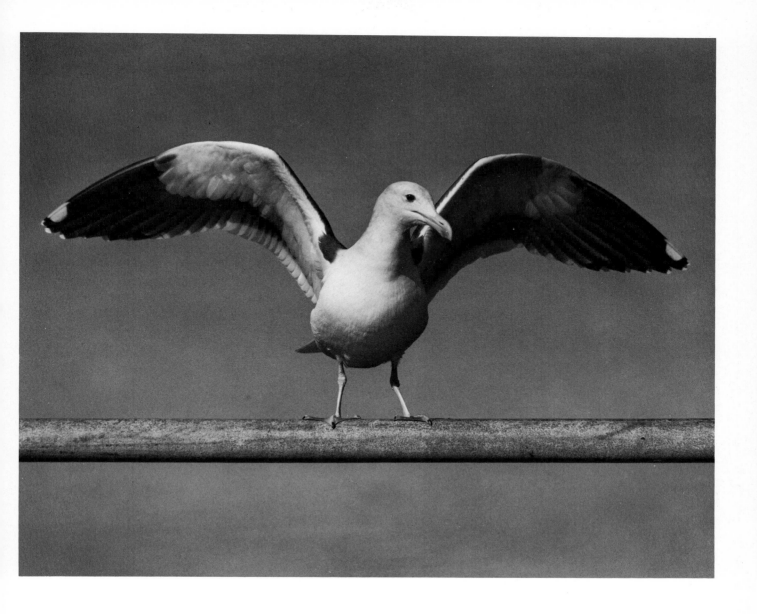

## WESTERN GULL
*Larus occidentalis*

This large, dark-mantled species is quite common along the Pacific coast of the United States. Like all gulls, it has long, pointed wings, which are well designed for fast gliding and enable the bird to remain in the air for long periods of time with very little effort. Although the western gull has a slow, deliberate wing beat of two or three strokes a second, it can travel with great speed. I timed several of these birds flying down the California coast and found that their speed averaged 42 miles an hour.

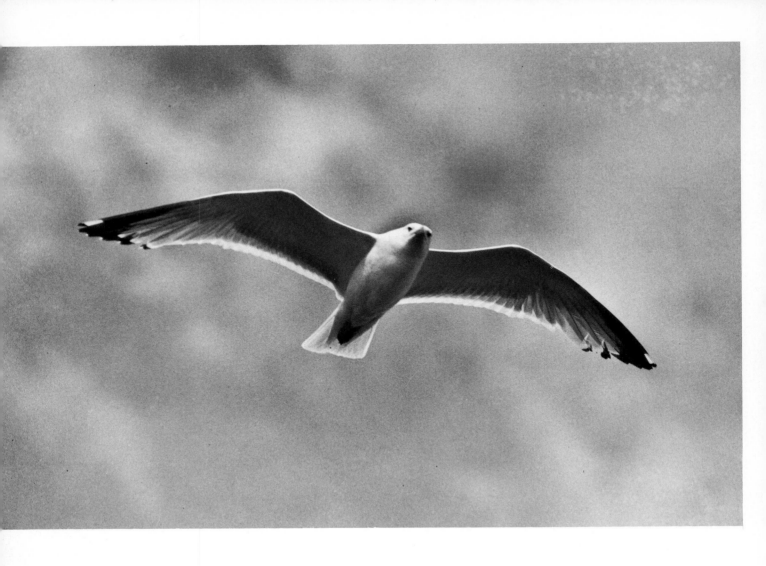

## HERRING GULL
### *Larus argentatus*

Long considered the most common and widely distributed gull in the Northern Hemisphere, the herring gull may have to bow to the great black-backed gull in the future if the numbers of the latter species continue to increase as they have over the past two or three decades. The herring gull is well known, for it frequents beaches, harbors, rivers and city dumps, cleaning up offal and garbage and in general serving man as a useful scavenger. To most people it is the common "sea gull," that name being applied even to those birds seen on the Great Lakes and on rivers, ponds, reservoirs and marshes of the interior.

## YOUNG HERRING GULL
### *Larus argentatus*

Birds may be divided into two major groups: altricial and precocial. The altricial ones, such as robins, orioles and sparrows, hatch naked, blind and helpless and have to remain in their nests for some time, carefully tended by their parents. Precocial birds, like ducks and chickens, emerge from the egg covered with down, with their eyes wide open, and are able to move about as soon as their down dries off. As a general rule birds low on the evolutionary scale have precocial young and birds higher in the scale have altricial young. The fluffy herring gull shown in this photograph is a typical precocial bird.

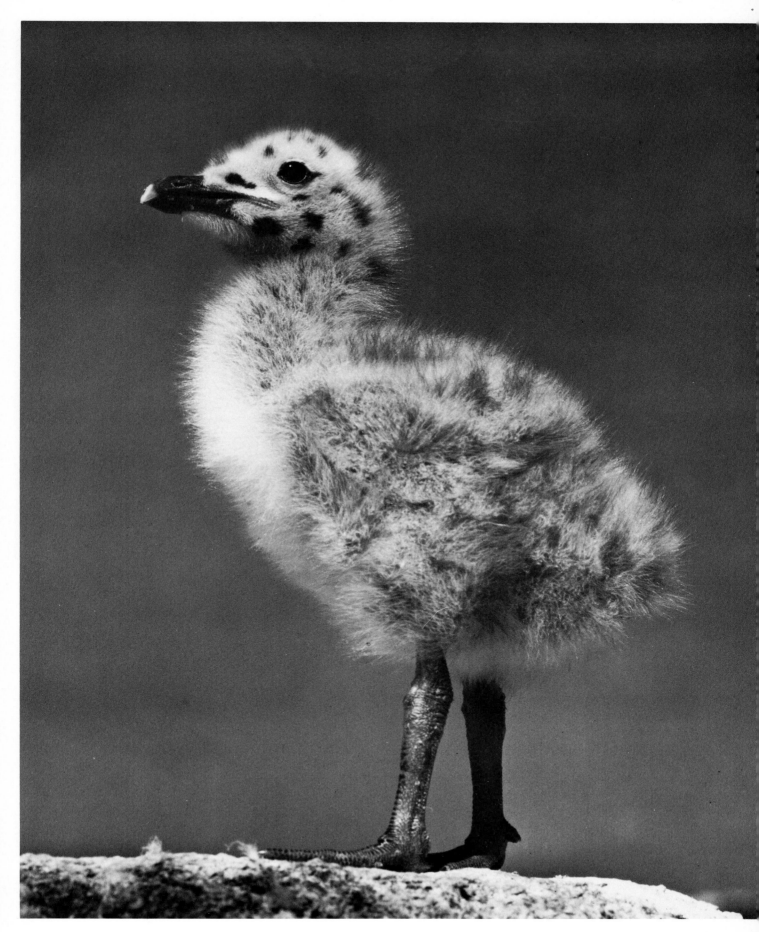

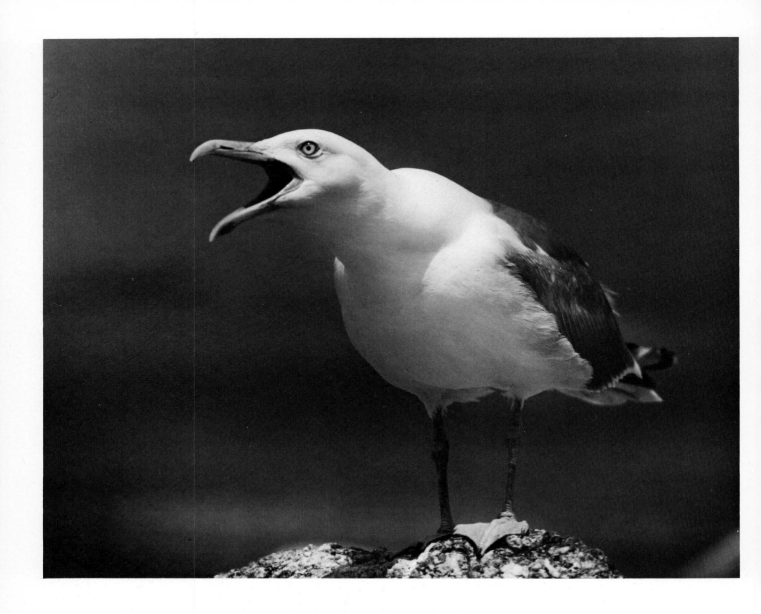

## HERRING GULL
*Larus argentatus*

The raucous cries of a herring gull as it challenges an intruder near its nest, or one of its fellows in winter that would like to chase it from a favored perch, are familiar sounds along our eastern seaboard. The territory of a gull, even though it is but a few square feet of nesting space, is protected diligently from all comers. If a young gull belonging to another family wanders into a protected area, the "owner" of the plot may seize it and shake it until it is dead. This must not be regarded as cruel, for this system of space protection has evolved over countless centuries as the best means for the survival of the species.

100

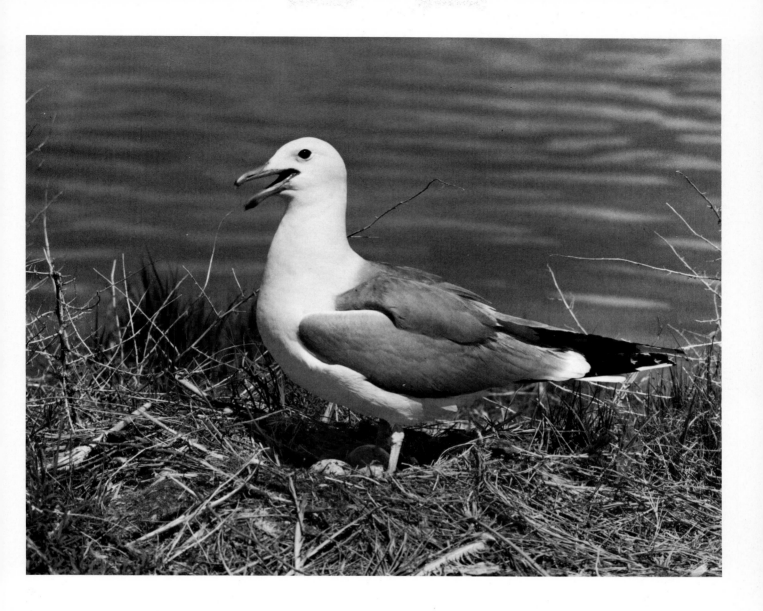

## CALIFORNIA GULL
*Larus californicus*

In 1848 the Mormon settlement at Salt Lake was faced with utter disaster. It had barely survived the harsh winter, and now the tender plants on which the future of the colony depended were being devoured by "Mormon crickets." As if by a miracle thousands of California gulls swept into the fields and saved the vital crops from the voracious insects. The gulls had not, however, made a journey to the Mormon fields from the Pacific Ocean; they nest inland and tens of thousands of them nest on islands in the Great Salt Lake. They are now protected as if sacred by the Mormons, and in Temple Square in Salt Lake City there is a tall monument commemorating the saving of the settlement by the gulls. Their food habits still make them valuable to farmers and ranchers, for they keep many harmful insects under control.

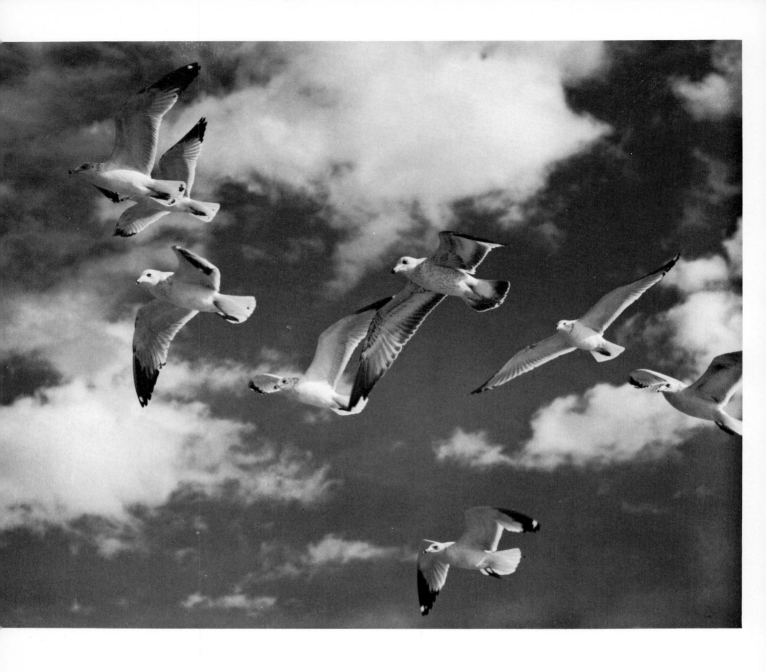

## RING-BILLED GULLS IN FLIGHT
### Larus delawarensis

Gulls are masterly in the air, demonstrating their skill to greatest advantage when wild winds blow. They ride the gale with amazing skill. One minute they are hanging motionless, as though suspended by some invisible thread; the next they are soaring upward with great speed, often disappearing from sight. Reappearing, they scale low with their pinions barely clearing the waves, or advance rapidly against the wind without a single flap of their rigid wings.

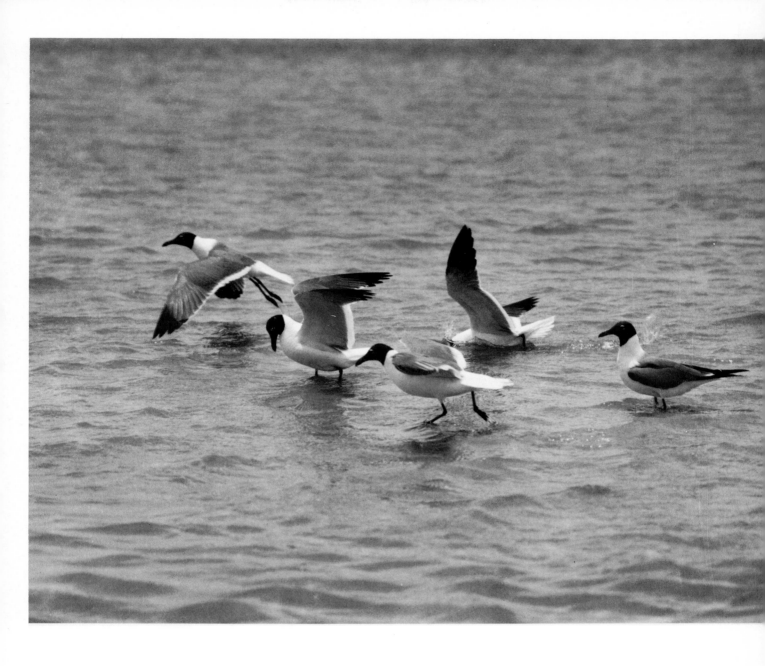

## LAUGHING GULLS
### Larus atricilla

In the breeding season the laughing gull is a handsome creature with its dark gray mantle, black head, white spectacles and a faint rosy tint on an otherwise snowy breast. It is the only species of gull nesting on the South Atlantic and Gulf coasts of the United States. The bird is well named, for its wild stirring call sounds like some feigned operatic laughter. In the South I have frequently seen these birds land momentarily on a pelican's head and snatch fish projecting from the larger bird's remarkable bill.

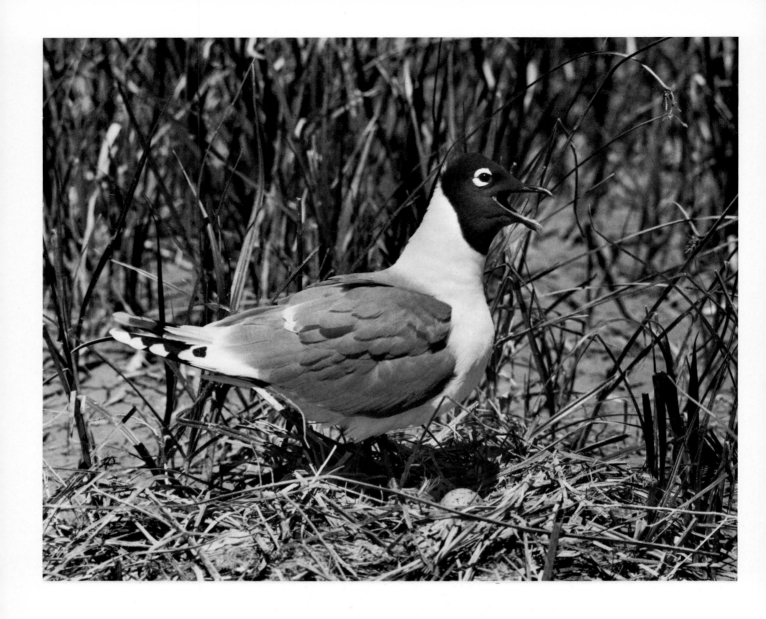

## FRANKLIN'S GULL
*Larus pipixcan*

The Franklin's gull lives inland and is a common bird on the prairies, where it often follows farm machinery to pick up insects. In the winter the laughing gull is common along our South Atlantic and Gulf coasts, while most Franklin's gulls go south of the United States. Those who observe birds often find them doing extraordinary things. One summer at the Bear River Migratory Bird Refuge in Utah, a marsh dried up where a large colony of Franklin's gulls had their nests and also obtained much of their food. The birds led their tiny, downy young for more than two miles to water, over land that was baked so dry and hard that it felt uncomfortably hot even through the soles of my shoes.

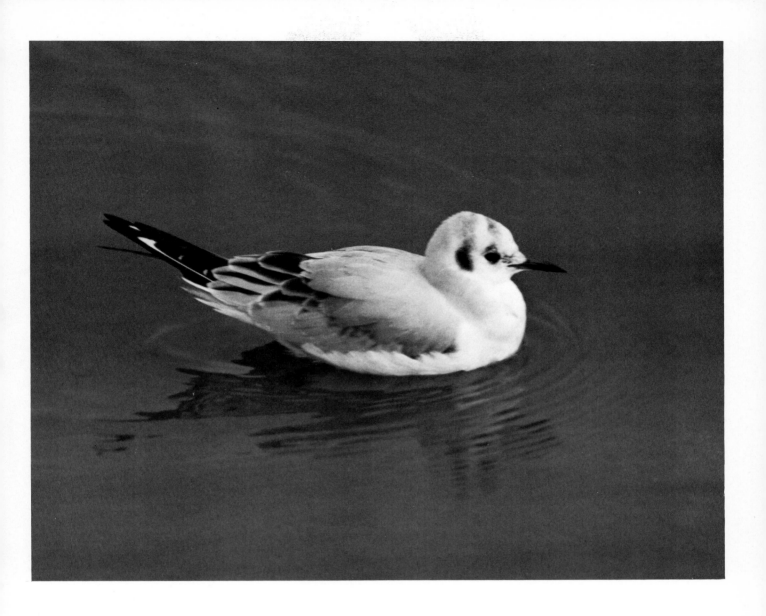

## BONAPARTE'S GULL
*Larus philadelphia*

This smallest of American gulls was named for the eminent zoologist Charles Lucien Bonaparte, nephew of Napoleon I, who for many years lived in the United States. It is graceful even for a gull, being almost as dainty as a tern. *The* *Handbook of British Birds* lists only seven records for this American gull. Imagine, therefore, the lift it gave me to observe one of these familiar birds while traveling in a dreary wartime convoy off northern Ireland.

## HEERMANN'S GULLS AND WESTERN GULLS
*Larus heermanni*
*Larus occidentalis*

Here on a rock off Monterey Peninsula, California, western gulls that look much like great black-backed gulls (though they average ten inches less in length), are resting with a group of Heermann's gulls. The latter are still in breeding plumage and their bills, red with a gray ring near the tip, are still brightly colored. While the Heermann's gull, like most of its family, does a lot of scavenging, more than most species it catches fish that come to the surface. Back in the days when brown pelicans were common on the California coast those birds would locate schools of fish and begin feeding from the surface when large fish drove the smaller ones to the top. Then a Heermann's gull would station itself close to a pelican, and as the latter threw up its bill to swallow its catch the gull would leap forward and snatch it. Adept though it is at catching fish for itself, it takes an easier way to obtain food whenever it can.

106

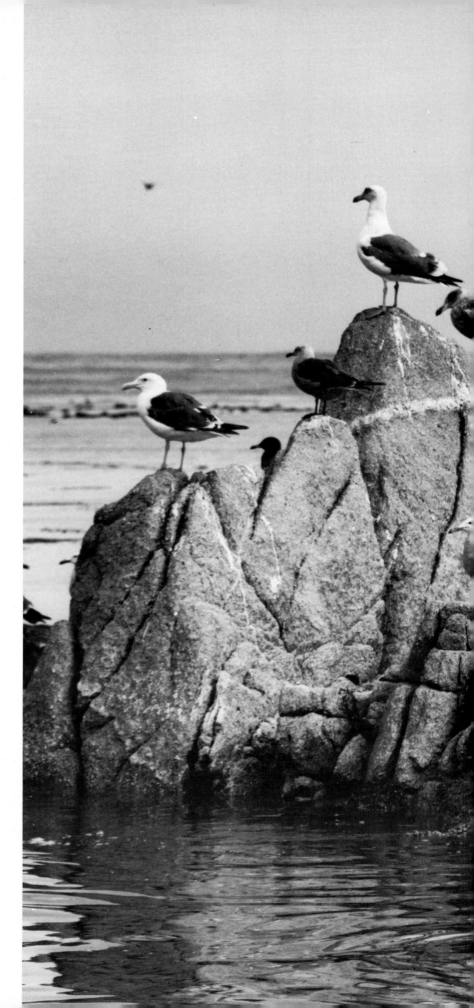

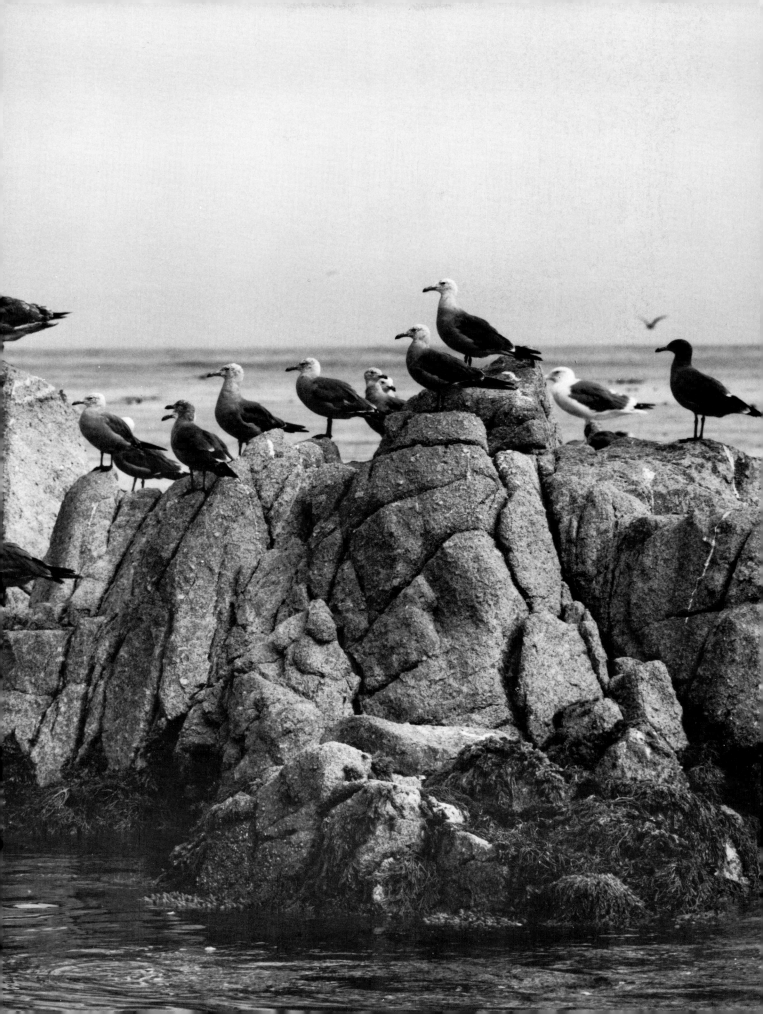

## GULL-BILLED TERN
### *Gelochelidon nilotica*

Unlike most terns, this species has a short, rather stout bill. In the United States it breeds locally and in small numbers along the South Atlantic and Gulf coasts, and on the Salton Sea of southern California. It also differs from most members of its family by feeding to a great extent on insects, which it gathers in the marshes or snatches from the air. Its rasping call is suggestive of chattering laughter. In fact, its scientific name, which it inherits from an Old World relative, literally means "laughing swallow of the Nile."

## FORSTER'S TERN
### *Sterna forsteri*

This dainty tern is widely but sparsely distributed over the United States, nesting either in fresh or saltwater marshes. In the days when the feathers of these and other terns were used to decorate ladies' hats they were reduced to the verge of extinction. One queer habit of these birds made them extremely vulnerable to destruction. When one of them was shot and fell fluttering to the ground or water, all the other terns in the neighborhood would rush over and hover above the wounded bird as though wishing to help. In these concentrations they made easy targets for the plume hunters crouching below.

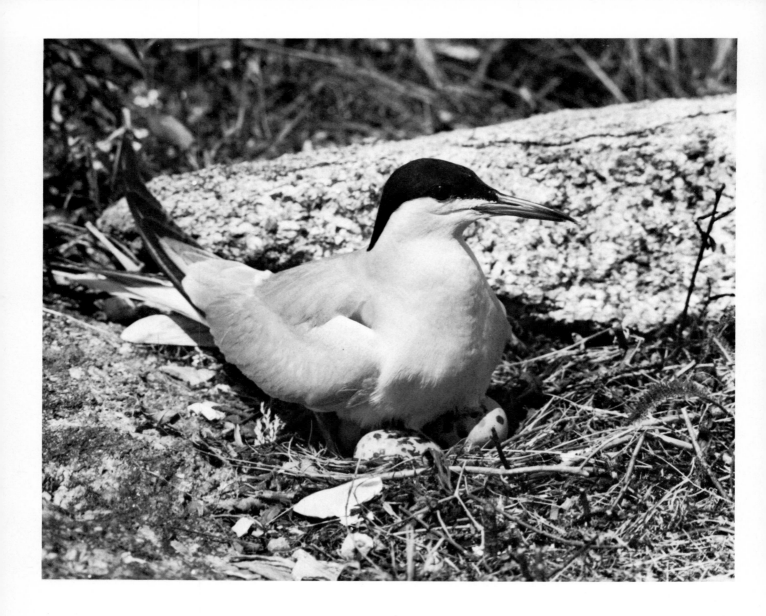

## COMMON TERN
*Sterna hirundo*

The common tern breeds on every continent except Australia. Because of its long forked tail and graceful buoyant flight it is widely known as the sea-swallow. Fishermen in the North Atlantic prefer to call it the mackerel-gull, for it frequently guides them to concentrations of these tasty fish. When great schools of voracious mackerel chase fry to the surface, terns spotting the commotion rush to feast on the smaller fish. Fishermen have learned what these tern gatherings indicate, and speed to the scene with line and bait.

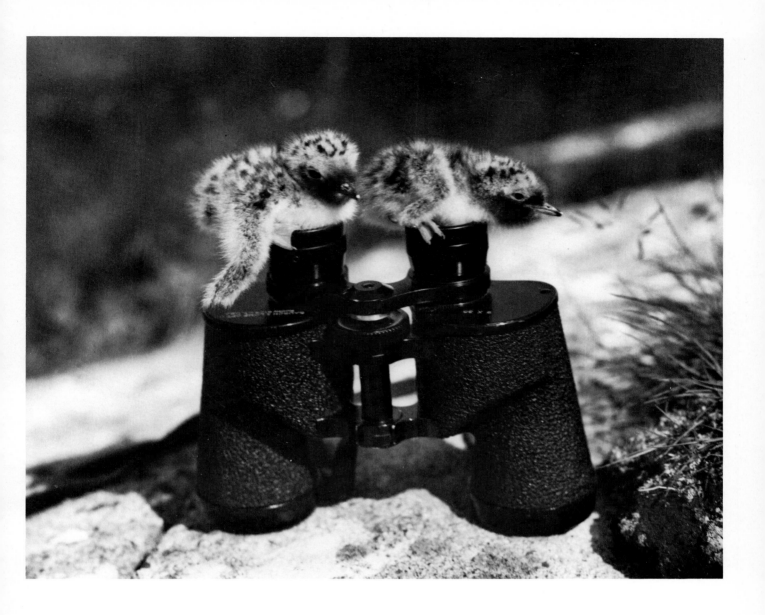

## ARCTIC TERNS
### *Sterna paradisaea*

Though unrecorded over great areas, the Arctic tern is probably the most widely distributed species of bird in the world. It sees more hours of daylight in a year than any other bird and is the champion long-distance traveler of all our avifauna. The birds breed in the northern part of the Northern Hemisphere, many within the Arctic Circle and some only 450 miles from the North Pole. They pass the winter in the southern part of the Southern Hemisphere and occasionally wander as far south as the Antarctic.

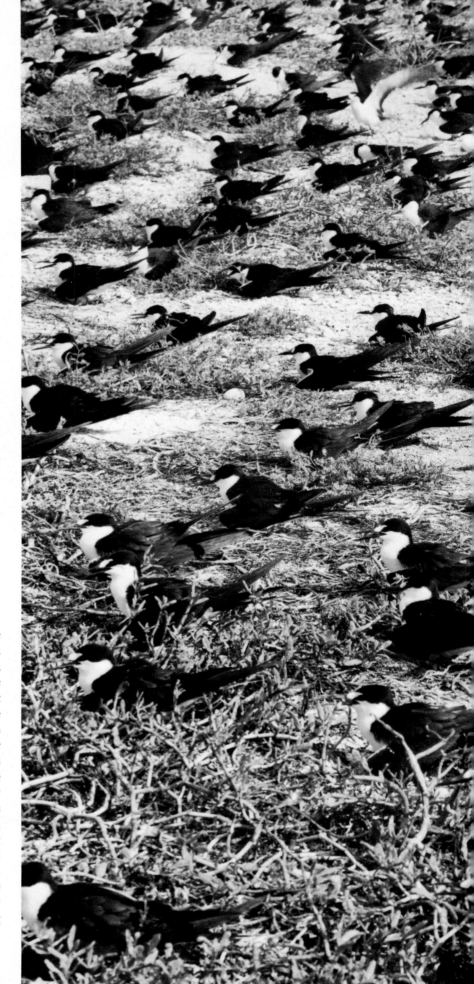

## SOOTY TERNS
### *Sterna fuscata*

Tropical seas are the normal home of these small terns but hurricanes have blown them as far north as Nova Scotia. They nest in territories scarcely two feet square on the Dry Tortugas off the Florida Keys. If a gust blows one off target when landing in the midst of the crowded colony a rumpus erupts and quickly involves a hundred or more terns in an uproar of flapping wings and earsplitting screeches. They are active day and night, and because of this many people call them wide-awakes. As soon as nesting is over they vanish from their island homes, and nobody knows for sure where or how they spend their months of freedom from nest duties. Their feathers lack water-proofing oil so they cannot settle on the water, and they are not known to visit any land; therefore it is supposed that during that time they must sleep on the wing.

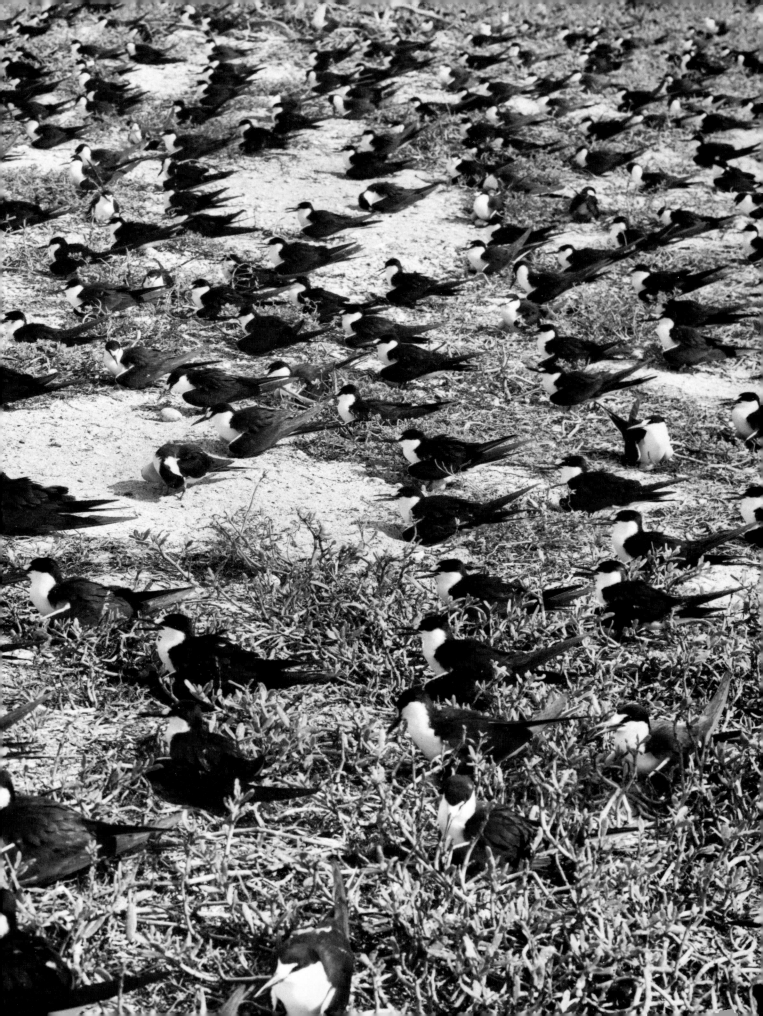

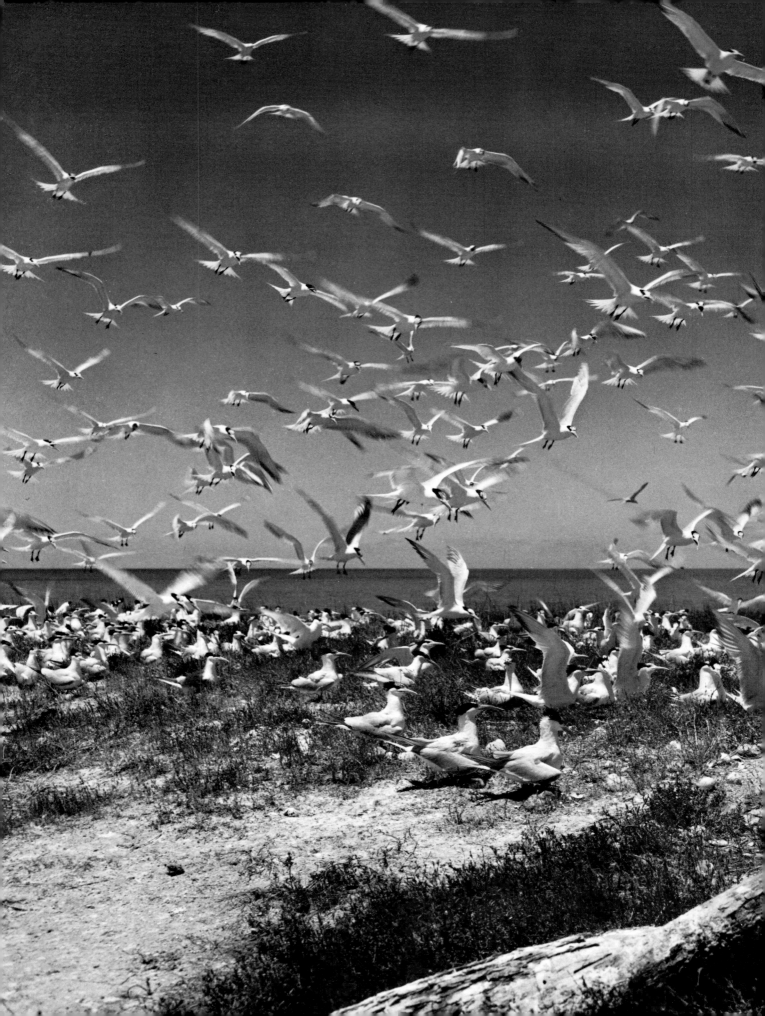

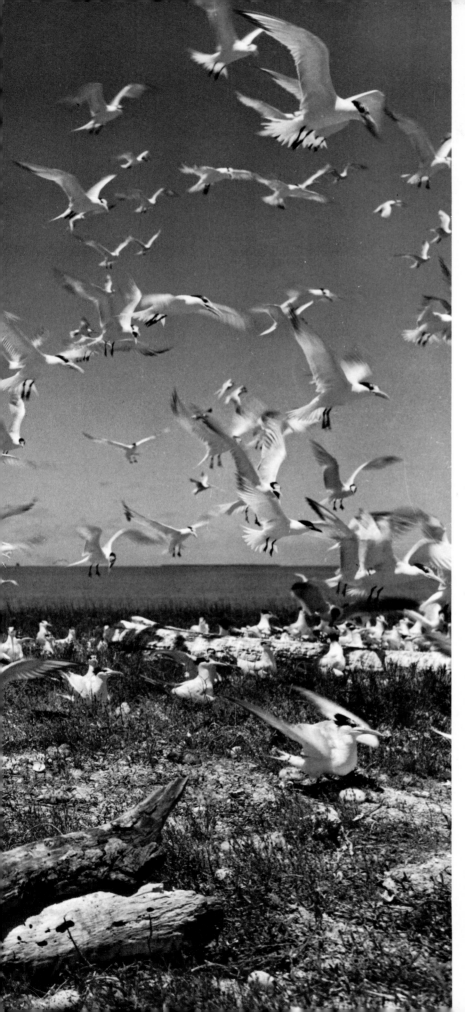

## ROYAL TERNS
### *Sterna maxima*

This is our second largest tern. It is strictly a saltwater species and often fishes far from land. Its body is snowy white and its mantle pale gray. The tail is deeply forked, the bill yellow to orange, and it has a black crest on the back of the head. In some, the forehead is white, in others it is speckled with black and occasionally is solid black.

My first time in a great colony of royal terns was a miserable experience. This was on Lydia Ann Island not far from Corpus Christi, Texas, and as I entered my blind I anticipated a joyful day of entertaining bird-watching and photography. Certainly the colony was full of activity, with terns so closely packed that it looked as if a white blanket had been spread over it. The excitable birds were constantly leaping into the air, forming a snowy, whirling cloud. But instead of pleasure, the day was one of endurance as my ears were assaulted by the incessant, strident, earsplitting cacophony. The terns stood over their hatching eggs, bills pointed upward, and screamed. I urge anybody who plans to photograph in a royal tern colony, especially at hatching time, to take along a supply of ear plugs.

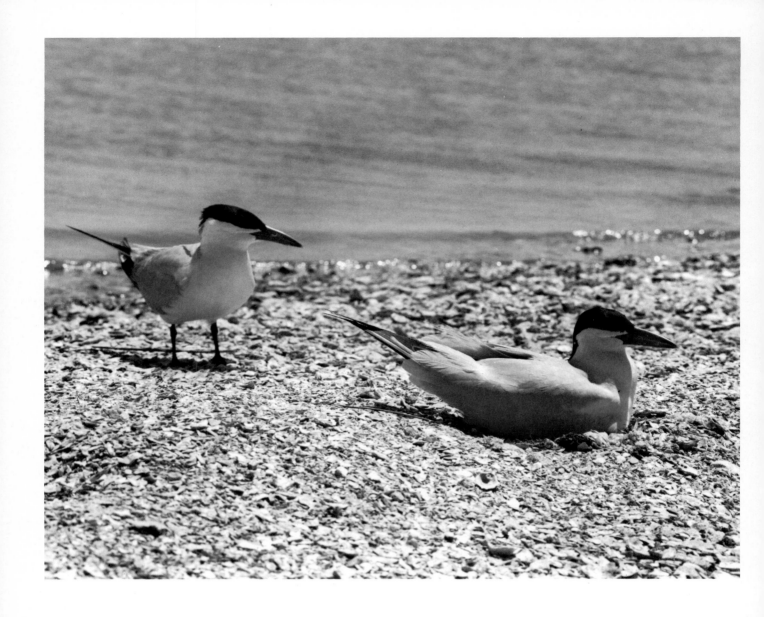

## CASPIAN TERNS
*Sterna caspia*

Of all our terns, the Caspian not only is the largest but the most solitary and gull-like. It looks much like a royal tern but its large bill is coral red and its tail less deeply forked, and unlike the royal, which is strictly a saltwater species, the Caspian often nests on islands of inland lakes. Though in general these birds often nest in small groups, this pair of Caspian terns nested alone on the gravel and shell of a narrow reef in Matagorda Bay off the coast of Texas. Caspian terns occur in many parts of the world: in Australia, around the Mediterranean, in Mongolia, and even in offshore East Africa. It is one of the comparatively few species of birds nesting in North America that an observant traveler may see in a suitable habitat wherever he goes.

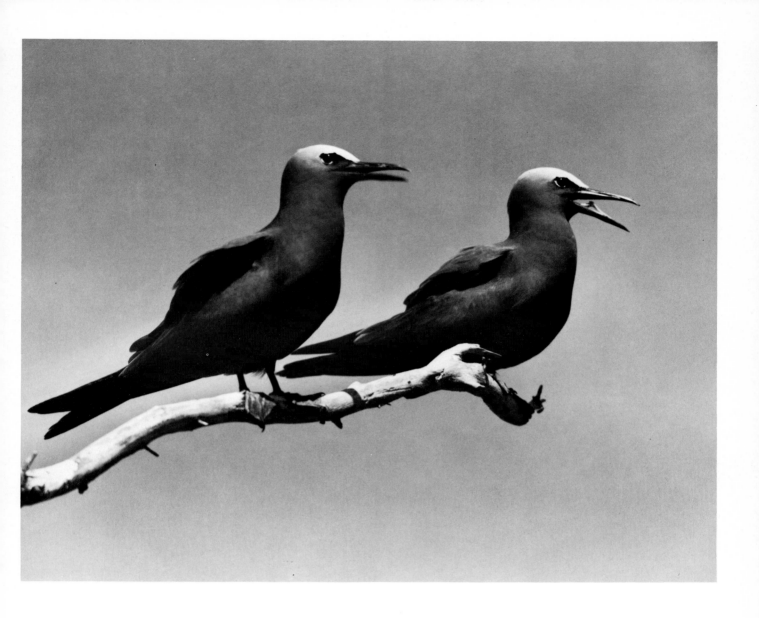

## NODDY TERNS
### Anous stolidus

This dark chocolate tern with a white forehead and crown is restricted to tropical seas on both sides of the equator. In the strictly tropical parts of its range it is reported to nest any month of the year. This pair of noddy terns was photographed in May on the Dry Tortugas, some 60 miles west of Key West, where they nest only in late spring and early summer when the temperature is truly torrid. They arrive in late April and go through an elaborate courtship ceremony in which a small fish held by the male often plays an important part. The only nests I saw were in bushes at the edge of a sooty tern colony but it is said that they often nest on the ground. They never come to land except to nest, and like the sooty tern, their whereabouts after nesting are a mystery.

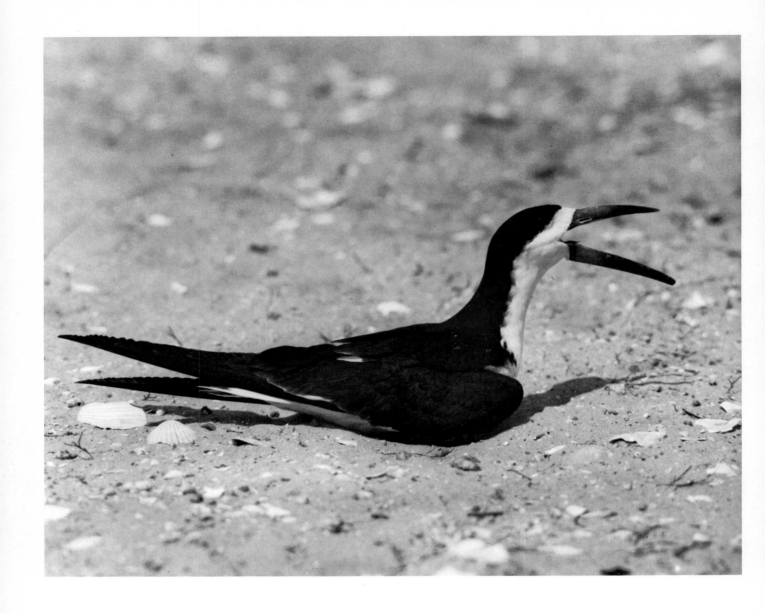

## BLACK SKIMMER
### *Rhynchops niger*

There are only three skimmers in the world and of these our black skimmer is the largest. The knife-like bill is flattened vertically, and they are the only birds whose upper mandible is shorter than the lower one. Their method of fishing makes this odd bill a perfect tool, for they fly close to the water with the lower mandible slicing the surface with an audible zip. When a fish is scooped up the short upper mandible closes to hold the slippery catch. Many a night I have listened to the bark of skimmers as they set out to feed in one of the Everglade rivers, sounding remarkably like a pack of hounds. No doubt most of their food is caught by feeling rather than by seeing their prey. For the daytime, however, nature has endowed them with vertical pupils that contract to mere slits in the brilliant light of their resting and nesting places on white sandy beaches.

## YOUNG BLACK GUILLEMOT
*Cepphus grylle*

Imagine my astonishment at seeing a fledgling of this species that had never been in the water plunge into the Gulf of St. Lawrence, dive without a moment's hesitation, and swim expertly beneath the surface for over a hundred feet. On its first attempt it had complete confidence and performed just as though it had practiced for years. Such is the instinctive ability of birds. Fishermen usually refer to the black guillemot as the sea-pigeon. It breeds chiefly along the rockbound shores on both sides of the North Atlantic south to the seagirt islands of central Maine.

## WHITE-WINGED DOVE
*Zenaida asiatica*

There are 287 species of doves (pigeons) in the world. All have stout bodies and small heads, but they range in size from six inches to three feet, and in color from pale gray to bright rainbow hues. White-winged doves are especially abundant in mesquite and palo verde thickets of the southwestern desert. There they sometimes nest in large, very noisy colonies, though solitary nests are also found.

Those who watch birds at feeders often wonder why doves have become associated with peace, for even tiny ground doves will fight birds three times their size in an attempt to monopolize any food supply. Ever since Noah sent a dove to bring back news of the subsiding flood waters, however, their remarkable sense of direction has been utilized in a number of ways, and to this day the military uses them to carry messages quickly and safely.

## MOURNING DOVES
### Zenaida macroura

Of the doves of the United States, *macroura* is the best-known and most widespread. It readily accepts suburban areas and is also found on farms and ranchlands. It is the most frequently seen species feeding beside the highways when one drives from coast to coast, for it thrives wherever weed seeds and waste grain are abundant. In fact, many people believe it has benefitted by erosion, overgrazing, and other results of man's foolish abuse of the land. I have found their nests in orange trees in Florida, in pines in Michigan and on the ground of grazing prairie in Montana. The fat squabs in this photograph are almost ready to fledge from their flimsy nest in Colorado. They were fed when very young on "pigeon milk," a substance secreted in the crops of the adults, and later they consumed partially digested food which the parents regurgitated.

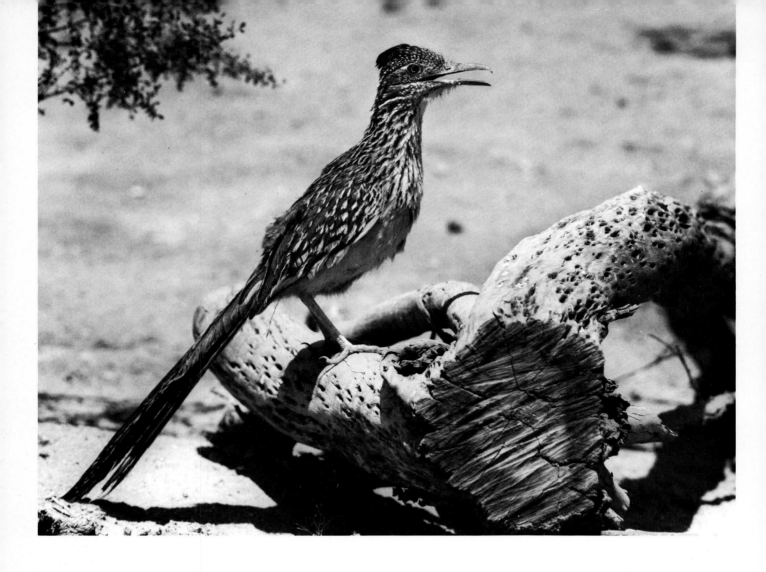

## ROADRUNNER
### *Geococcyx californianus*

The sight of a roadrunner is greeted with more enthusiasm by travelers in the southwest than that of any other bird. It belongs to the cuckoo family but has no apparent relationship to the cuckoos we know in the eastern United States. There is always a comic air about the roadrunner. It has very strong legs and when stretched to the full extent of its nearly two-foot length it reminds one of a race horse. It can maintain a speed of 15 miles an hour for short distances. Its favorite foods are lizards and snakes, with small rattlers often being on its menu. If the catch, which is swallowed head first, is really long, the tail end often dangles from the roadrunner's bill for some time after the front is well on the way to being digested. Unfortunately it often eats young game birds, so many hunters are its implacable enemy: they do not want to share any quail with the roadrunners. Often a roadrunner stares when surprised and, as its excitement grows, its crest rises and a triangle of white skin behind the eye turns blue and then bright red.

## BARN OWL
### *Tyto alba*

The barn owl may well be called a flying mousetrap. Careful scientific investigations have proved that it lives almost exclusively on rats, mice and other small rodents. Dr. A. K. Fisher of the Smithsonian Institution examined 454 skulls taken from barn owl pellets. He found these to represent 225 meadow mice, 179 house mice, 20 rats, 20 shrews, six jumping mice, two pine mice, one star-nosed mole, and one vesper sparrow. Many people have queer prejudices against owls. Such dislikes are unjustified, for not only are these birds extremely interesting but they are decidedly useful to man.

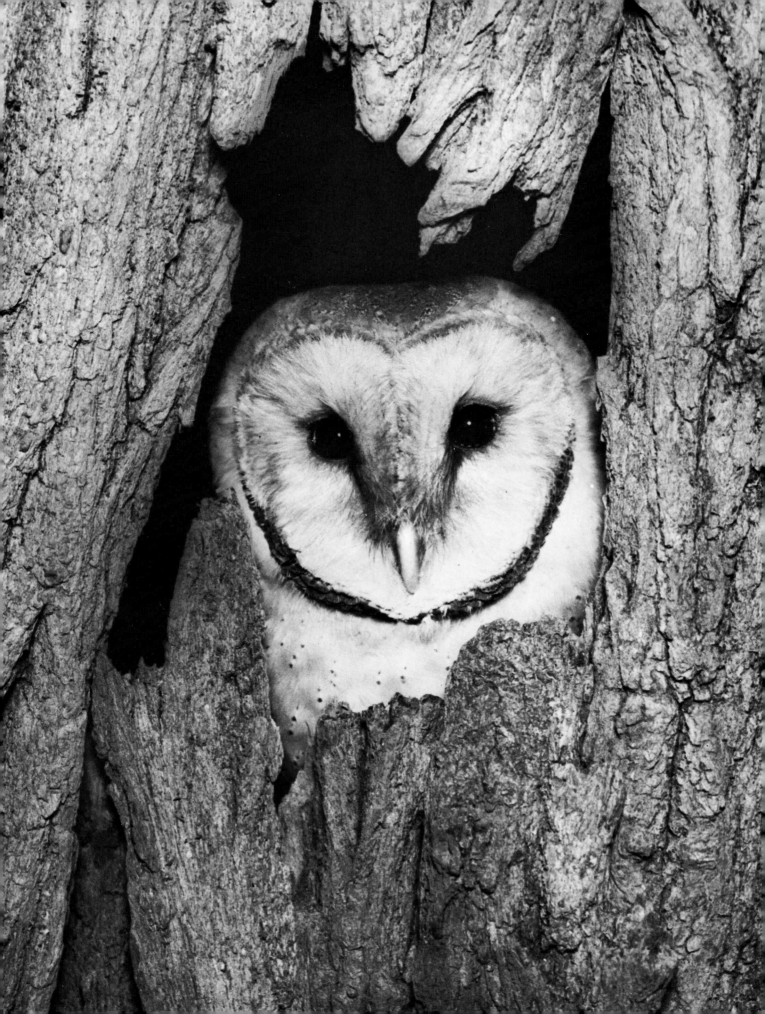

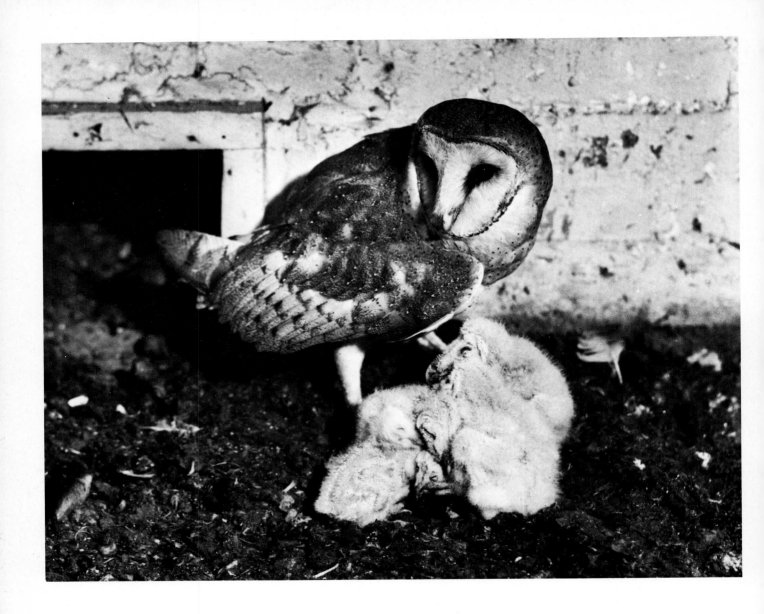

## BARN OWL AT NEST
### *Tyto alba*

This flashlight photograph of a barn or monkey-faced owl standing over its young was taken at two o'clock in the morning in the attic of an old deserted house on the outskirts of New York City. The photographer hid behind an improvised rubbish pile for several hours waiting for the old bird to return. The nest, giving a graphic picture of the bird's diet, was made entirely of regurgitated bones and fur from rats and mice.

## SCREECH OWL
### *Otus asio*

The little ten-inch screech owl nests in the natural cavities of trees and in old woodpecker holes, but it often accepts boxes placed close to homes even in highly developed suburban areas, where it makes a fascinating neighbor. Certain sounds encourage them to sing, and I once had one in my garden that especially liked Tchaikovsky's symphonies. One evening it perched on the edge of an open awning window and accompanied the entire record of Tchaikovsky's *Pathétique*, its quavering wail rising and falling with great enthusiasm. Like most owls, their large eyes give them a wild and strange aspect. The owl was the bird of the goddess Athena and was highly regarded by the ancient Greeks, but, oddly enough, many people in this country have been afraid of owls and believed its calls were an omen of death. Screech owls occur from Alaska to Maine and southward to the Gulf states.

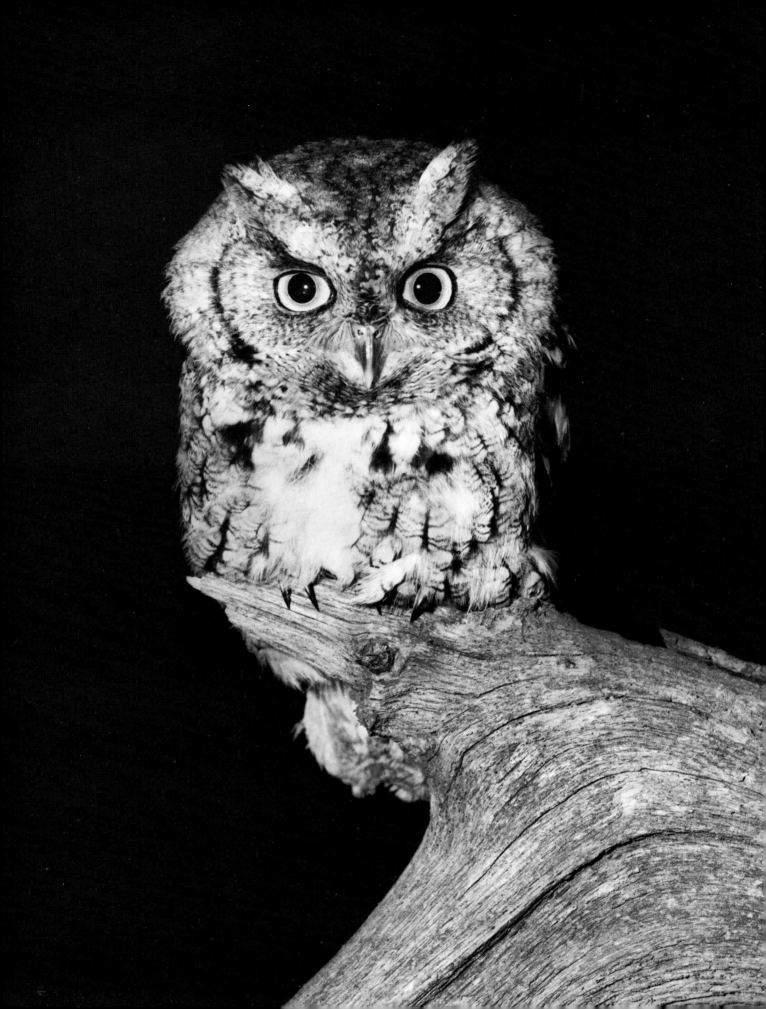

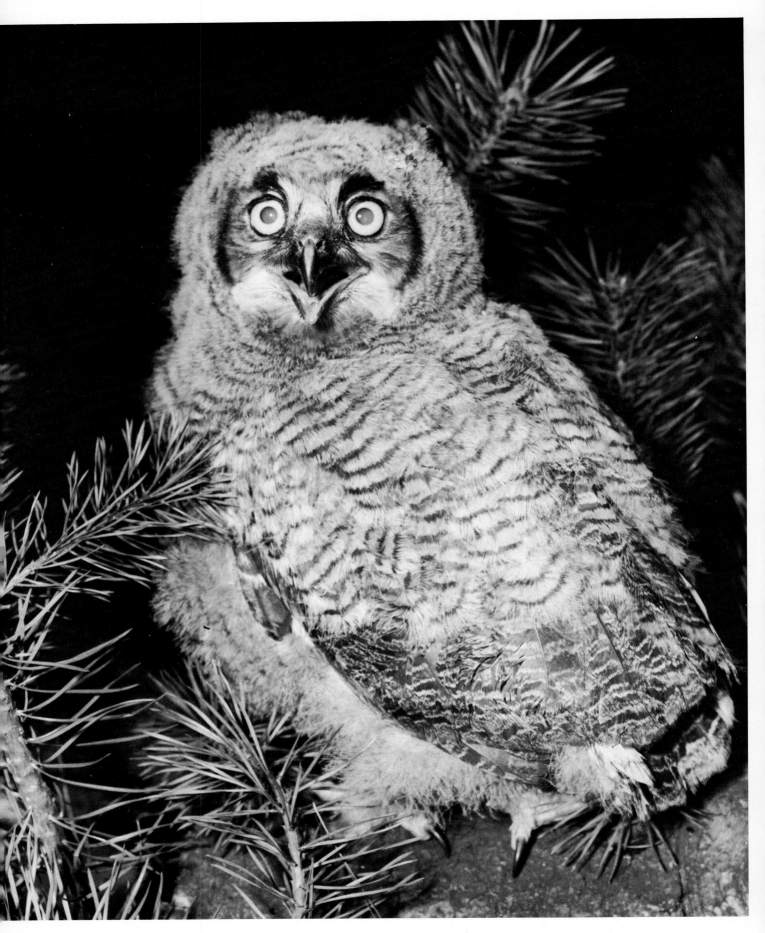

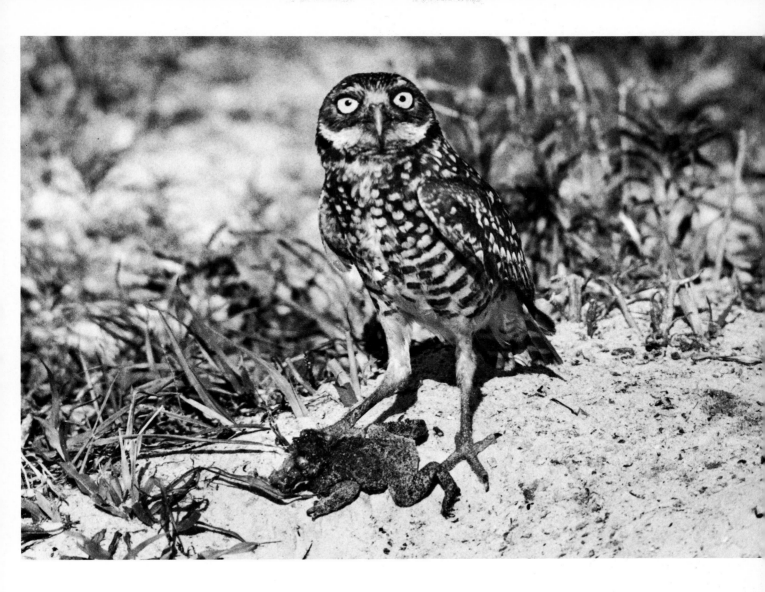

## GREAT HORNED OWL
### Bubo virginianus

This is our largest owl with "horns." It occurs across the entire continent. A low bass hooting is part of its courtship, which begins very early, and in Florida its duets are best heard on moonlit nights in November and December. Some scientists have claimed that since the great horned owl's hoot is so low-pitched, it follows that they cannot hear high-frequency sounds. This, however, cannot be the case, for clearly they are able to hear the high-pitched squeaks of rats and mice—one owl, upon examination, was found to contain 11 rats! Great horned owls often occupy hawk and eagle nests, and since their breeding time comes first, they are able to repel the rightful owners with a show of their powerful claws. Moreover, anybody who tries to band their young runs the risk of a dangerous attack. In spite of this stalwart defense by the adults, nests can be destroyed, and the downy young are sometimes rescued by humans and have made gentle pets.

## BURROWING OWL
### Speotyto cunicularia

In a family thought of as nocturnal, the burrowing owl appears to be almost exclusively diurnal. It is a bird of open country and the prairies. In Florida some have even found airports acceptable nesting places. They dig burrows by scooping out earth with their feet, but they also like ready-made burrows found in prairie-dog towns. Lubbock, Texas, for example has enclosed a large prairie-dog town with a concrete wall. Prairie dogs romp about, delighting the people who come to watch them—but there is more to see. In the summer when the young burrowing owls are feathered, nearly a hundred of them are in evidence at a time, some standing in the shade of a bush, some gathered on the mound of a burrow they have occupied, and others staring with bright yellow eyes from the burrow's entrance. These eyes are fixed in the sockets and, to compensate for this, the owl is able to twist its neck a full 180 degrees.

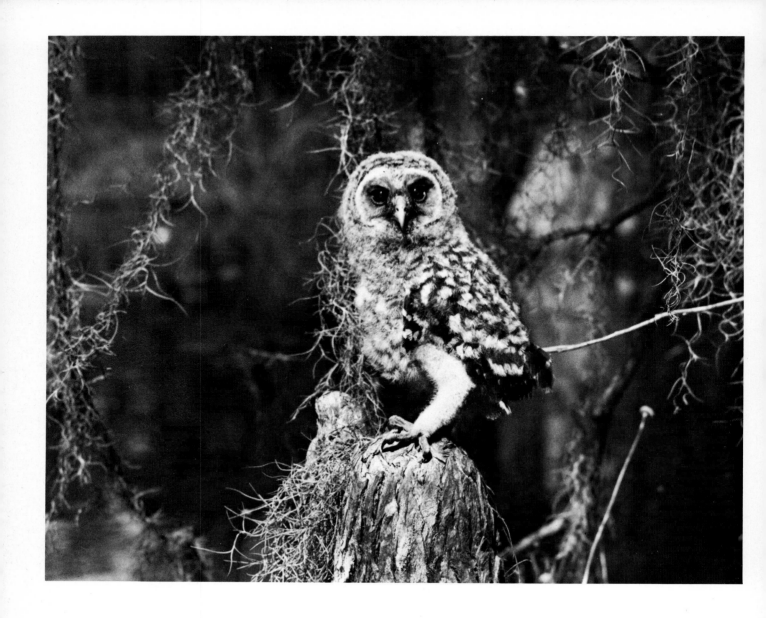

## BARRED OWL
### Strix varia

The barred owl is widely distributed over most of North America east of the Rocky Mountains. In many sections it is fairly common and, since it is a loquacious bird, its eight-syllabled baritone hooting is well known. It is the species most frequently referred to as the hoot owl. Contrary to what most people believe, owls can see in the daytime and many species, including the barred owl, hunt regularly during the day. This photograph of a young one perched on a cypress knee in a setting of delicate "Spanish moss" was taken in the depths of the great Okefenokee Swamp in southeastern Georgia.

## SAW-WHET OWL
### Aegolius acadicus

One evening in Maine I was positive I heard the deliberate, evenly spaced, monotonous notes of a saw-whet owl. I looked for the bird and found that the sounds were made by a farmer sharpening his saw. Thus experience taught me that this bird has a most appropriate name! The species breeds chiefly in the Canadian zone of North America and is known over the greater part of this country only as a winter visitant. It is one of the smallest owls in the United States, comparable in size to a wood thrush.

128

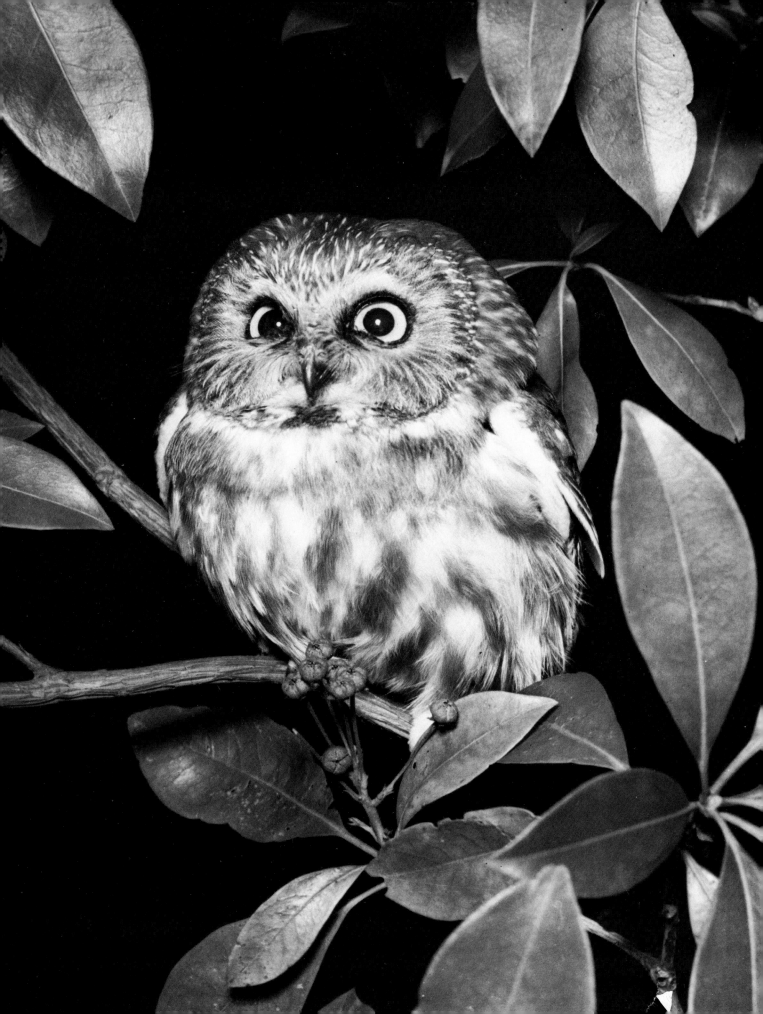

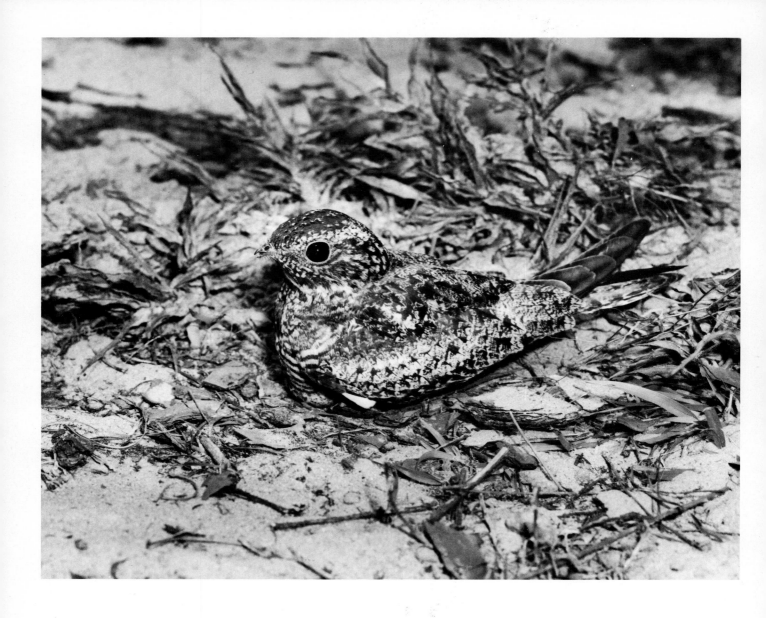

## COMMON NIGHTHAWK
*Chordeiles minor*

A nighthawk incubating its eggs, perhaps on brown leaves or even on bare ground, blends so well with its surroundings that many people walk within a foot or two of it without seeing it. Nighthawks are active at dusk and before dawn but they are not hawks. The family name, goatsucker, stems from an ancient superstition that these birds, with their tiny bills and enormous mouths, sucked milk from goats, and caused them to go blind. They are also called nightjars from the habit of some of the family to repeat over and over again a short monotonous phrase. Whip-poor-wills and chuck-will's-widows are also especially notorious for repetitive calling at night, and the calls of some tropical species are so weird that they are regarded with fear. Nighthawks are highly efficient insect catchers. During courtship their graceful, bounding flight is accented with sudden plunges that terminate with a boom as the male pulls out of a fast dive. Most birds perch at right angles to a branch or wire but nighthawks sit parallel to it.

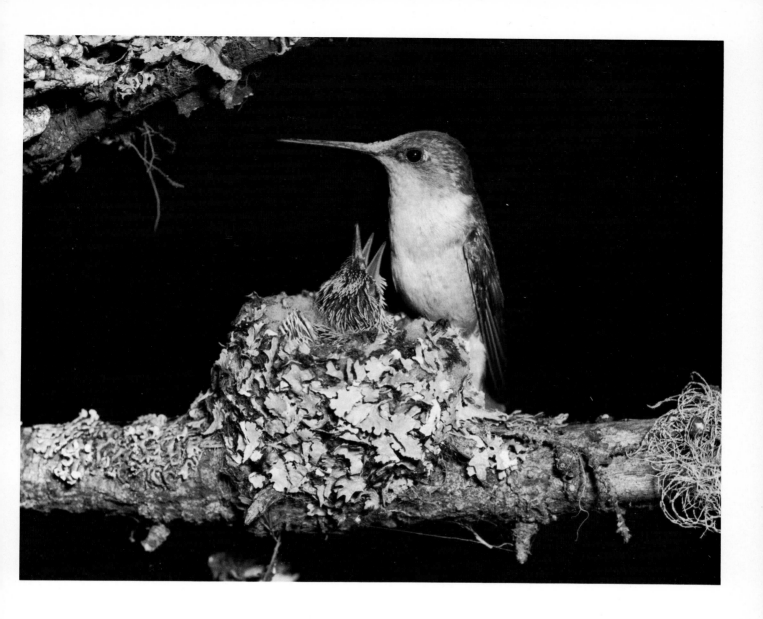

## RUBY-THROATED HUMMINGBIRD
*Archilochus colubris*

All 319 species of this glittering family live only in the Western Hemisphere. They congregate commonly near flowers from which they obtain nectar, a substantial part of their diet. The largest of these tiny birds is the 8½-inch giant hummingbird of the Andes, though the long tail of the streamertail of Jamaica gives it a length of 9½ inches. The bee hummingbird of Cuba, at 2½ inches, is the smallest bird in the world. Most hummingbirds glitter with rainbow colors, and this led to the slaughter of millions in the nineteenth century, when their bright feathers were used in jewelry. One spring I hung sugar water in front of a cabin in the Santa Rita Mountains of Arizona and half a dozen species visited it daily. Only the ruby-throated hummingbird nests in the eastern United States, and the nest is so tiny it can be covered by a bottle cap. The eggs are the size of small peas. Though the ruby-throat weighs about the same as a penny, some regularly fly nonstop 500 miles or more across the Gulf of Mexico each spring and fall.

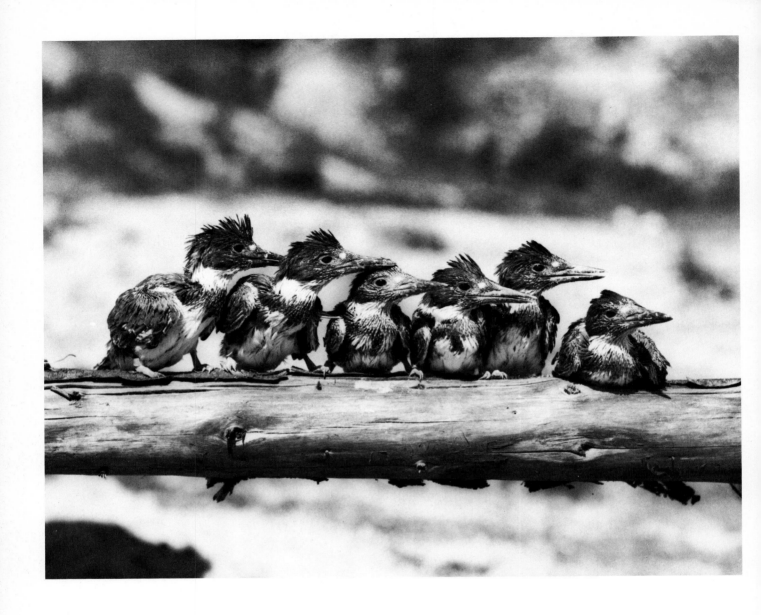

## BELTED KINGFISHERS
*Megaceryle alcyon*

Generally belted kingfishers nest at the end of a four- to 12-foot tunnel which they dig in the side of a bank, but according to Greek mythology kingfishers built their nests on the water. The myth tells us that Halcyon was the daughter of Aeolus, god of the winds. Because of her grief for her dead husband, she was turned into a kingfisher like her beloved one. Thereafter Aeolus quieted the waves for a period each year so that his daughter might build her nest upon the water; thus the popular expression, halcyon days.

## COMMON FLICKERS
*Colaptes auratus*

The flicker is one of the most widely known woodpeckers in North America and possesses more than 125 nicknames. Although a woodpecker, it spends much time on the ground, and ants constitute fully 50 percent of its food. Moreover, it is one of the few birds that devour great quantities of destructive European corn borers. Like most members of its family, it drums a loud rolling tattoo. This is delivered with special vigor and persistence when the season comes for the bird to announce its territorial claims. One spring a bird near my home discovered that a tin ventilator on a barn was a much better sounding board than any branch. Each morning at dawn his startling riveting-machine reveille would awaken the entire family.

132

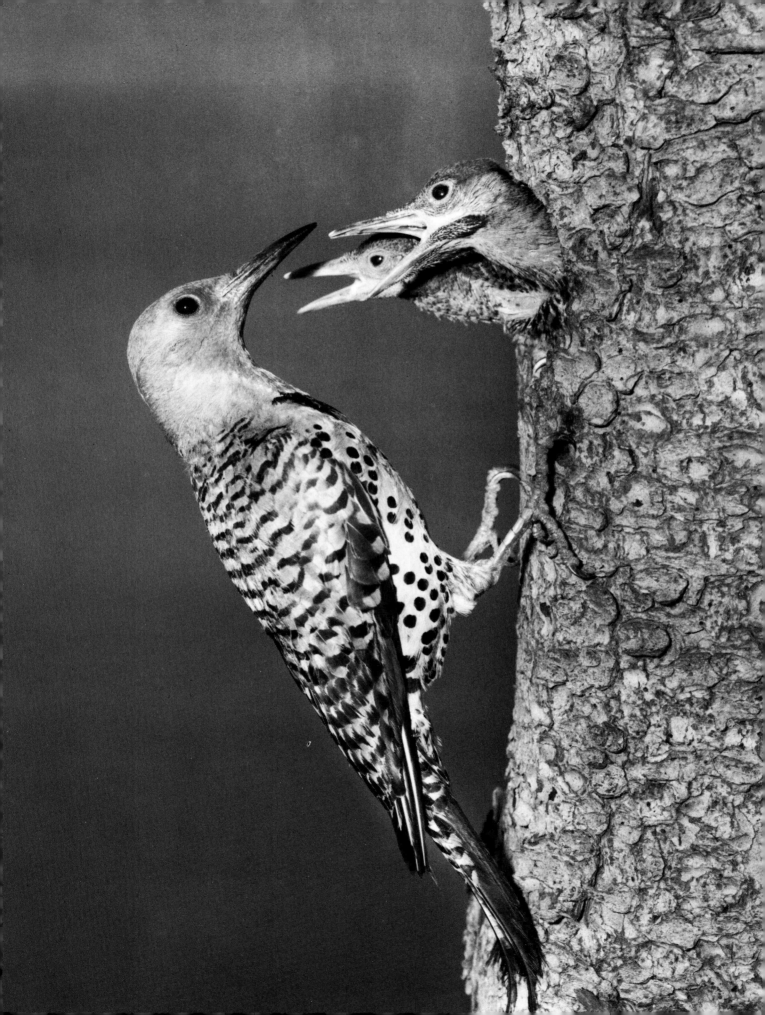

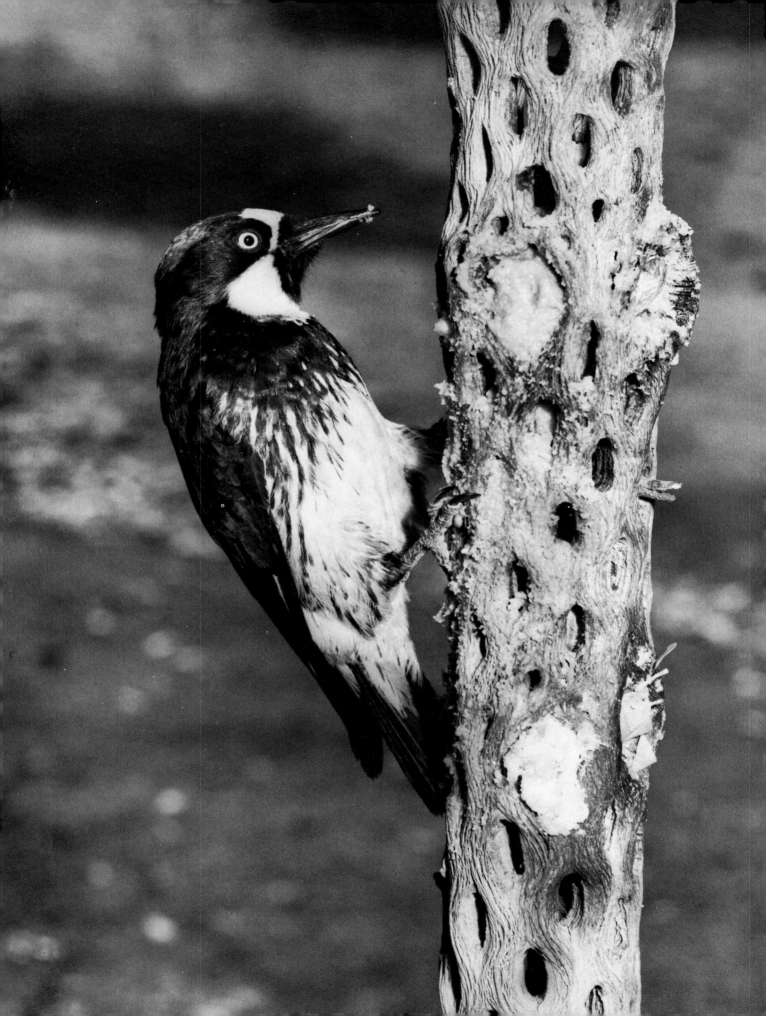

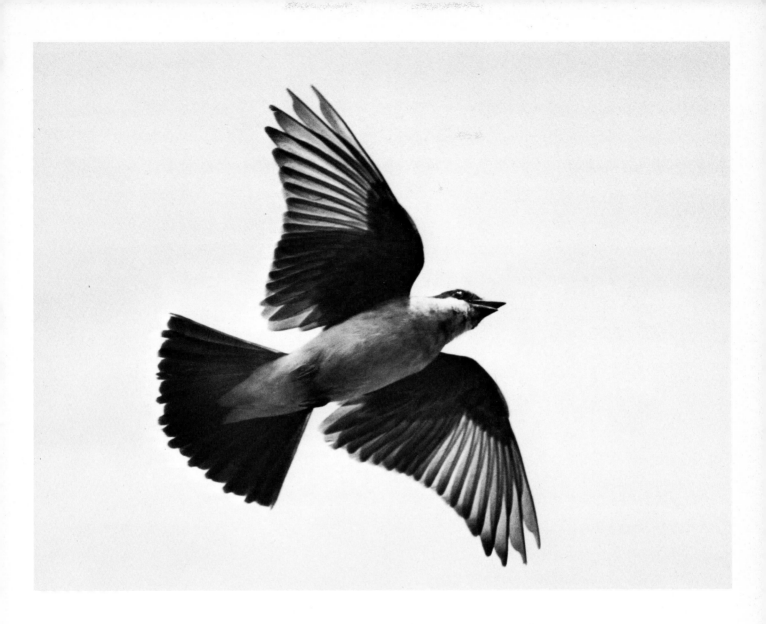

## ACORN WOODPECKER
*Melanerpes formicivorus*

This striking black-and-white woodpecker has, like so many of its relatives, a red crown. As the name suggests, it associates regularly with oaks. One of their odd habits is drilling holes in tree trunks, telephone poles and so on, into which they hammer acorns for later use. These are, however, often stolen by jays and squirrels. No other woodpecker in our country has as startling an eye as this species, with its white iris dotted by a black pupil.

Once I had a pet woodpecker that sat on my shoulder when thirsty. I would fill a glass tumbler with water, and then the woodpecker would stick its long tongue, which can be thrust several inches beyond the tip of the hard, straight bill, all the way to the bottom of the glass. Such a tongue is useful to woodpeckers when they wish to pull a grub from a hole they have drilled in a tree.

## EASTERN KINGBIRD
*Tyrannus tyrannus*

As Forbush has pointed out, some of the American Indians knew this species as the "little chief." Early settlers fleeing from tyranny at home dubbed him the kingbird. And kingbird he is. No annoying winged creature entering his territory, be it crow, hawk or eagle, is too large to escape his fierce attacks. I once saw one of these fearless little flycatchers dart up to meet a low-flying bald eagle, pounce upon its back, and cling there for a few seconds, trying to deal out punishment to the bird many times its size.

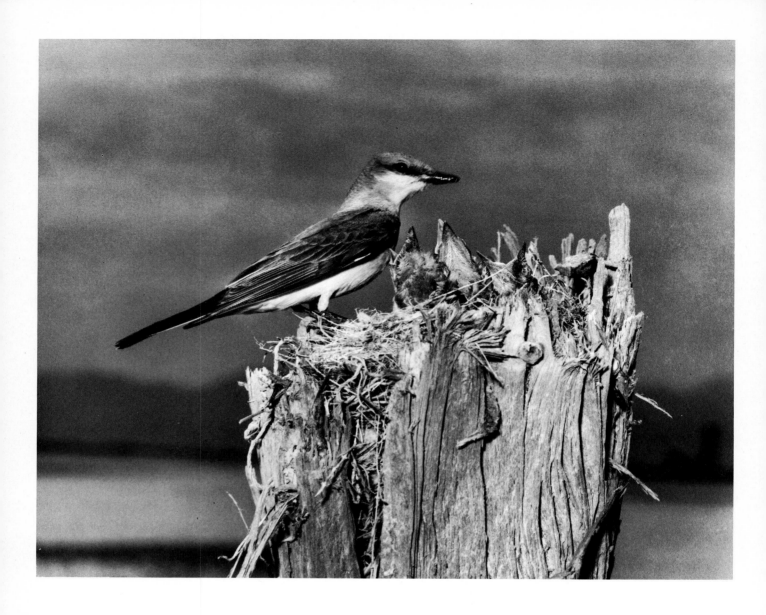

## WESTERN KINGBIRDS
*Tyrannus verticalis*

As a nesting bird this species is restricted to the western part of our country; the eastern kingbird is less properly named for it nests almost as commonly in our northwest as this species.

In a harsh desert area in Utah, where the sun blazed furiously and was reflected upward from bare, white, alka-line-covered earth, this western kingbird placed its nest in the top of a battered fence post. Like a fighter plane it chased marauding magpies, ravens and short-eared owls that were three times and more its size away from the vicinity of its nest. All three young kingbirds fledged in spite of these predatory neighbors.

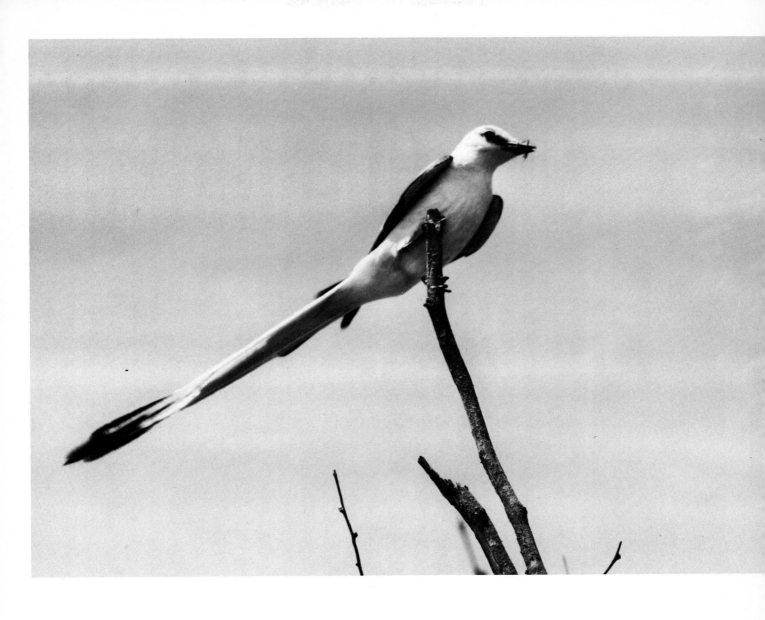

## SCISSOR-TAILED FLYCATCHER
### Muscivora forficata

These exquisite flycatchers migrate in flocks, and on the spring migration they are often very noisy throughout the night. They perform spectacular aerobatics over their chosen territories in which the long flexible tail, the salmon pink under their wings, and their gray and white plumage blend into breathtaking beauty. In southeast Texas they often nest in the vicinity of vermilion flycatchers, the most brilliantly colored species of the entire family. Like so many flycatchers, scissor-tails prefer open country with scattered perches from which they can watch for insects and then dart out to catch them. Some nest as far north as Nebraska. In autumn they again gather in flocks to migrate, and then the sight of several hundred gathered on wires and in trees is one to remember.

137

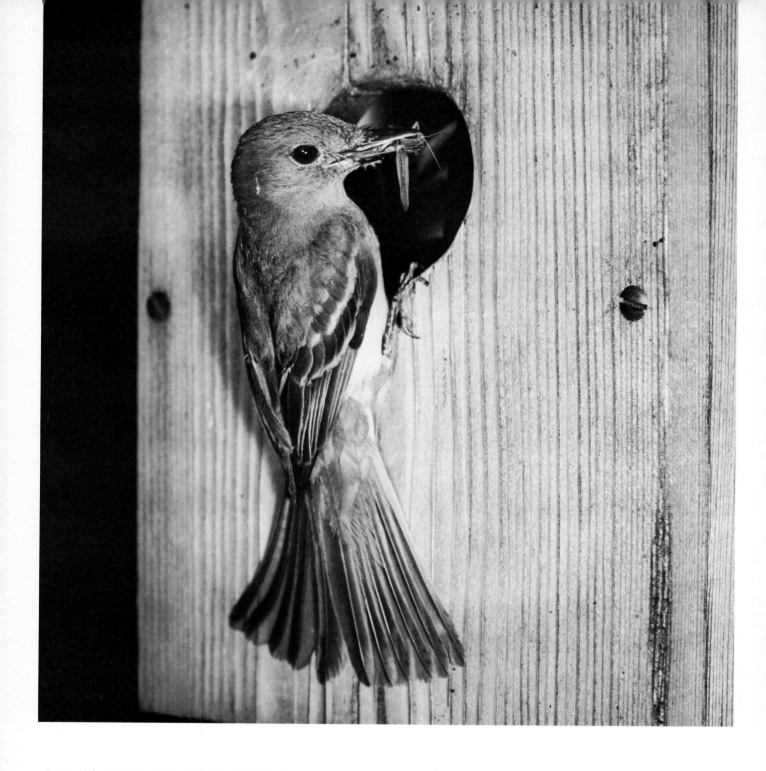

## GREAT CRESTED FLYCATCHER
*Myiarchus crinitus*

This common summer bird attracts the attention even of unobservant people, for many of them have moved from woodlands to occupy bird boxes in gardens, mailboxes that are left open, drain pipes and even plastic tubes put up for newspapers. Its loud "wheeep wheeep" sounds off key and is heard often throughout the early part of its nesting cycle. Much has been written about the prevalence of cast-off snake skins in the nests of great crested flycatchers; it has been claimed that this tends to frighten away predators. Lately this idea has been abandoned, for they are more likely to add strips of shiny cellophane to their nests than snake skins. At the Aransas Refuge in Texas, where snakes are very abundant, I have found their skins used in the nests of cardinals, mockingbirds, thrashers and even mourning doves. Apparently many species of birds like to add a few fancy decorations to their nests.

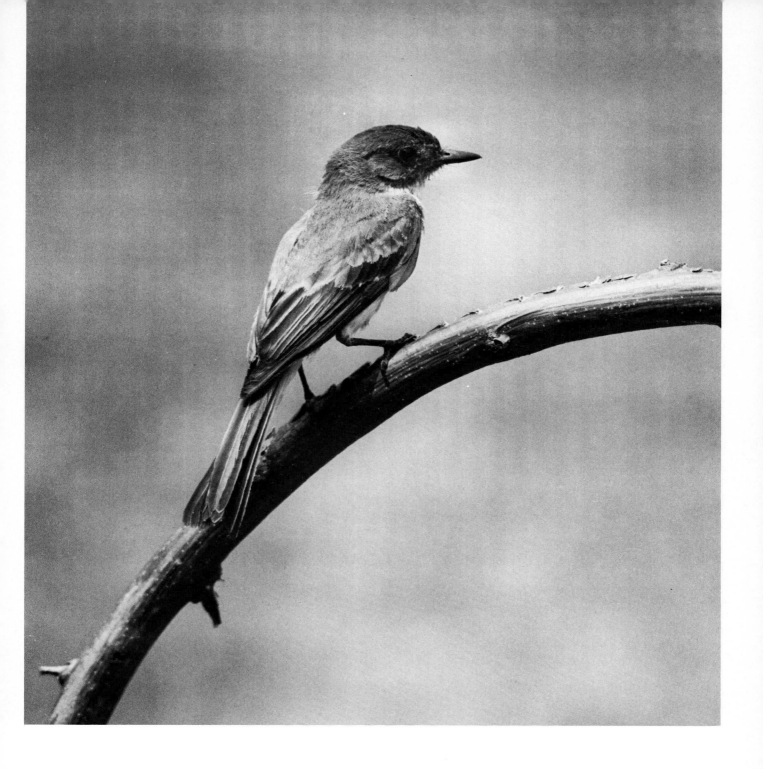

## EASTERN PHOEBE
*Sayornis phoebe*

In 1803 Audubon found a brood of phoebes near Philadelphia and on one leg of each firmly tied a light silver thread. The following year two birds wearing this identification were found in the same locality. This is the first record of bird banding in the United States. But from time immemorial man has been marking birds. The earliest definite date is 1710, when a heron captured in Germany was found to have metal leg bands, one of which had been attached several years before in Turkey.

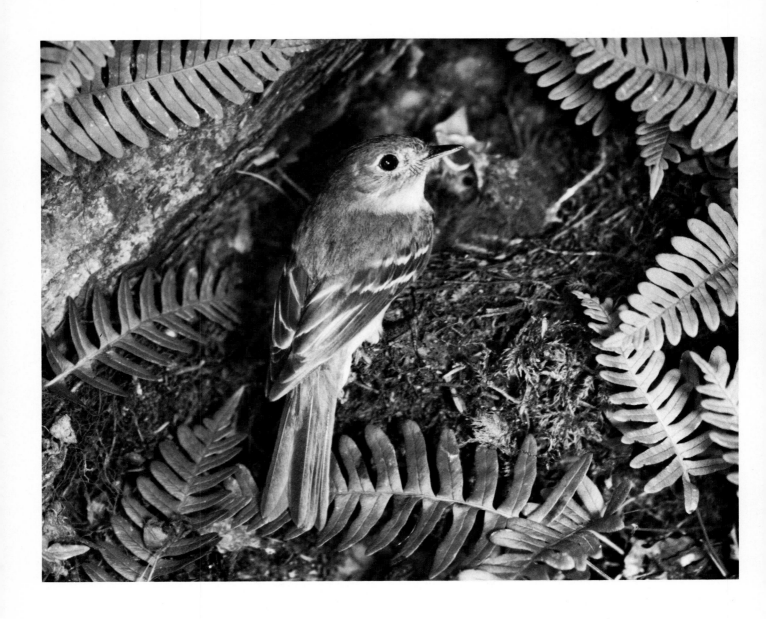

## YELLOW-BELLIED FLYCATCHER
### *Empidonax flaviventris*

This species belongs to the most difficult genus of fly-catchers to identify in the field in North America. Unless the flycatcher is heard, and they are relatively silent much of the time, the observer must use rare caution when identifying it. Knowledge of their range, and their habitat within the range, is very useful. This yellow-bellied flycatcher was photographed on the lower, conifer-forested slopes of Mount Katahdin, Maine. It nested on the ground among northern ferns and mosses. No other *Empidonax* nests in such a place. This species, which, ironically, has a yellow throat, can be more surely identified in the field than any other of the genus.

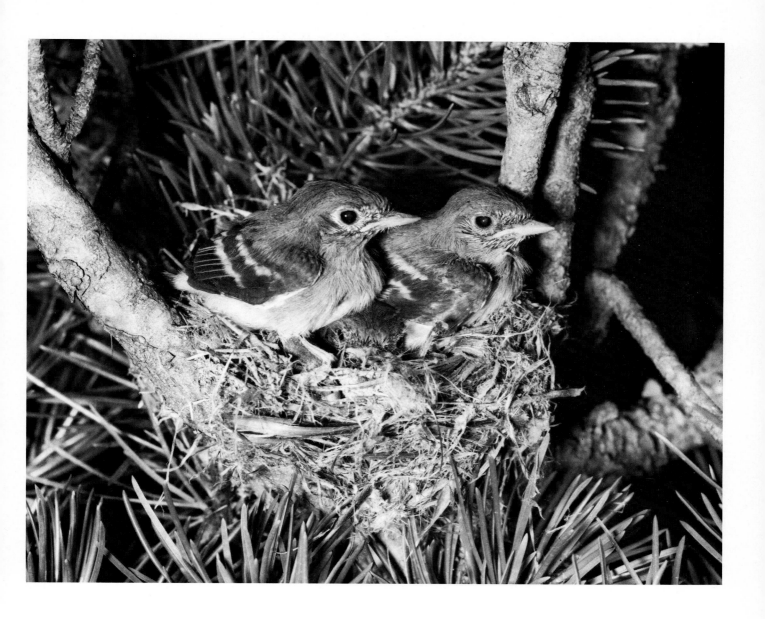

## HAMMOND'S FLYCATCHERS
### Empidonax hammondii

These Hammond's flycatchers are almost ready to fledge. The nest is in an Englemann's spruce in the Uinta Mountains of Utah at an altitude of about 9,500 feet above sea level. Only the location of the nest permitted me to identify the species with confidence. Like the yellow-bellied flycatcher of the East, this western species of *Empidonax* has a very definite preference not only for the location of its nest but its structure as well. Here it is saddled on the horizontal limb of a conifer. Many people consider the western members of the genus even more puzzling than the eastern species. Even when he holds the bird in his hands and uses a precise caliper, a scientist can sometimes be in doubt about which species of *Empidonax* he has.

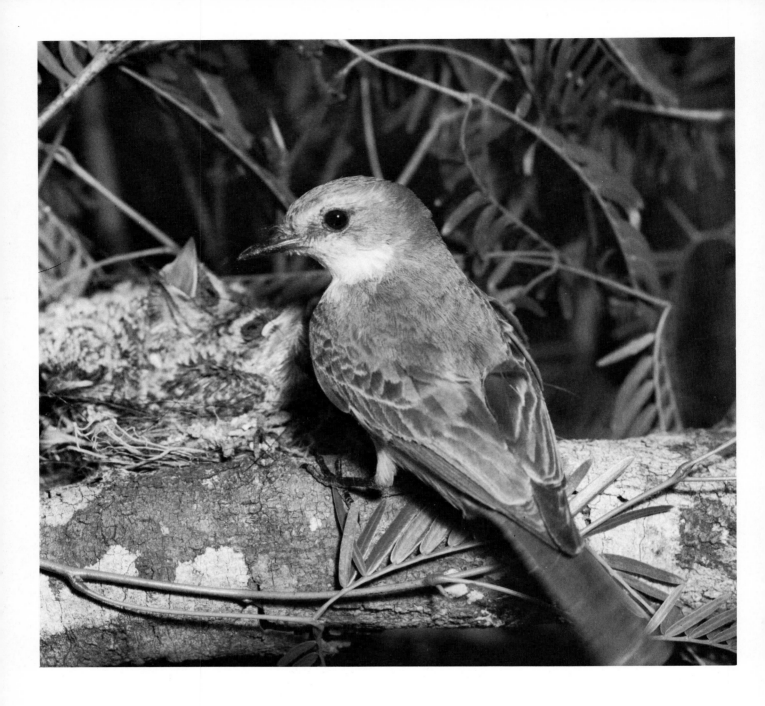

## VERMILION FLYCATCHER
*Pyrocephalus rubinus*

The fiery male vermilion flycatcher is a bird of our arid southwest mesquite country. This brightest member of the large flycatcher family is also distinguished by its peculiar wintering habits, for it appears in unexpected places. One December it turned up near Charleston, South Carolina, more than a thousand miles beyond its normal range. Another winter hundreds of people flocked to see one that took up residence near Flamingo in Everglades National Park. It has never been recorded on the islands in the Carribean

yet it is fairly common on the Galapagos Islands more than 500 miles west of Ecuador. Most of our male and female flycatchers look so much alike that it is impossible to tell them apart in the field. In contrast, the female vermilion flycatcher does not look at all like the brilliant male, but is nevertheless a handsome bird. Her back is soft brown, her white breast is delicately streaked with dark lines, and her belly and undertail coverts glow with rosy salmon.

142

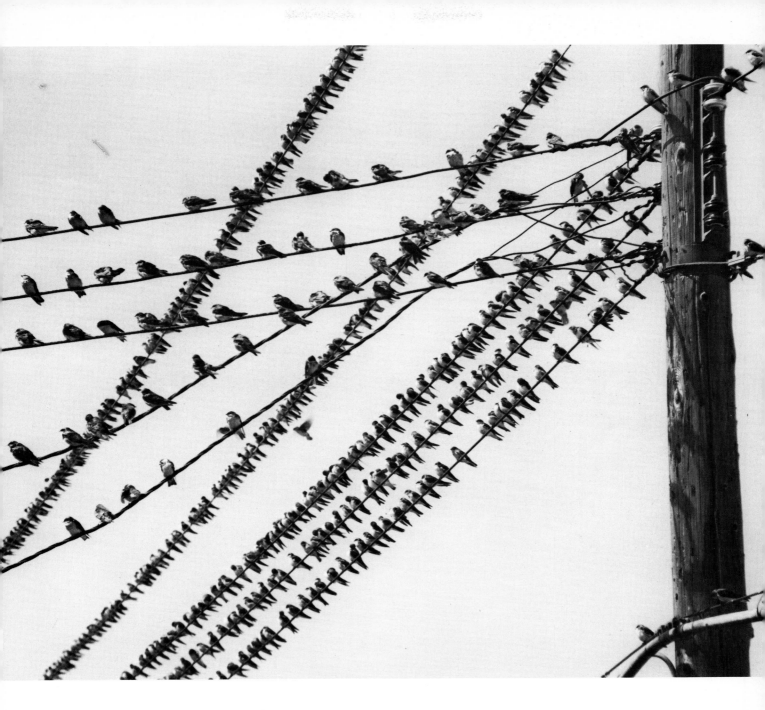

## TREE SWALLOWS
### Iridoprocne bicolor

When I took the accompanying photograph, all the wires for more than a mile along the coastal marshes of Long Beach, New York, were sagging with the weight of tree swallows. Even before summer is half over these birds finish with their nesting activities and begin gathering around extensive marshlands where food is abundant. In some choice areas their numbers swell until late in the summer when concentrations of up to several hundred thousand may be encountered. Their departure is abrupt. One week after this picture was taken the great flock had left for the south and I was able to find only 30 tree swallows in this section of Long Island.

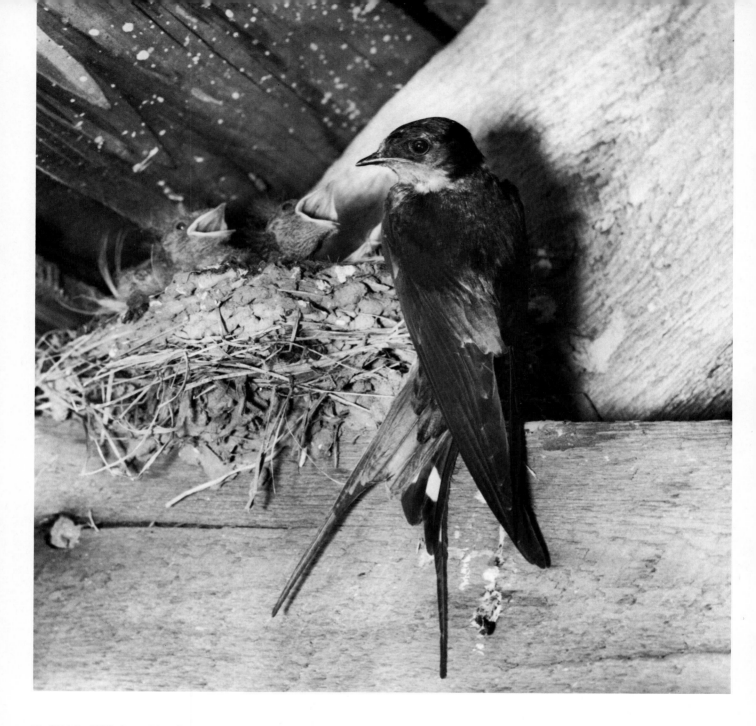

## BARN SWALLOWS
### Hirundo rustica

Swallows occur nearly everywhere in the world except the polar regions and some Pacific islands. They are among the most beloved birds: their pleasant twittering delights the ear while their graceful but erratic flight charms the eye. Unlike most insect-eating birds, swallows migrate by day, swooping after their prey as they advance. Barn swallows, with a shining dark blue back, rusty underparts and deeply forked tail, have been welcome around farm buildings since the early settlers arrived on these shores. These birds build their mud and straw cup-like nests lined with feathers on beams or plaster them on the inside walls of barns.

When Bent's *Life Histories of North American Flycatchers, Larks, Swallows and Their Allies* was published in 1942 he was concerned about the future of these swallows, for modern farming was eliminating the old-time open barn doors and hay lofts. Would they return, he wondered, to their primitive way of nesting? Apparently some already are doing so for on Matinicus Rock in Maine in July 1976, one pair of barn swallows nested on the ledge of a cave-like hollow under some huge boulders while another had built on a shelf in a very deep, narrow crevice of a great cliff.

144

## BLUE JAY
### Cyanocitta cristata

This dashing, impertinent bundle of vitality is an uproarious rascal with personality difficult to surpass. It is one of the most handsome birds in the world and, being related to the crow, it is astonishingly smart and resourceful. No bird is bolder and more fearless in defense of its young. I learned this at the age of 12, when two blue jays, angered by my attempt to climb to their nest, attacked in unison, struck me repeatedly on the back of the head, and soon had me hurriedly backing down the tree in utter rout. The young blue jay in the photograph has just fledged and looks like its parents even though its tail is still very short.

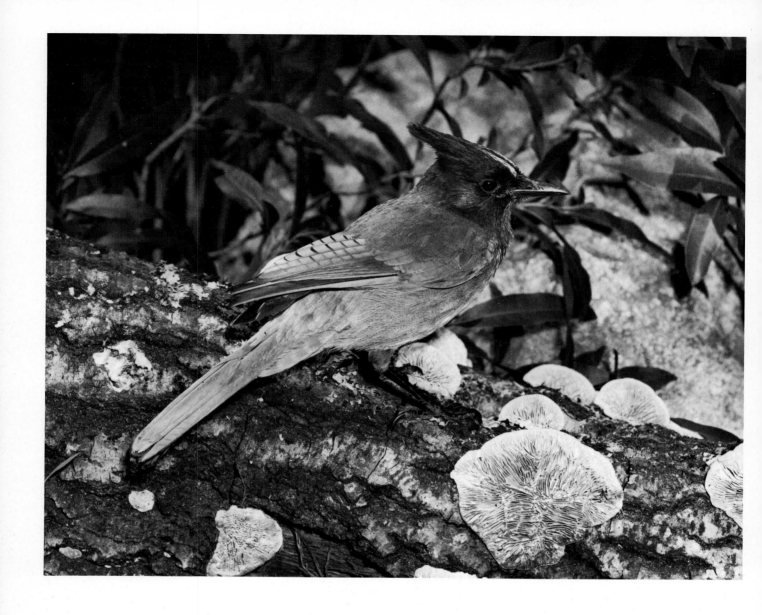

## STELLER'S JAY
*Cyanocitta stelleri*

This is our darkest jay and the only one with a crest living in the Rockies and west to the Pacific. The head and silky crest are black, with white "frown lines" between the eyes. The blue on its wings and tail is as rich as lapis lazuli, delicately barred with black. Like most jays, it eats almost anything that it can find, animal or vegetable, including the eggs and young of other birds. Ironically, this offends many people who eat great quantities of eggs and fowl. Like the blue jay, the Steller's imitates other birds, especially hawks. In winter it moves down the mountain slopes and often enters the outskirts of cities, where it is a regular visitor at feeding shelves.

## SCRUB JAY
*Aphelocoma coerulescens*

The scrub jay, living on peninsular Florida and separated from others of its genus by more than a thousand miles, is partial to dry scrub lands, where oaks, sand pines and myrtle bushes provide most of the cover. An analysis of its food habits shows that acorns are the preferred item, constituting approximately 34 percent of the total stomach contents. The rest of its varied diet includes a great assortment of flies, beetles, bugs, ants, wasps and grasshoppers. One stomach upon examination contained a total of 468 termites.

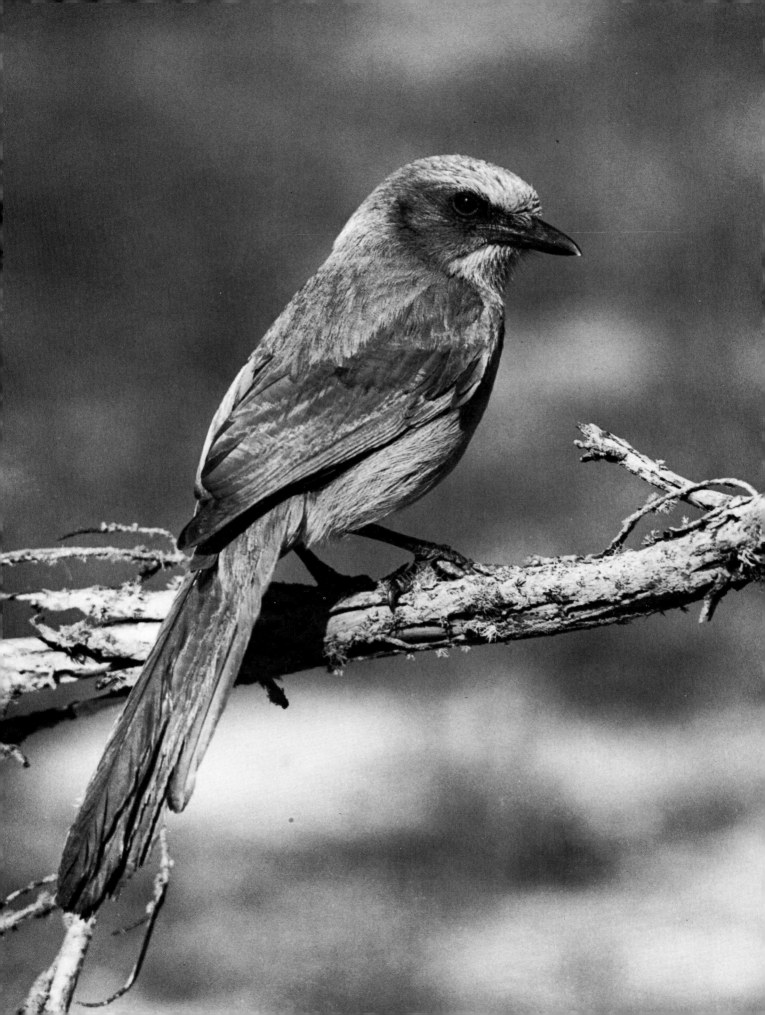

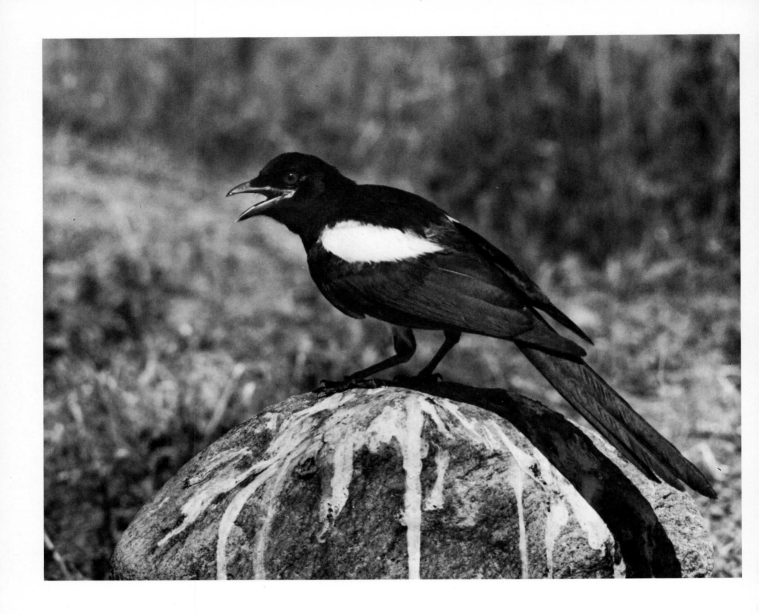

## BLACK-BILLED MAGPIE
*Pica pica*

This young magpie has been out of its bulky domed nest for a week. It remained closely associated with its six nest mates, and in the extreme heat of the Montana prairie they often gathered in the shade of a bush close to my blind. There they kept up a constant soft conversation, in sharp contrast to their raucous chatter as they moved across the prairie in search of food. Except for the scissor-tailed fly-catcher, magpies are the only birds in our country that have a tail longer than the body. The tail of this young magpie is slightly more than half the length it will attain by late autumn.

Magpies occur around the world and almost everywhere they come into conflict with man, for its food needs overlap with ours. The great explorers Lewis and Clark were the first to call attention to this bird. Near Crow Creek, South Dakota on September 17, 1804, Clark wrote: "Capt. Lewis. . . . killed a Buffalow and a remarkable bird (Magpy) of the Corvus Species, . . . a butiful thing." On the same day Lewis also expressed his admiration of his discovery when he noted the ". . . remarkable long tale, beautifully variagated." Later four live magpies were shipped to President Jefferson and were received in good condition.

148

## FISH CROW
### *Corvus ossifragus*

Even though buntings stand on the peak of the avian family tree, some people believe that crows are more highly developed. If mental development is taken as the sole criterion, then crows assuredly have a claim to this high station. As Forbush has suggested, it is probably this marked cleverness that has placed the crow in such low regard among some men. It believes in dwelling in fertile regions where food is abundant, and it claims a share of this wealth. It is highly successful in avoiding the range of a gun and the most clever traps. In short, to some it is a mischievous rascal to dare compete with the interest of man.

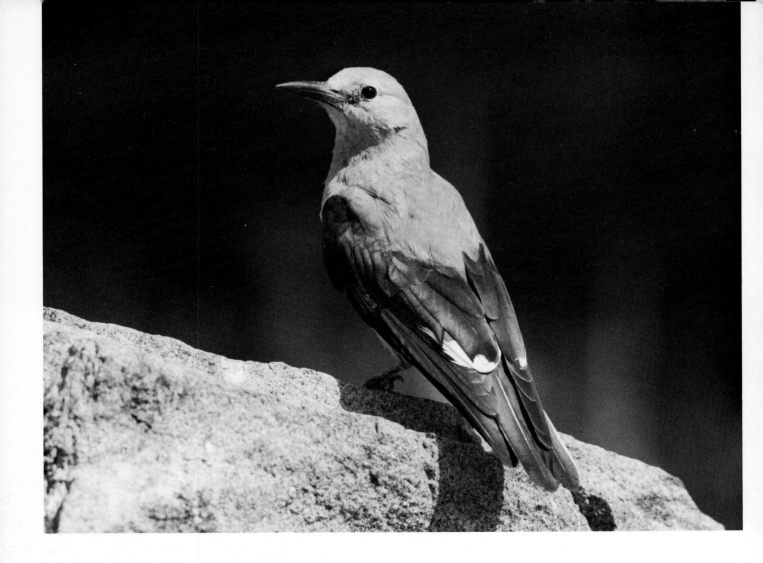

## CLARK'S NUTCRACKER
### Nucifraga columbiana

This nutcracker is one of the noisy, conspicuous birds of the forested western mountains. It was described and named by Alexander Wilson from three specimens in the Lewis and Clark collection in Philadelphia. On August 22, 1805, close to a Shoshone Indian Camp near the present town of Tendoy, Idaho, Lewis noted a new species of bird as follows: "I saw today a species of woodpecker which fed on seeds of pine, its beak and tail were white, its wings were black . . . about the size of a robin." The nutcracker does fly very much like a woodpecker. In 1806, however, when a specimen was obtained, Lewis corrected his error, and properly called this bird with the woodpecker flight a *Corvidae*. More often than not the weather of the mountainous regions where the nutcracker lives is severe. Nevertheless, they begin nesting in Frebruary and often huddle over their eggs in the face of raging blizzards and sub-zero temperatures. By early June the young are on their own around Oregon's Crater Lake, where they often take tidbits from visitors.

## BLACK-CAPPED CHICKADEE
### Parus atricapillus

Little wonder that both Maine and Massachusetts have selected the attractive little black-capped chickadee as their state bird. Certainly no member of our avifauna is more trusting, more cheerful, more energetic, more acrobatic. It is a vivacious bundle of feathers even when the mercury tumbles below the zero mark. I can think of no bird that has a greater number of admirers. Moreover, the chickadee is decidedly useful. Professor E. Dwight Sanderson has estimated that in Michigan alone these birds destroy more than eight billion insects annually.

## VERDIN
### Auriparus flaviceps

This tiny member of the chickadee family is closely confined to desert scrub, where it builds an astonishingly large nest. The ball-like mass is formed of prickly twigs with the thorns bristling outward and tied firmly to a branch. No attempt is made to hide this impregnable nest. The entrance is placed on one side near the top and the inside is lined with soft grasses and stuffed with feathers. Inquisitive Herbert Brandt once tore a verdin nest apart and counted more than 2,000 twigs in it. The soft olive-gray bird has a yellow head and a chestnut shoulder patch. It often lives far from water so it must get all that it needs from its food. In the desert, verdin nests remain in good condition for several years. Both when foraging and when approaching the nest, verdins whistle repeatedly.

## BUSHTIT
### *Psaltriparus minimus*

The 4½-inch bushtit is as tiny as the verdin and belongs to the same family. It builds a very odd nest, a pendant bag up to a foot long, unlike the thorny globular nest of its relative the verdin. The nest is built of dried leaves, mosses, lichens and other pieces of vegetable matter all tied together with spider webs. The bushtits often take up to two months to build their remarkable works of art. The entrance is near the top and usually, as in the nest in the photograph, is placed directly under the branch from which the nest is hung. In spite of its fantastic length, the nest fitted inconspicuously into the twigs of the shrub.

Bushtits often have two broods a season, which is fortunate since many of their young are eaten by larger birds, snakes and lizards. One nest I found had been destroyed by ants, and after the attack the young birds were looking out of the entrance with miserable, dull eyes. A line of ants was marching in, so I carefully removed the young birds and got rid of the ants. The little birds seemed to revive and I watched them take food from the adults. But when I checked the next morning all were dead and being eaten by ants. My efforts to save them had failed.

153

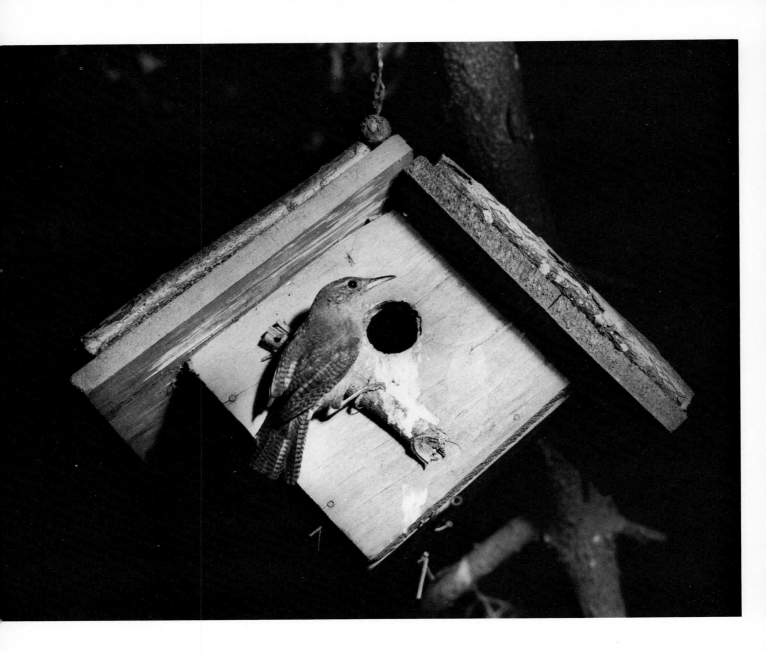

## HOUSE WREN
### *Troglodytes aedon*

The bustling, irrepressible little house wren has adapted itself to civilization. It quickly accepts a birdhouse in which to nest. If such a house is not offered, it may well build in a letter box, the pocket of a coat, a broken jug, a knapsack, or any other convenient cavity that takes its fancy. The males are frequently polygamous. In fact, some are veritable Casanovas. They think nothing of having several mates in a season and at times will actually preside over two large families simultaneously. Moreover, they take desertion lightly, and frequently within a few hours will pick up a new unattached partner or even steal one from a less aggressive neighbor.

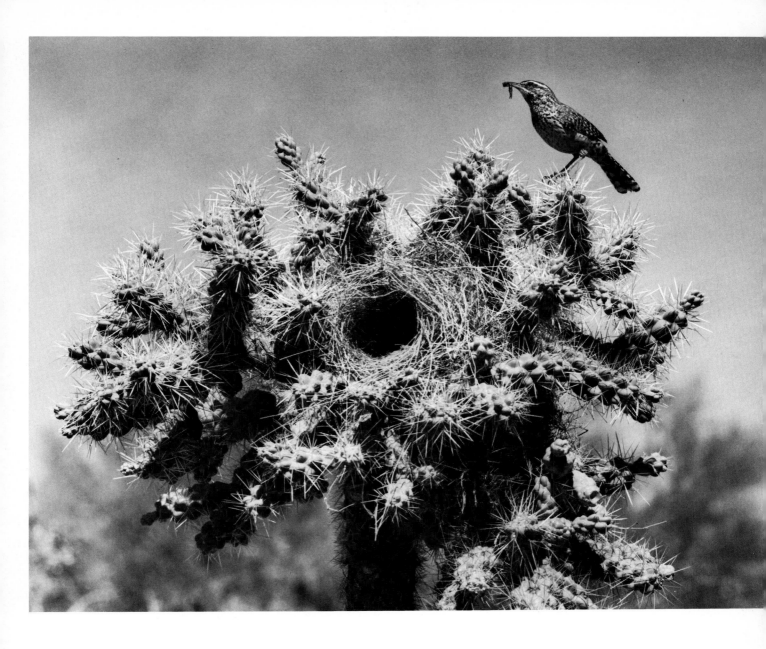

## CACTUS WREN
### *Campylorhynchus brunneicapillus*

This is our largest wren and looks more like a thrasher than it does like its own relatives. It is confined to the desert Southwest where its loud but unmusical songs are frequently heard. In folklore, the wren is the king of birds. The kingly crown was to go to the bird that flew the highest and the wren won it by an unsporting trick; it hid in the back feathers of a great eagle that finally became exhausted and could go no higher. At that, out leaped the wren and, climbing still higher in the air, it outdistanced all the other birds.

The cactus wren builds a large, shaggy nest with an open-ing at the side. It is not used just for rearing the young but is also occupied as a bedroom throughout the year and as a place for shelter in storms or from enemies. Because of this regular use, the nests are frequently repaired. It is said that soon after they fledge, young cactus wrens begin building their year-round nests. The cactus wren nest in this photograph was built in cholla, considered the worst of all cacti to come in contact with. Disregarding the sharp spines, the cactus wren went in and out with food for its young, and with impunity stood on the spines to sing.

## LONG-BILLED MARSH WREN
### Cistothorus palustris

True to its name, the marsh wren is a bird of the marshes. The photograph was made at the cattail and tule border of a water empoundment in Utah, but this species nests from coast to coast in similar situations. While the female builds the domed nest in which she will lay up to six eggs, the male may construct up to a half dozen nests, none of which is ever completed. Perhaps this is a way to work off excess energy, since no known use is ever made of these nests. The family name, *Troglodytidae*, means cave or hole dweller. The reason for this name is clearly shown in each of the three wren nests in this book. Each is quite different from the others, yet each has a side entrance into a completely walled nest.

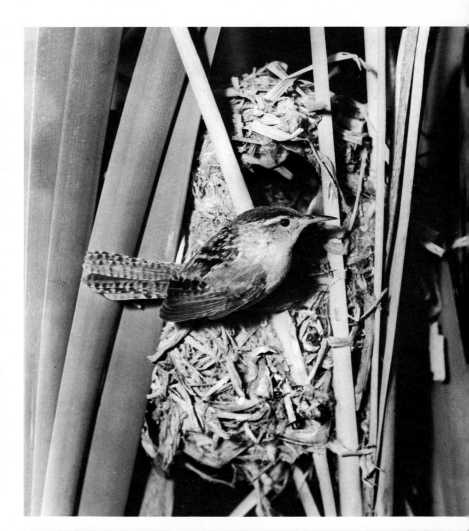

## MOCKINGBIRD
### Mimus polyglottos

This distinctly American bird is one of the most gifted singers in the world. Not only does it pour forth a flow of cheery phrases all its own, but it often intersperses excellent imitations of songs and noises in the area. Some of the odd sounds I have heard them give are the crow of a rooster, the squeaking of a rusty pulley, the mournful blast of a ship's horn and the scream of a fire siren. When the breeding season arrives, the male, overflowing with hilarious excitement, mounts some prominent perch and performs aerial evolutions, all the while shouting a song of challenge, love and *joie de vivre*. At this time the tireless bird often sings throughout the night, its ever-varying song sounding even more mellow and rich in the flood of moonlight.

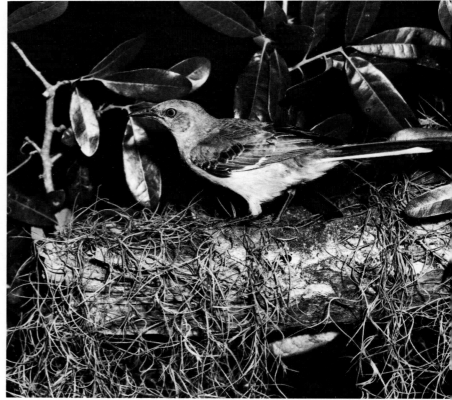

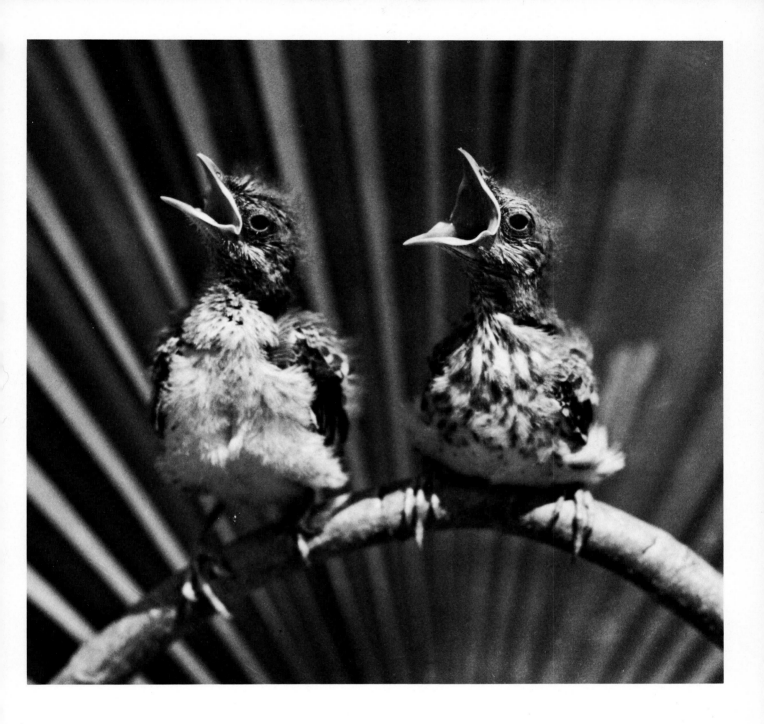

## YOUNG MOCKINGBIRDS
*Mimus polyglottos*

Arkansas, Florida, Mississippi, Tennessee and Texas all chose the mockingbird as their state bird, a testimonial not only to the popularity of the species but to its adaptability to varied habitats. Because it likes gardens and suburbs as well as open and brushy country, it is probably more abundant today than when expanses of wilderness spread across the continent. Though we in America have but one species of *Mimus*, there are nine others scattered through the West Indies, Mexico, Central America and South America. All are sufficiently alike in shape and behavior to be easily identified as mockingbirds, with the possible exception of the blue mockingbirds of Mexico. Of all the species I have heard sing, however, none equals our mockingbird, the greatest virtuoso of them all.

157

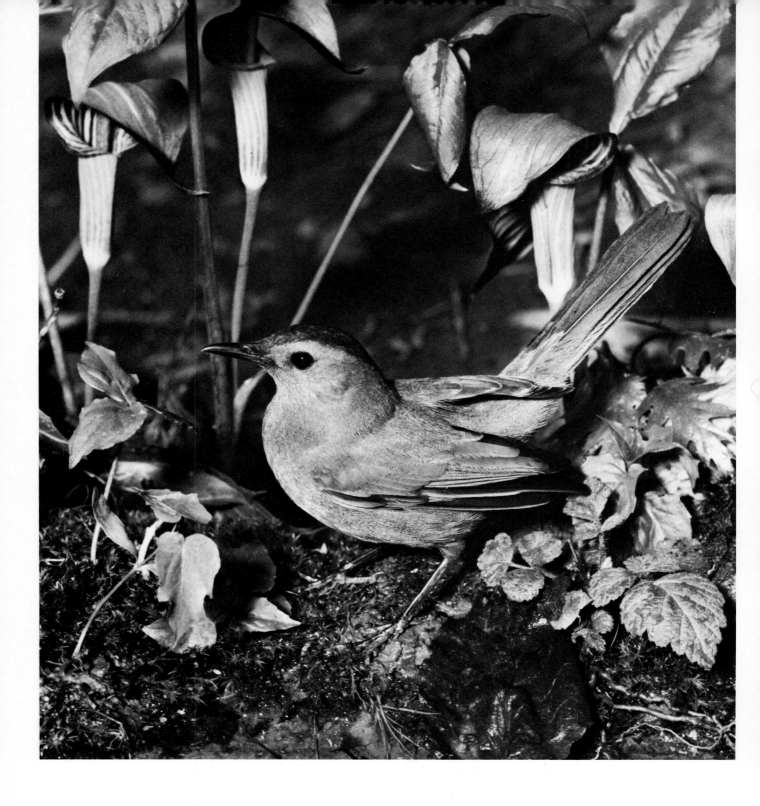

## GRAY CATBIRD
### Dumetella carolinensis

Wherever the catbird occurs it is well known, for no other bird is more boldly inquisitive. It has an insatiable desire to know everything that is going on and will persistently follow man around, studying his every move. In tangles and bushy thickets it is a common summer resident over most of the United States and southern Canada. Being a member of the mockingbird family, it has a marvelous repertoire, and were it not for the interjected catcalls and harsh squeaks and squawks it might well rival if not surpass both the mocker and thrasher for sweetness and quality of song.

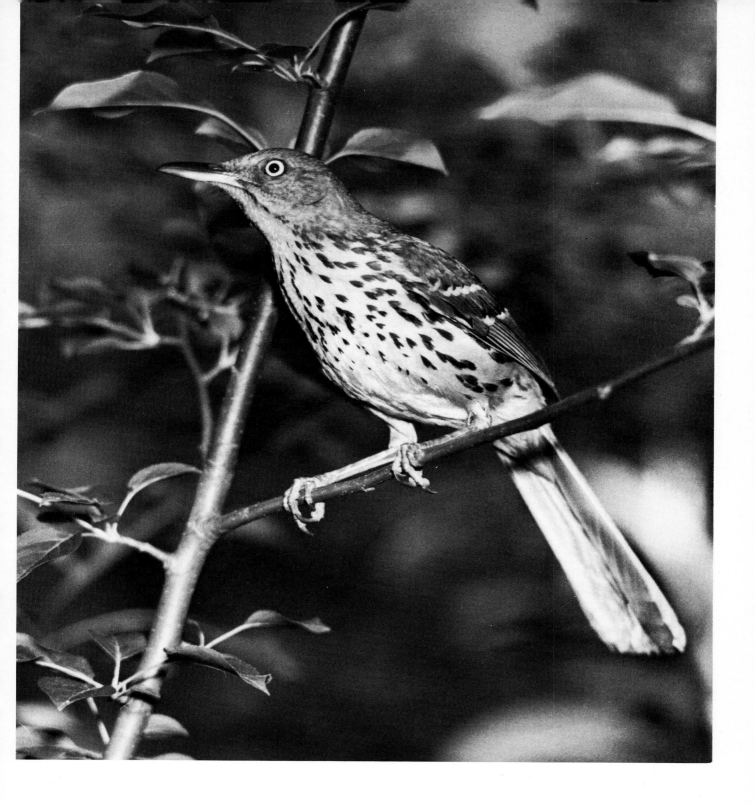

## BROWN THRASHER
### *Toxostoma rufum*

When one realizes that a brown thrasher has more vertebrae in its neck than a giraffe or a camel, it is easy to understand how the bird can move its head with such speed in any direction. This extreme flexibility gives the thrasher a decided advantage when it snatches at some fast-moving insect. It enables the bird to preen its feathers from its tail right up to the back of its neck and even under its throat.

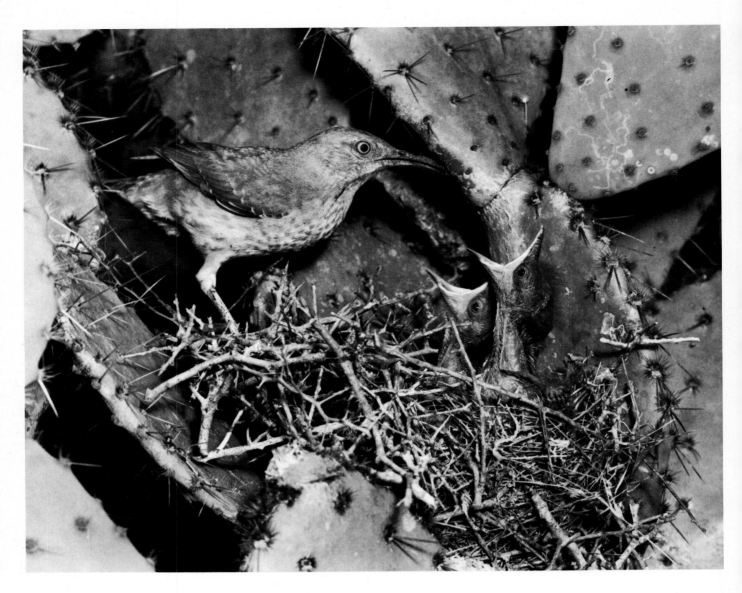

## CURVE-BILLED THRASHERS
*Toxostoma curvirostre*

While the brown thrasher is the only one of its genus in the eastern and central parts of this country, there are seven thrashers in Texas and the West, and of these I first became acquainted with the curve-billed thrasher. East of Brownsville, Texas on the flat coastal plain, a few lomas (hills) rise like islands a few inches above the level expanse. These are covered with dense, almost impenetrable vegetation. All the land birds necessarily nest in these dense thickets since the surrounding plain is subject to flooding. On Loma de la Montuosa I found nine curve-billed thrasher nests in a single hour. These thrashers, with faint spots on the breast and yellow-orange eyes, built bulky nests of thorny twigs, sometimes placing them in equally thorny bushes while others were in the grasp of opuntia cactus. When the lovely blue-green eggs speckled with brown hatched, the young were naked, blind and helpless, and how such tender bits of life survived surrounded by thorns and needle-like cactus spines seemed like a miracle.

## WOOD THRUSH
*Hylocichla mustelina*

The wood thrush is a widely distributed summer resident in the transitional and austral zones of the eastern United States. Its large size, conspicuously spotted breast, and striking cinnamon upper parts make it an exceptionally comely bird. It is without question one of our most gifted singers. Its sweet flute-like notes have strength and vitality, and their solemn rising and falling produces avian music ideal for the restfulness of cool moist woodlands and well-shaded gardens.

160

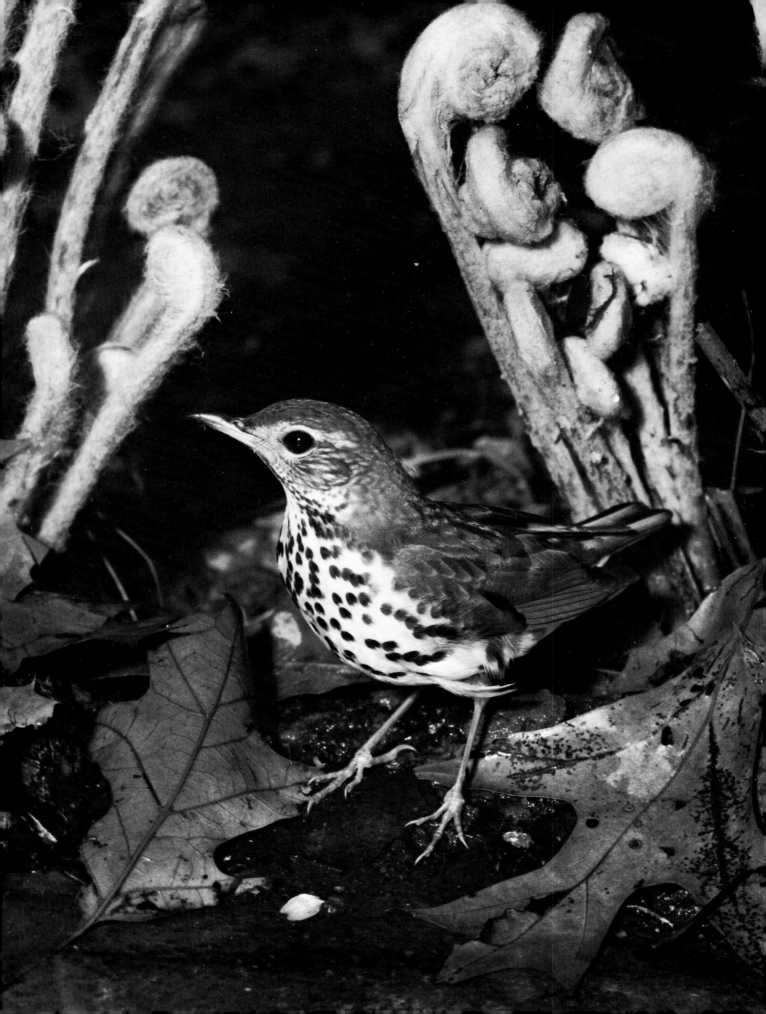

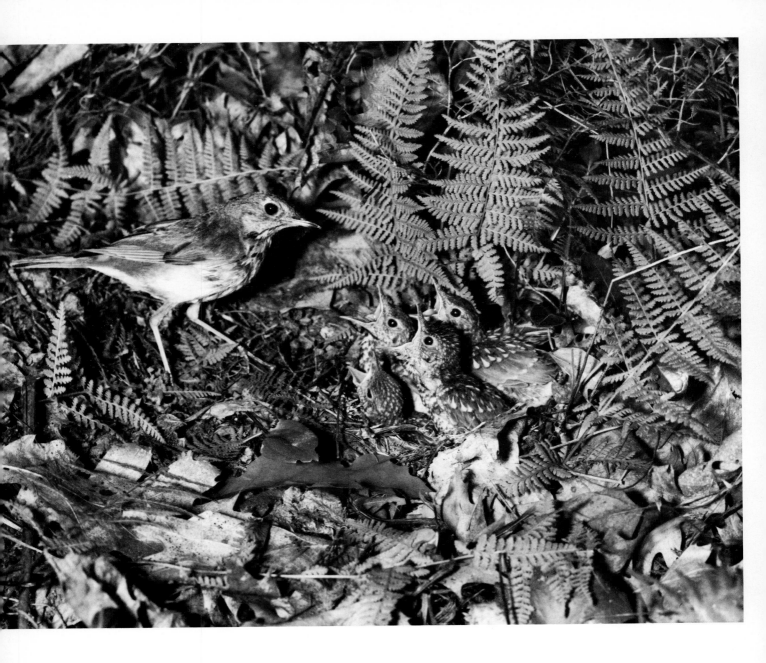

## HERMIT THRUSHES
*Catharus guttata*

This thrush nests on the ground among mosses and lichens in the cool, remote forests of the north. It has a plain olive-brown back, rusty tail and lightly spotted breast. Its song is so beautiful that many regard it as the supreme bird song of the entire world. Even as a symphony orchestra needs the right acoustical situation to be heard at its finest, so the hermit thrush requires the right position to render its full haunting richness. From the top of a tall tree high in the mountains, its clear, liquid resonance is lost. But when the hermit thrush sings close to the edge of a northern lake bordered by a forest, the song is truly brilliant; a silvery sustained note like that of a flute may be followed by a stunning burst of wild movement. There are pauses to give time for thought between themes, some of which are in major keys and some in minor. Some phrases may be plaintive, others joyous, but all are sweet, full and vibrant. It is well worth the effort to travel many miles to listen at dawn or dusk to the song of America's incomparable woodland musician.

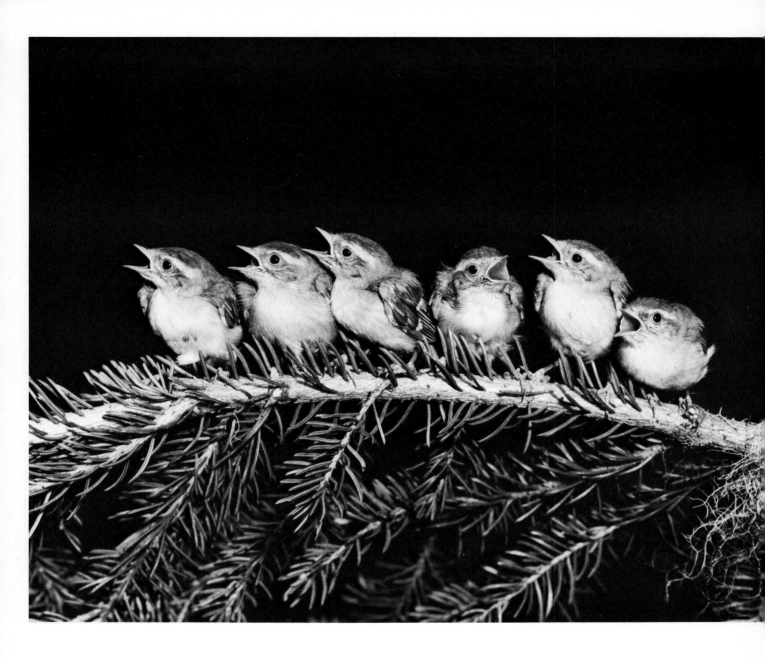

## GOLDEN-CROWNED KINGLETS
*Regulus satrapa*

Next to the hummingbirds, the golden-crowned kinglet is the smallest bird in our country. The gold-crest of the Old World is believed by many people to be the same species. The brilliant golden crown is rarely seen except when it is flared during courtship. It is a bird of northern conifer forests where it places its cup-like nest, in which it may lay up to nine eggs, high in one of the tall trees. Its foraging for tiny insects and similar food is largely carried on high in the forest. Its unmusical calls and slight song are so high-pitched that many people cannot hear them. Once the young are on their own, golden-crowned kinglets travel in small groups and many of them remain in the far north throughout the frigid winter.

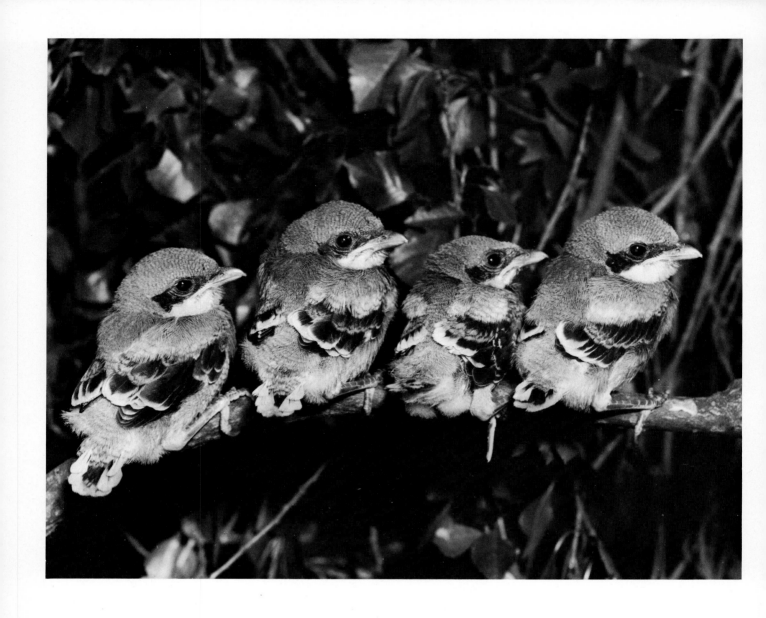

## LOGGERHEAD SHRIKES
### Lanius ludovicianus

Shrikes are the most predatory of our passerine birds. They have the strange habit of hanging part of their catch on thorns or the barbs of wire fences. Because of this habit they are often called butcherbirds. In shrike larders I have found frogs, a mouse, lizards and once three baby shrikes. Had it impaled its own young or raided the nest of another shrike? Their chief food, however, is insects. As fledglings, young shrikes already look like short-tailed adults. Where they occur, shrikes are conspicuous, for they like high open perches from which they can see widely and dart out to catch their prey.

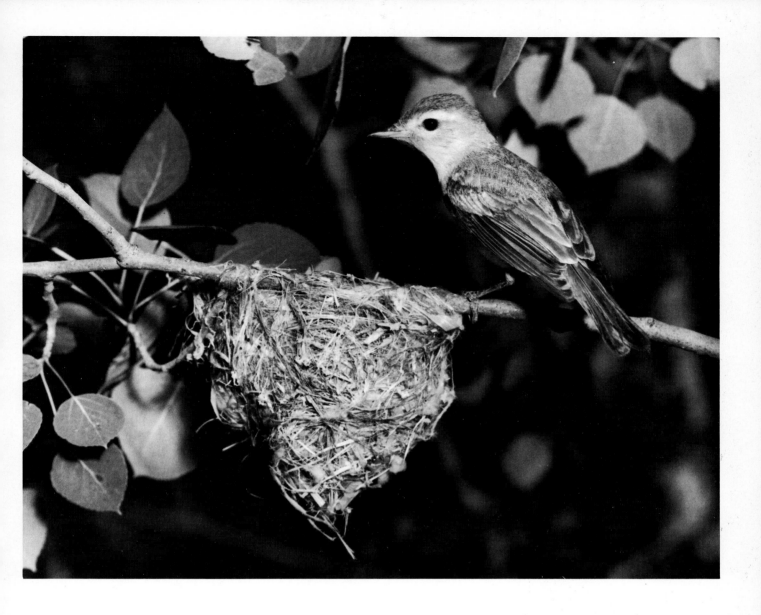

## WARBLING VIREO
### *Vireo gilvus*

Throughout much of the eastern United States this palest and grayest of our vireos is far better known by its un-hurried and often repeated pleasant warble than by its appearance. It frequently nests near the tip of a delicate branch of a lofty elm. I am a good tree climber but once Roger Tory Peterson wrote that I had better hurry and photograph the warbling vireo, for one day I would not be able to climb high enough to do so. Then to my surprise I found they do not always nest very high in tall trees in the West. This warbling vireo nest, for example, was photographed in Box Elder Canyon, Utah, in a small aspen. It was only six feet above the ground. The more we know a bird, the more we realize that a blanket statement about its activities is likely to have many exceptions.

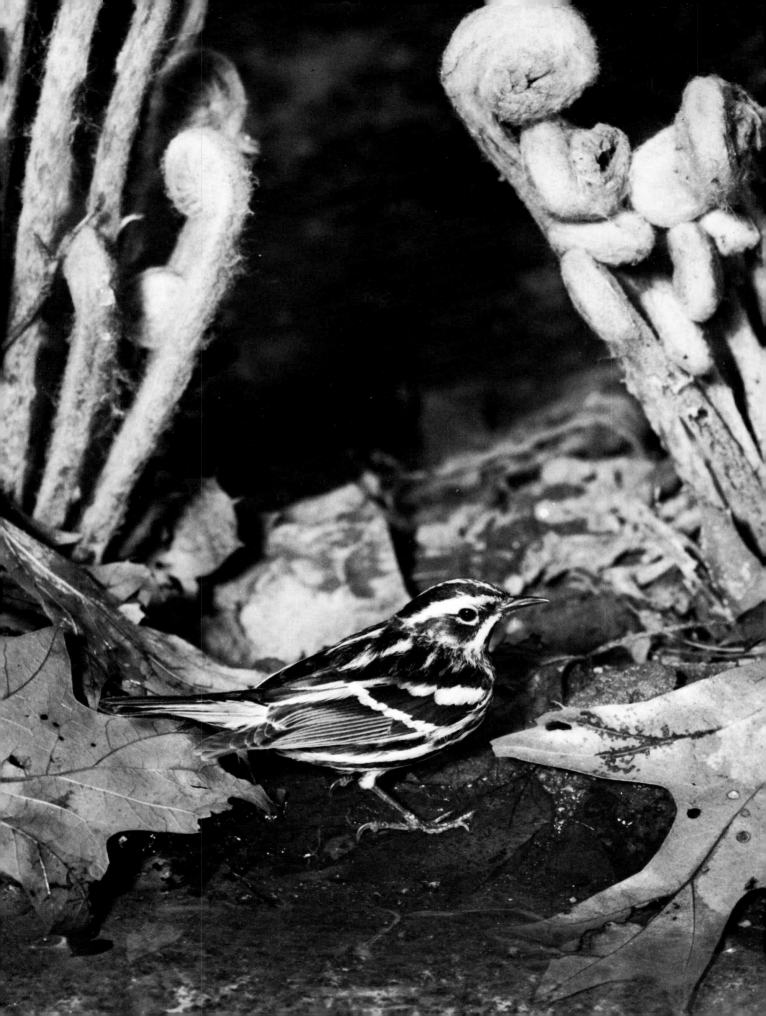

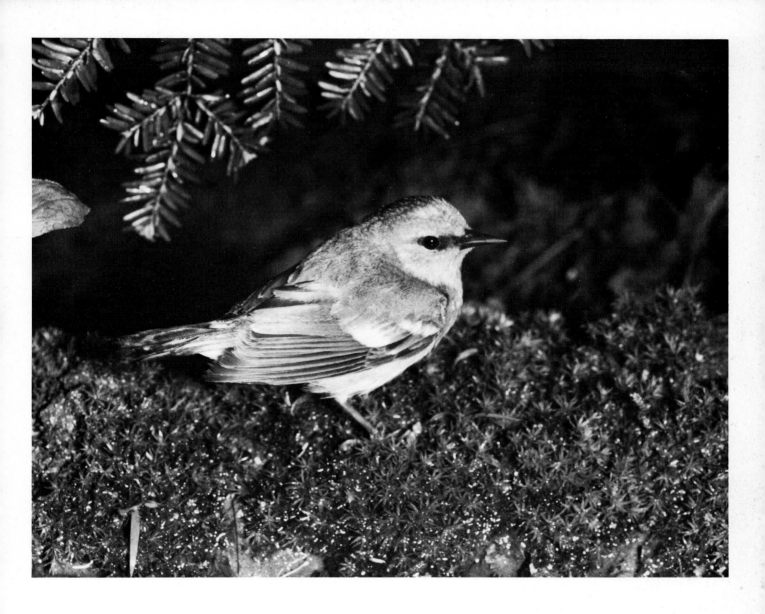

## BLACK-AND-WHITE WARBLER
*Mniotilta varia*

Wood warblers, because of their small size and usually brilliant colors, are often called the butterflies of the bird world. Even the conservative black-and-white warbler is an arresting sight. The wood warblers arrive in the north as the tree buds are swelling, lending a gay touch to the still wintery-looking forests. In places such as the Elmsford Ridge of Westchester County, New York, they often arrive in spectacular waves sometime in early May. This warbler was once called the black-and-white creeper because of its habit of flying to the base of a tree and creeping up the trunk and along the branches, then flying to the base of another tree and repeating its odd behavior.

## BLUE-WINGED WARBLER
*Vermivora pinus*

This small warbler, with yellow face and underparts and a black line through the eye, has two conspicuous white wing bars. It is forever associated in my thoughts with warm May days in old pastures of Westchester County, New York, where it was a fairly common nesting species.

Why Linnaeus gave this bird of hedgerows, scrubby fields and woodland borders the specific name *pinus* I do not know, for it is in no way associated with pines. It nests on the ground, and the young leave the nest at the tender age of eight or nine days, at which time they are fully feathered. Blue-winged warblers winter mainly in southern Mexico but have been recorded as far south as Colombia.

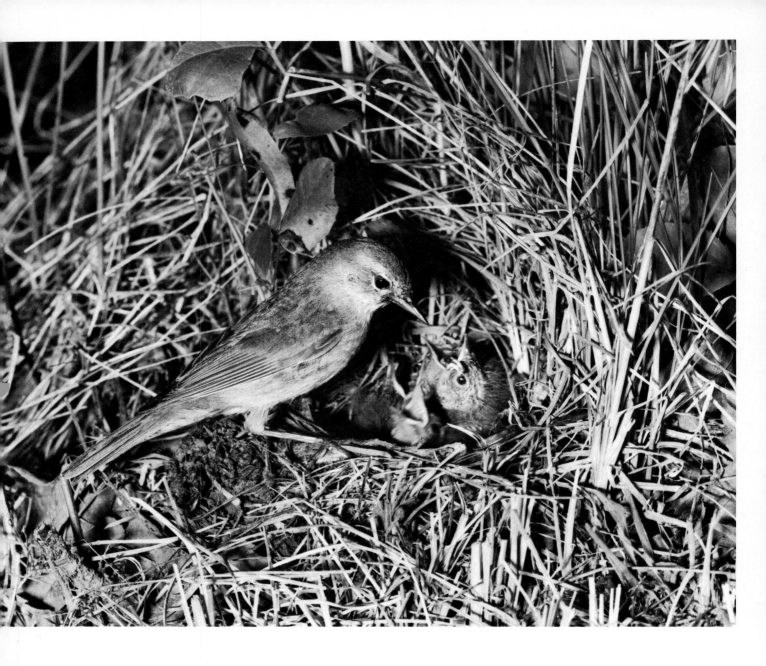

## ORANGE-CROWNED WARBLER
### Vermivora celata

This nondescript warbler rarely displays its orange crown. It is fairly common in the Northwest and nests northward beyond the Arctic Circle. Many move southeast in winter and the species is regularly found in the orange groves of Florida.

One late May night in Montana it snowed for hours and the temperature fell to freezing. Next morning as I walked along a muddy road I saw an orange-crowned warbler carrying a green caterpillar. It went to a nest on the ground where naked young warblers begged for it. Incredibly, the tiny birds, scarcely the size of a bumblebee, seemed unaffected by the storm and frost.

168

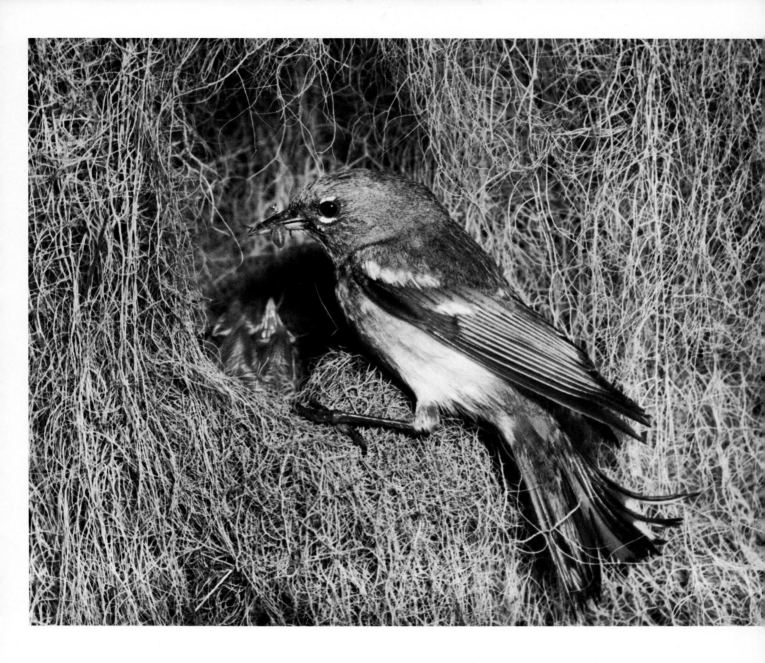

## NORTHERN PARULA
*Parula americana*

This is the smallest of all eastern warblers and the only one that habitually builds a hanging nest. In the north the bird's breeding range is limited to a remarkable degree by the growth of usnea lichen, which is the chief material of most nests. The range of the southern birds is likewise governed to a great extent by the growth of so-called Spanish moss.

In between these two main nesting grounds one will find scattered areas where northern parulas breed. In such localities their cup-like nests are built chiefly of grasses and plant fibers and are frequently suspended in the hairy growth of poison ivy or in tufts of drift left in branches that overhang rivers.

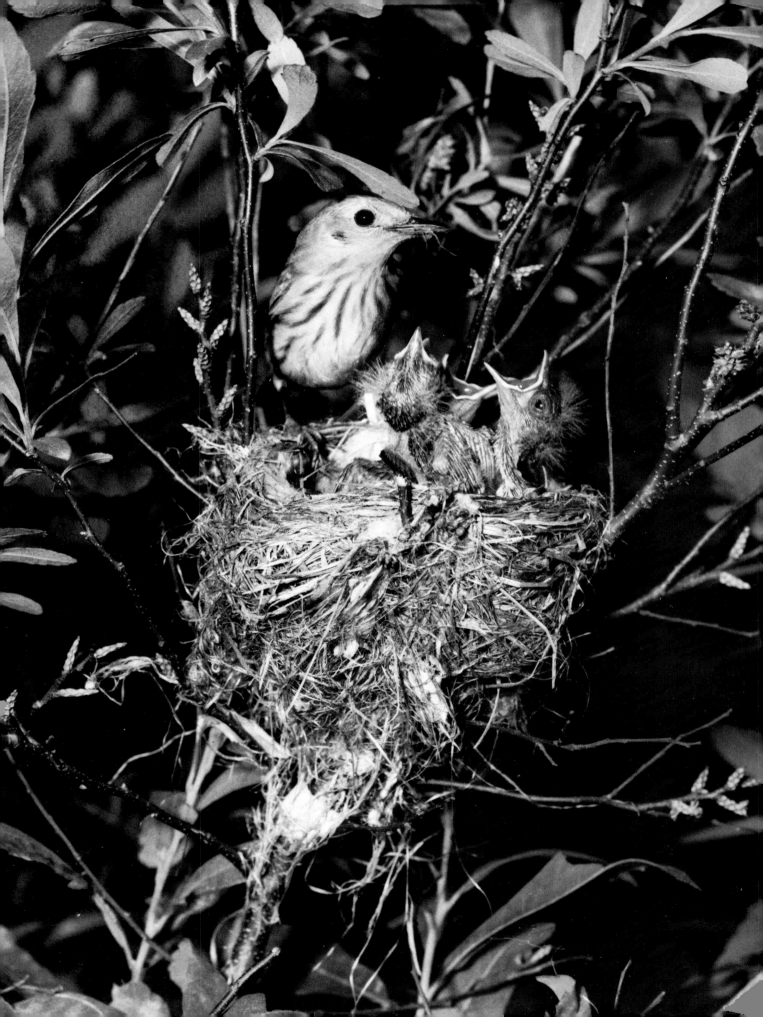

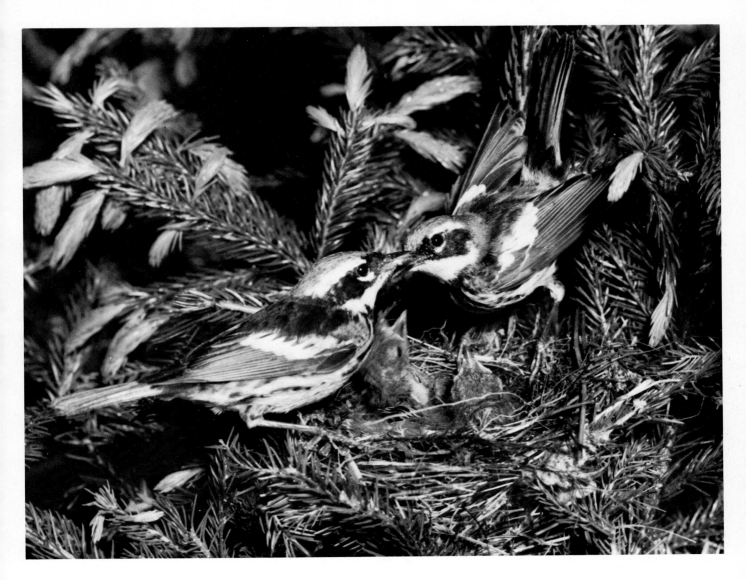

## YELLOW WARBLERS
### *Dendroica petechia*

These bright warblers are among the most widely distributed of the family. They vary considerably, from the brilliant yellow with reddish streaks on the breast of the male to those in the far north with an olive back. They are among the few warblers that have no white anywhere. Their deep, solidly built nest may be found in a garden shrub but more often they nest in brush along a creek or other stream, where a willow is often their first choice. Usually they build between three and five feet above the ground but this nest, the highest I have even found, was a little more than 15 feet above the surface of a swamp.

## MAGNOLIA WARBLERS
### *Dendroica magnolia*

These black-and-white warblers with an intense yellow throat and underparts nest in the cool spruce and hemlock forests of the north. They appear to prefer rather young trees that spring up quickly after fire or storm has destroyed a mature woodland. As with all migratory birds, the journey between their wintering place from central Mexico south to Panama is a hazardous one. They make their flight at night, and on the way innumerable catastrophes may overtake them, such as a strong weather front with low clouds and rain or fog. Under such conditions, the warblers are forced to fly low as they hold to their course, and in the murky night air they do not see obstructions in their path. They often crash into buildings, radio and television towers, and wires. At the Vertical Assembly Building at the Kennedy Space Center migrating birds have sometimes been killed by the hundreds. Security police who witness this rain of birds alert officials at a nearby university, who collect as many as possible; the birds are frozen and later used for various ornithological research projects.

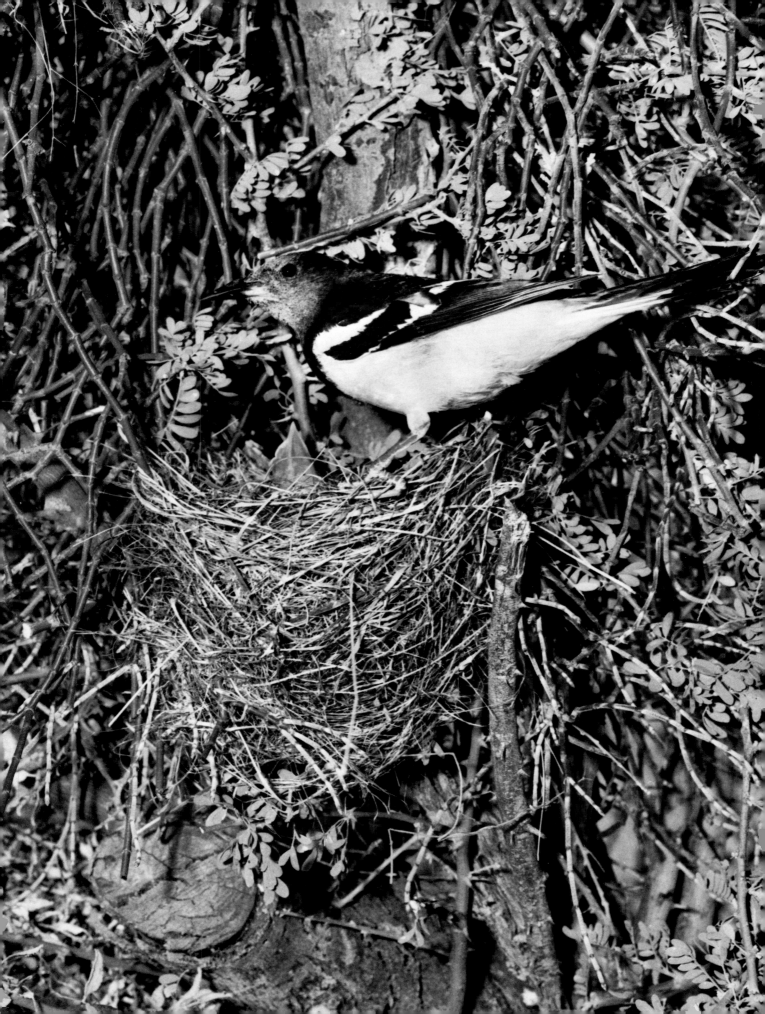

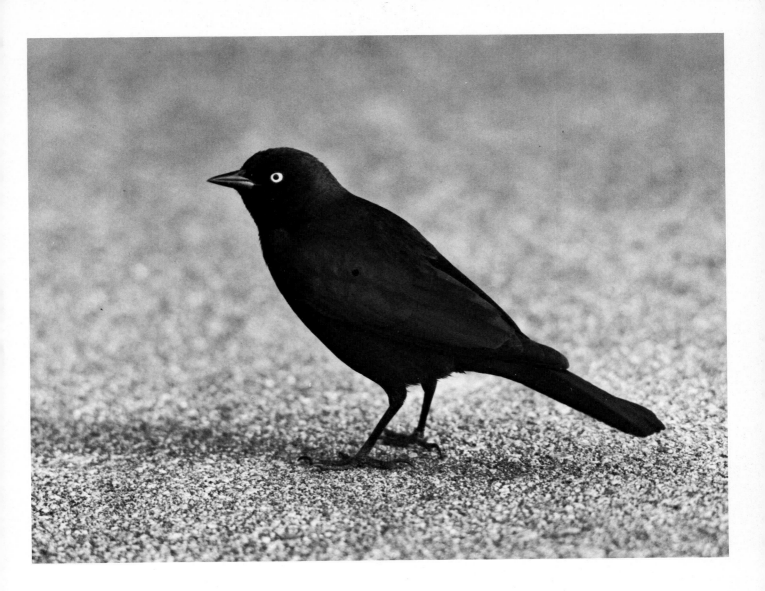

## SCOTT'S ORIOLE
*Icterus parisorum*

This small, black and clear yellow oriole has none of the orange that brightens our other orioles. It is also the most persistent singer of the genus and its musical song is repeated over and over. In contrast to most orioles, which hang their nests from branches, the Scott's oriole lashes its nest firmly to a low branch of a small tree or hides it within the dead, sword-like leaves of yucca. The nest in the photograph was woven in Saguaro National Monument, Arizona. It was tied to branches of an acacia where it was well concealed by the leaves. In contrast, the oropendolas of the tropics nest in conspicuous colonies where they make tremendously long hanging receptacles in which the nest at the bottom may be as much as six feet below the top opening. Of the orioles in our country, the Lichtenstein's, a rare resident along the Rio Grande in south Texas, makes the longest nest container, which may measure more than two feet.

## BREWER'S BLACKBIRD
*Euphagus cyanocephalus*

Audubon named this trim blackbird of the western United States in honor of the early American ornithologist Thomas Brewer. It is a typical example of the order of perching birds. At present taxonomists recognize some 21 different orders of birds, yet more than half of the approximately 37,100 named forms living in the world today belong to this highest and most modern of avian orders. The calculations of Dr. Ernst Mayr, one of our leading authorities, indicate that these named forms may be divided into 8,600 valid species and 28,500 subspecies.

173

## SCARLET TANAGER
### Piranga olivacea

The male scarlet tanager is sometimes appropriately called firebird, for in spring it is garbed in intense red with shining black satin wings. It reaches the north when oak leaves are still rosy midgets and dogwoods are in bloom. One spring in Louden Woods of Rye, New York, I was arrested by the sight of five migrating scarlet tanager males clustered in a small dogwood. The memory of those brilliant birds among the snowy blossoms remains as vivid as the day I saw them.

After the nesting season the black wings lose their gloss and the body, for a time, is oddly spotted with scarlet, yellow and green. By the time the tanagers reach their wintering territory in the hot and humid jungles of northern South America, the body of the male is smoothly green and he resembles the inconspicuous female.

## CARDINAL
### *Cardinalis cardinalis*

The cardinal or redbird, with its large, bright, conical bill, its sharply pointed crest, its brilliant plumage, and its loud clear song, is one of the most widely known and popular birds in the United States. It is one of the few species in which the female has vocal powers rivaling those of her mate. Because of its charm the cardinal was once in great demand as a cage bird. Gennelli Careri, writing in 1699, told how in Havana alone the Spaniards, paying $10 apiece, bought $18,000 worth. Now laws forbid trapping and confinement of any native bird.

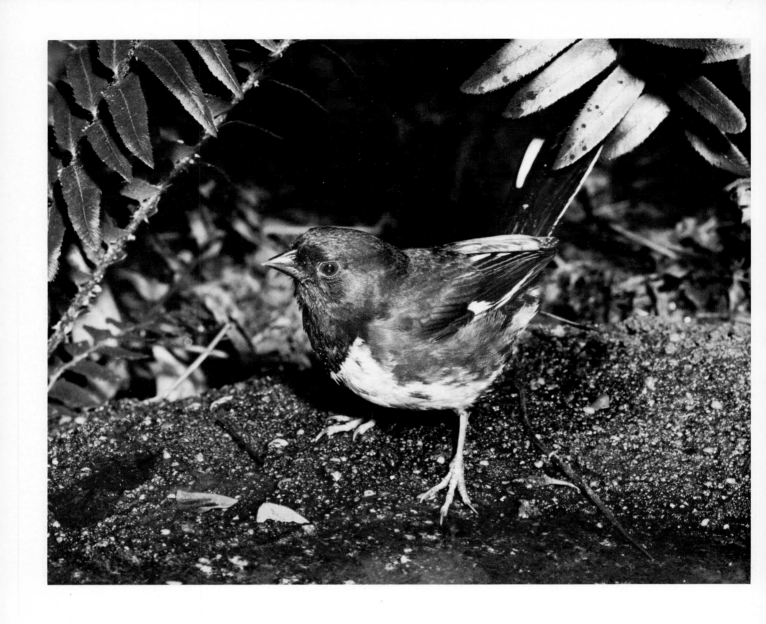

## RUFOUS-SIDED TOWHEE
*Pipilo erythrophthalmus*

This large, noisy sparrow is a bird of thickets and tangles. Like most passerine birds it is extremely territorial during the breeding season. When spring comes each male selects a piece of ground which it claims for its own. Mounting some favorite perch, it sings a song announcing this ownership and warning all other males of the same species to keep away. If another male does venture on the chosen ground, it is vigorously driven off. Thus the entire land is divided into territories, direct competition is partly avoided, and each family is assured of having enough food to raise its young.

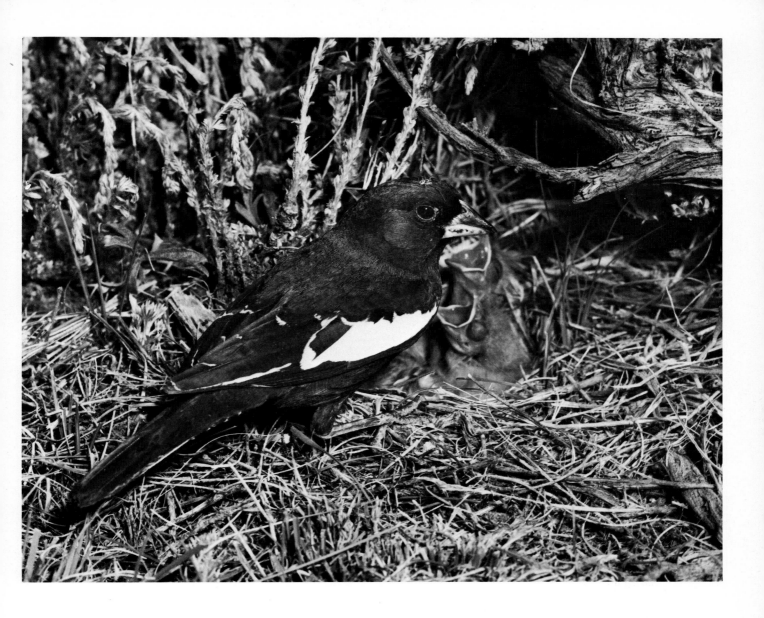

## LARK BUNTING
### *Calamospiza melanocorys*

During the winter lark buntings, the state bird of Colorado, are very gregarious and move across dry west Texas, New Mexico and Arizona in large flocks. Then male and female buntings look almost alike. When spring comes, the male becomes black with large white patches on his wings. Then the buntings move north in huge groups, the ones in the rear constantly flying to the front so that the flock presents a rolling appearance. As they reach the Great Plains they begin to disperse to nesting territories, where the males arrive before the females. With other prairie-nesting species (Sprague's pipits, horned larks, chestnut-collared longspurs and so on) they have a delightful habit of singing aerial solos. While lark buntings may sing on the ground or a perch, their beautiful flight songs involve leaping into the air, rising higher and higher, all the time singing their clear, high warble and trill; then, slowly as a drifting leaf, with their stiff wings quivering, they descend to the area of their nest. Apparently the male takes no part in incubation: his duty at this period of the nesting cycle is to sing and to protect his territory. When the eggs hatch, however, the male usually feeds the young at more frequent intervals than the female.

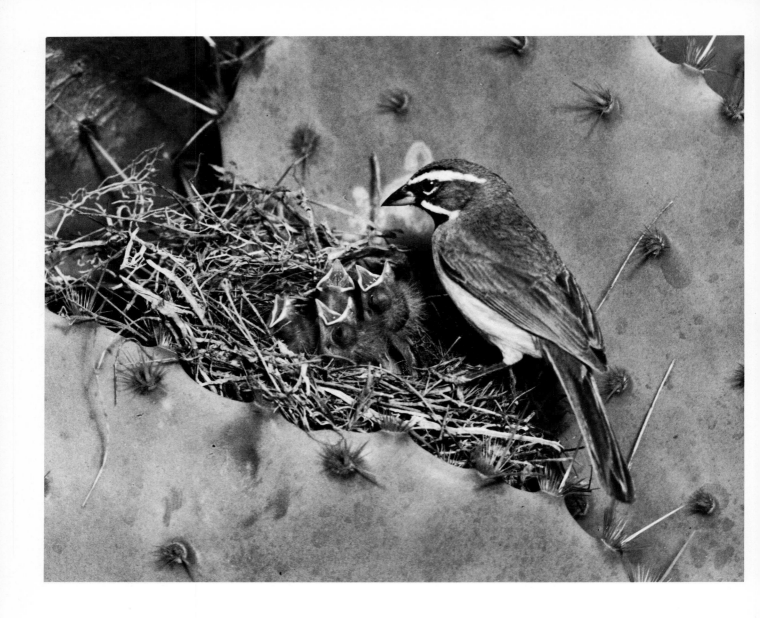

## BLACK-THROATED SPARROWS
*Amphispiza bilineata*

To those of us who love the desert and find its plant and animal life fascinating, this sparrow, formerly called desert sparrow, is one of its most beautiful birds. Sparrows are often dismissed as dull, drab creatures, but this trim gray bird with a clean white line over its eye and a sharply defined black throat and bib is a good example of beauty of design without color. On the desert its nests are found with ease, for vegetation is sparse and places to build nests are limited. Often desert birds nest in cactus, which we touch with very painful results; black-throated sparrows often nest in a veritable thicket of spines and land on cactus with impunity. Somehow its delicate, naked young avoid these same spines that could easily pierce and kill them.

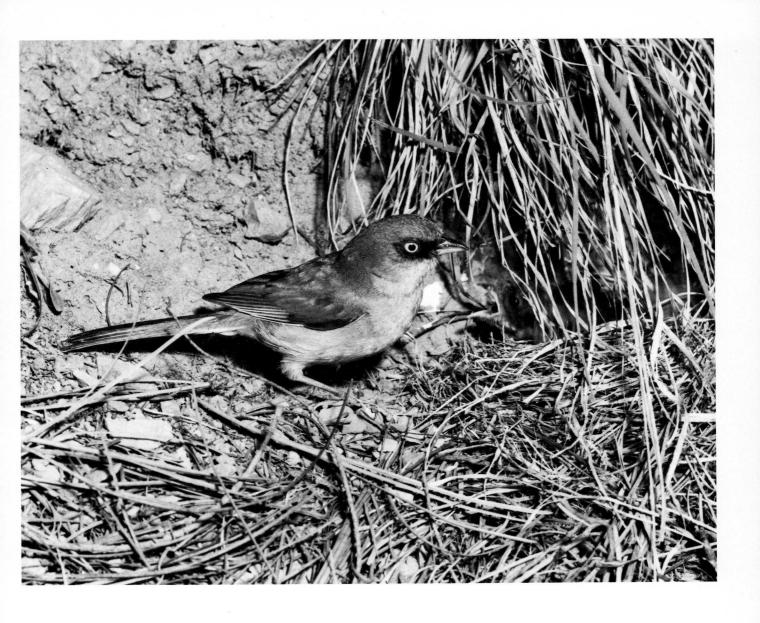

## YELLOW-EYED JUNCO
### *Junco phaeonotus*

Recently the American Ornithologists' Union lumped all North American juncos but one into a single species called dark-eyed junco. The exception lives high in the mountains of Arizona and New Mexico (and on southward into the mountains of Mexico), where conifers dominate the forest: the handsome rusty-backed junco with a bright yellow eye. Once called Mexican junco, its name was changed to yellow-eyed junco at the same time the other juncos were rechristened. Its nest is generally considered a most difficult one to find but this one was not. Tucked into a high bank beside the road above Bear Wallow on Mount Lemmon in Arizona's Coronado National Forest, it was concealed by grasses but the adults approached it along a well-defined path, walking with an odd shuffle halfway between a walk and a hop. The species is resident throughout its range and those who know it in winter say that it rarely descends below 4,000 feet except in the most severe weather.

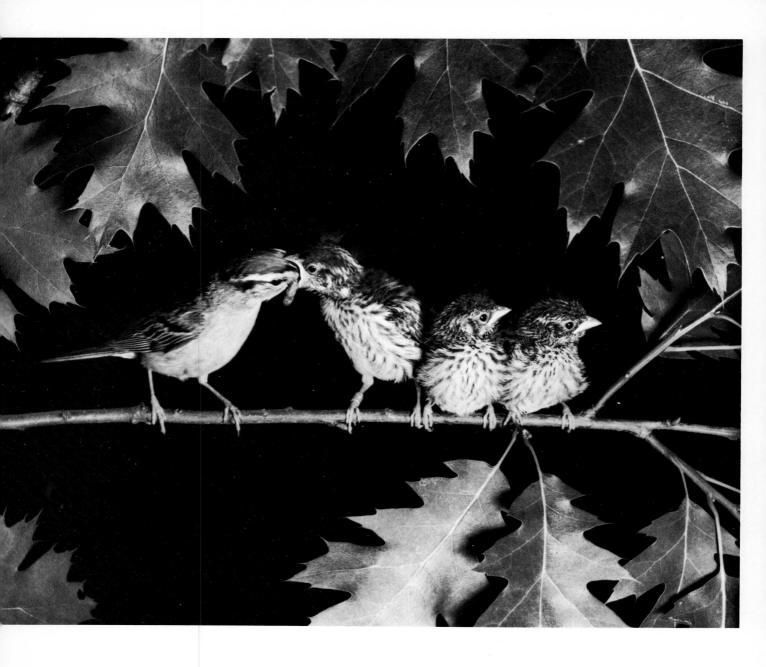

## CHIPPING SPARROWS
*Spizella passerina*

Sparrows belong to the largest of all bird families, a family that has representatives distributed in all parts of the world except the Australian region and at present is comprised of over 1,200 species and subspecies. In the systematic classification of animals they are now generally accepted as the most highly developed of all birds and consequently have the honor of being placed at the top of the avian family tree. This, I believe, must be startling news to the average person who, when speaking of birds, often talks of the "lowly sparrow."

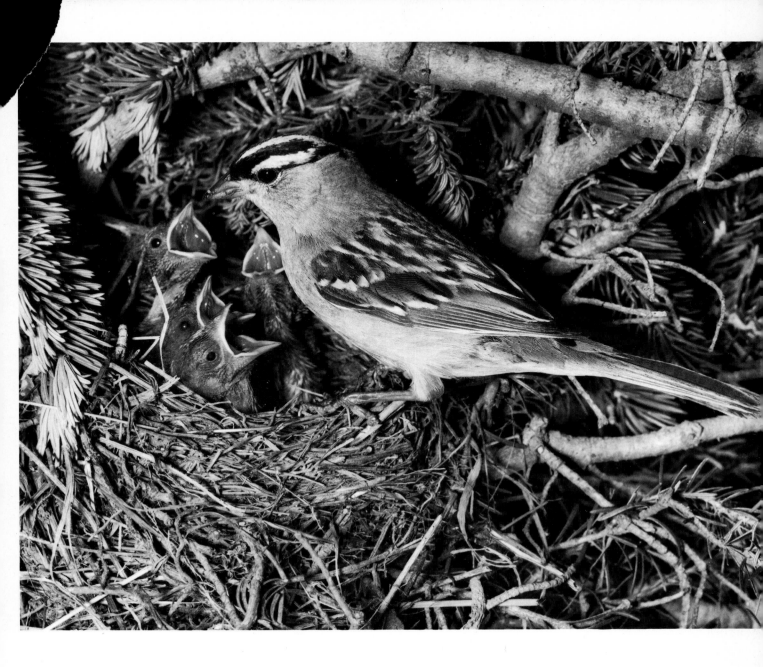

## WHITE-CROWNED SPARROWS
*Zonotrichia leucophrys*

Though some white-crowned sparrows spend the winter in Florida, they always bring the western mountains to my thoughts. To be sure, they have as wide a range as any of our passerine birds. They nest from coast to coast and from sea level on the west coast to well above 12,000 feet. Their intense energy at migration time once led at least one sparrow to overshoot its nesting range by some 2,000 miles and end up only 150 miles from the North Pole. In the West their brave songs may be heard when snow is falling and the temperature stands well below freezing. One such day in Alaska, when my fingers were stiff and the cold even slowed the shutter speed of my camera, the plaintive whistle followed by a series of trills of a white-crowned sparrow rang through the crisp air with as much enthusiasm as if the mercury stood at a mild 70 degrees. As they sing, and often as they forage on the ground for food, the white-crowns fluff their striking black-and-white crown feathers into a little crest.

181

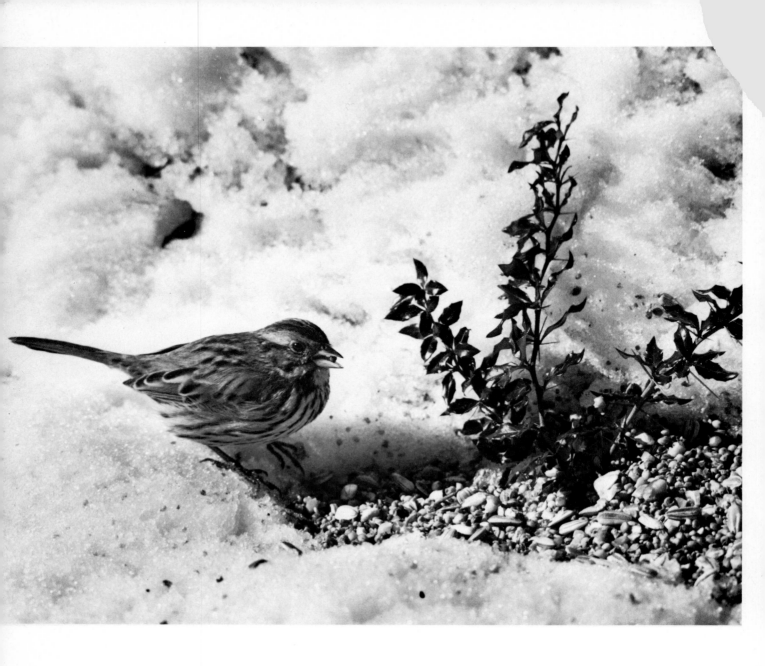

## SONG SPARROW
### Melospiza melodia

It is not necessary to go far afield or search for some great rarity in order to enjoy the thrill of bird photography. A little feeding station or birdbath in the backyard will usually attract a quantity of subjects. In spite of the fact that I have been in almost every corner of the United States and have photographed over 500 species ranging from a humming-bird, 3.74 inches in length, to a California condor, with a wing spread of 11 feet, some of my favorite pictures have been taken right out of my bedroom window only 20 miles from New York City.

The end